辛董事長

澎評指正

Liang

永斐

2019. 7. 12

梁永斐書藝創作集

Liang Yung-Fei <Calligraphic Art Unbounded>

序 Foreword

3　以書入畫、斐然有神/鄭麗君

4　書藝的常與變—梁永斐的現代書法/廖新田

7　書藝無界、擴大價值/郭國華

8　心無量、藝無界/梁永斐

9　Calligraphy in Painting - Gracefulness and Vigor by Cheng Li-Chiun

10　Normality and Deviance of Calligraphic Art:
　　LIANG Yung-Fei's Modern Calligraphy by Liao Hsin-Tien

13　Calligraphy Art Unbounded and Expanding in Value by Guo Guo-Hua

14　LIANG Yung-Fei's Preface
　　Immeasurable in Heart, Unbounded in Art

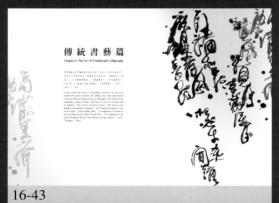

16-43

傳統書藝篇

Chapter I. The Art of Traditional Calligraphy

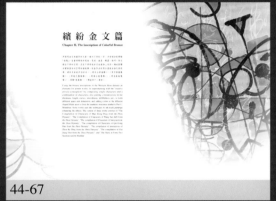

44-67

繽紛金文篇

Chapter II. The Inscription of Colorful Bronze

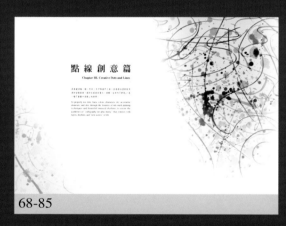

68-85

點線創意篇

Chapter III. Creative Dots and Lines

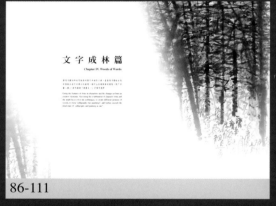

86-111

文字成林篇

Chapter IV. Woods of Words

112-133

大地山河篇

Chapter V. Land, Mountain and Lake

134-151

圓滿人生篇

Chapter VI. A Complete Fulfilled Life

鄭部長麗君序—以書入畫・斐然有神

　　梁永斐先生長年涵泳於藝事，在公餘之暇，持續創作不輟。這本《書藝無界》，已是他的第八本書畫專輯。誠如書名，梁永斐先生的書畫，近幾年從「書有法」轉向「書無法」：將傳統書法經由多層次的書寫，結合彩墨技法蛻變成畫，突破書法與藝術的傳統界線，達到「書畫合一」的境界。

　　能有如此創新及突破，必須奠基於紮實的書法功力為基礎。梁永斐先生的書法自幼受伯父梁昭金先生的啓蒙，求學階段深受陶金銘老師、洪文珍教授及陳丁奇校長指導，從歐陽詢的楷書、黃山谷的行書、米芾及二王的行草、張遷碑的隸書、吳昌碩的篆書及西周金文當中，奠立下深厚基礎。梁永斐先生服務公職三十餘年間，更利用公暇大量閱讀藝術書籍，加強對於西方藝術家作品風格的研究，並潛心研讀佛經，對於萬物感悟更加靈敏，飽含充沛創作能量，方能在書畫藝術上迭有突破。

　　梁永斐先生至今已完成十縣市、十一場次的全國藝術創作巡迴展，是受國家文官學院邀請至該院展出，並安排在「菁英講堂」發表演講的第一位高階文官書藝家。更值得欽佩的是，梁永斐先生為了留下書藝資產，更積極出版《遊藝輔仁》等七本書藝展專輯，分寄予國內各大專院校及圖書館典藏，並免費贈予相關的書畫學會及協會會員，這種無私分享的精神，對推動臺灣書藝發展實有莫大助益。

　　欣見梁永斐先生再次突破自我，推出他的第八本專輯《書藝無界》。本書作品分類共有「傳統書藝」、「繽紛金文」、「點線創意」、「文字成林」、「大地山河」、「圓滿人生」等六篇，內容多元新穎、精緻豐富，讀者若能細細賞析，定是一趟收穫滿載的藝術之旅。特撰此序，以茲祝賀。

文化部長　鄭麗君

書藝的常與變—梁永斐的現代書法

廖新田/台灣藝術大學人文學院院長、台灣藝術史研究學會理事長

　　古老的中國書法藝術，其發展歷史綿長複雜，文化底蘊深厚無庸置疑。一管筆、一錠墨、一方硯，隨提按、轉圜、緩速、映帶等運筆技法的帶入而讓黑墨鋪散之際，能以如此簡單的工具完成藝術大業，且綿延千年時光而承載文化意涵，世界上藝術類型中，書法實無人出其右者。但傳統厚實也因此不免規制重重，難免有新意闕如之評。另一方面，現代化與全球化衝擊之下，文化交流頻仍，沒有任何藝術能完全故步自封、自絕於世。「世守勿替」其實是不可能、更是迂腐的想法。藝術若堅持恆常、亙古不變的觀念，最終只有走入死胡同一路。薪火是必須相傳，但承先啟後則是不可逃避的使命，任何藝術發展均是如此。這是藝術的「常」與「變」的原則—以常為經，變為緯，經緯交織，方成氣候。另外，在常與變之間是辯證關係，應是相互交替循環，不是二分狀態。再次強調，藝術必然朝向求新求變，是內鑑於體內的DNA，否則無法與時俱進，常保盈態。

　　依名，書「法」有法度、規矩的意思，畢竟，文字的結構要求是以辨識與閱讀為優先基礎，而數千年發展出來的用筆、結字、章法、氣韻等美學判準幾已自成「藝」格（「自成一格」之謂），甚至難以撼動，這就是「常」的狀態。有了可茲依賴可獲共識的筆畫架構及理論依據，毛筆書寫所產生的異於常態的諸種變化才可加以比較，才有空間拉開。進一步的，這個差異也逐漸累積出可能的意義，這是「變」。看似頗為普通的道理，若走到藝術的極致表現，就會回應到蘇軾的名言「出新意於法度之中，寄妙理於豪放之外」。這裡指出，創新不假外求，創意其實是源自藝術內部運作下的自體轉化，一種頓悟狀態。當吾人「眾裡尋他千百度」卻遍尋不著藝術方向或答案時，卻是「驀然回首，那人卻在燈火闌珊處」（辛棄疾〈青玉案〉）：原來，藝術創造的契機事實上就在眼前、在脈絡之中、在心靈之內，不在遙遠的他方。往往，鎖住自己創作的不是規矩，而是規矩運作下的慣性所形成的暗示—換言之，是創作者自身綁住自己，而非別的因素讓藝術萎縮（但失敗者或陳陳相因者總是歸罪它因，用以脫責）。總之，在傳統與創新之間存在著挑戰的鴻溝，而這困境，其實往往是「心鎖」，端看如何省視自身，並且勇於突破。套句當代的用詞，這是跨越疆界（跨域）的勇氣。當然，藝術冒險是要付出失敗的代價，但是若是成功，果實是甜美的、令人尊敬的。因此，勇於嘗試—在尋「常」中不斷試驗突破，來實踐嘗試，似乎有那麼幾分道理在。

　　書法之所以是藝術表現，實驗的精神是必要的。實驗是「變」，不滿足於現

狀，有時會一反常態（有時為反而反也無妨，畢竟藝術是另類天馬行空遊戲），合乎於蘇東坡的「反常合道」的藝術批評。這句頗句禪意的提點是蘇軾對柳宗元的評斷：「詩以奇趣為宗，反常合道為趣」。至少，反常的藝術作為可獲得趣味效果，而趣味不正是藝術的目的之一？書法藝術為什麼不能多一些「異端觀點」？為什麼不能判逆一些？為什麼不能「離經叛道」一些？特別是書法所累積厚重的「常」，其實更需要極端的「變」來活化、現代化這個傳統。明白地說，如果書法藝術以古老的姿態堅持那種發言的方式，當失去了當代人們的理解與欣賞的機會，當失去了溝通的平台，書法可能會成為放入博物館的文化「遺產」，成為歷史記憶，而非文化生活中的一部分。若走到這一步，身為文化的繼承者，我們會很遺憾與愧疚。另外的想法是，現代有志於書法藝術者不能只是傳承，死守不變的教條；即使做不到這一步，或許可以再開放一點心胸鼓勵、容許書法有變遷可能，可以欣賞書法的另類展現。總之，「奉古貶今」並不是健康的藝術史觀，但也奉勸「崇今抑古」的看法也應該修正或平衡一些。

梁永斐的書法藝術正是上述傳統與創新辯證的少數典型，是台灣書家中敢於在兩者之間嘗試與實驗的勇者；並且，從作品的質量觀之，他樂此不疲也充滿信心。整體看來，充滿新意與生氣，其戲墨與戲筆其實潛藏著嚴肅的書法革新的議題。

為了證明游移（不是「猶疑」）書藝是有意義的，梁永斐以流暢自在兼及沉穩厚實的書寫功力為基底探索、開發現代書法的新路徑。現代書法和傳統書法的差異，依筆者拙見，乃將西方視覺藝術元素融入於傳統書藝之中，開創出新的創作形式。另如，色彩的引入，讓獨尊「墨分五色」（語出唐張彥遠《歷代名畫記》：「運墨而五色具」）的理論有了對話：當色彩進入書法的黑色世界，會有如何的況味？還是「走味」？另外，不再純粹以書寫慣性為宗，而是朝向繪畫性的構成安排以挑戰我們觀看的身心狀態（是書還是畫？）；歸類上，是書還是畫，或是「畫書」（「以書為畫」）還是「書畫」（「以畫為書」）？

一位現代書家反省性地思考現代書法創作的何去何從，是負責的、冒險的，因為不以傳統為藉口，因此更需要擔負起保守主義者的各種指教，甚至是無端的指責。不過，在台灣，思欲突破的書家早有不少前仆後繼者（因此「前無古人後無來者」這句話在藝術世界或許是不能成立的）。根據黃智陽〈台灣現代書法初期發展的特色與價值〉，台灣現代書法發展中早有王壯為的亂影書，王王孫的大字彩丹書，史紫忱的彩色書法，陳丁奇的淡墨書法、少字數書、假名書法，張隆延的飛白書，呂佛庭的文字畫，以及楚戈的繩書、傅狷夫的童稚書寫等等。1 批評聲浪可以想見，但是，這裡至少突顯一個事實：即便是極為傳統的老派書家，「思變」的企圖仍然如此強烈，更何況當代書家世代所承接的文化衝擊是如此的多元與多方與多變？現代書法雖然走革新路線，就上述案例看來，其實也已是傳統的一部分。其次，書法「突變」的契機往往來自「圖變」——圖像化書法以突破文字的限制是現代書法的主流嘗試：向圖像靠攏。或者持平的說，六○年代的中國現代畫運動，以五月、東方兩畫會為代表（如秦松、莊喆、李錫奇等），則是文字化西方抽象藝術以營造東方氛圍：向文字靠攏。因此，我們看到光譜的這兩端，繪畫藉由文字（特別是甲骨文及金文等古文字）來轉化西方現代藝術思潮並涵化為本土藝術；而書法則藉由現代造形來革新，企圖與世界藝術溝通。不幸的，結果是不公平的，前者取得極大的成功，早已成為台灣現代美術史的標竿；後者則是毀譽參半，

至今尚未有定論。壓力是可以想見的，現代書法的創作者必須背負這些未獲共識的評價，並堅持走出一條道路，期待甚至相信此路終成大道。就這點而言，梁永斐的現代書法實踐，恐怕必須背負「千山我獨行」的孤寂及「雖千萬人吾往矣」的勇氣吧？！藝術是孤寂的，然寂寞多滋味。

相較於前輩書家對書法變異的淺嘗，梁永斐已發展出頗為風格穩定的系列創作，總的看來，質量上頗為成熟流暢，當然其間也展露其信心。每一件作品雖然意趣充滿，行雲流水，卻也能閱讀出鴨子划水的架式；表面輕鬆自再而骨子裡其實是思力交至的用心經營痕跡。

他擅用濃淡墨的交錯作為背景與線條，營造書寫的動態與變化，以及反轉「計白當黑」的規則，讓暗色為底、亮色為文。

他將米羅式或蒙德李安式的色彩計畫填充於各種變形的古文字的區域，加入自動性技法如滴流，整體產生音樂般的韻律感與造形的跳動，拙趣與童趣兼具。

他將文字極端擴張、擠壓、交疊，造成文字海氣勢，配以橫直色域，打破文字的表意慣性，重組之趣味橫生，別開生面。

他把線條誇張地拉長，「文字森林」似乎邀約我們的視覺於線縫間遊走，或圖或文的策略明顯可見。

他拆解文字與開發技法，再重新組合成新的視覺語彙，仍然有書藝的餘韻。

最極端的是讓線條滾動遨遊，跳脫文字暗示，是不折不扣的抽象畫。

梁永斐的「戲書」，體現現代書法藝術的精神：傳統與創新兼具、常與變的反覆辯證、新舊交疊詮釋，是充滿能量的「反常合道」，是「破壞式的創造」，是「創造性的模糊」，不只是離經叛道、背離正統，或膚淺的為反對而反對。

長期在公門服務的他，其實是「我心狂野」的。當然，他應心知度明他必須頂住現代書法的原罪式拷問：這是書法藝術嗎？梁永斐常以佛典經句作為書寫內容，或許，六祖慧能的「菩提本無樹，明鏡亦非台，本來無一物，何處惹塵埃」對照於神秀的「身是菩提樹，心如明鏡台，時時勤拂拭，勿使惹塵埃」的境界，是這個質疑的禪式回應。

1 黃智陽，2010，〈台灣現代書法初期發展的特色與價值〉，「近代書畫藝術發展回顧—紀念呂佛庭教授百歲冥誕國際學術研討會」。

http://cart.ntua.edu.tw/upload/st/201012/201012-12.pdf

[瀏覽日期：2017/9/24]

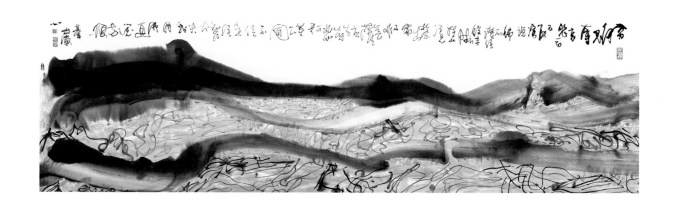

郭董事長國華序——書藝無界、擴大價值

　　永斐字慕巖，一九六二年出生於屏東縣高樹鄉，是我就讀研究所時的好同學，曾任文化部藝術發展司司長，現任文化部參事乙職，至今，其秉持著「大行普賢菩薩」的精神和跑「十項全能」的毅力，在這六年間已完成了十個縣市十一場次的全國書藝巡迴個展。其對佛學的研究、東西方藝術、建築美學、設計學的探討精神，實令人佩服。而這本命名為《書藝無界》的精裝專輯，是其第八本專輯，由我贊助印製兩千本，分享予藝術同好及國人，期許對國內的書藝推廣及國際交流有所助益。

一、書藝無界

　　從永斐至今出版的專輯作品中，可研析出其初期還是在傳統的框架中精進，也就是「字字獨立，字還是字」，而後其深入研究西周金文及西方藝術家的特色，逐步將字視為創作的元素，並在色彩、結構上用心，透過字體、濃淡、技法、線條、色彩……等有效組合，使作品更富有美學構面及哲學含義，這已跳脫單純為書法而書法，而是「字中有字」、「字中有畫」、「畫中有字」、「字畫中有境」，其透過一些簡單的水墨技法及色彩的運用，呈現深具獨特風格—「東方書藝為主，西方藝術為輔」的作品，這種的「融合創新」：是「自然樸拙，融合各家」、是「東西合併，大小得宜」、是「虛實展現，平衡和諧」，是「大破大立，禪機處處」、也直接的應驗了《小窗幽記》~「士人有百折不回之真心，才有萬變不窮之妙用。」這句話的哲理，因其「真心」，讓書藝「無窮妙用」，更展現了「書藝無界」深遠的美好未來。

二、擴大價值

　　永斐的作品從「傳統書法」蛻變為「繽紛書藝」，除符合當代外，更具有「獨特性」及「前衛性」，本人這幾年來特經其授權將其作品運用在建築設計及室內設計上，亦挑選其作品，製作「喜樂」、「圓滿」、「夆禾」、「昌吉」為名的杯子，頗獲肯定及好評，往後應好好思考：如何將其作品推向國際及擴大價值運用在各類文創商品上，因其作品深具潛力，亦是績優股，我將永續贊助，與他同行，共同用行動來「推動美學」、「行善積德」及「利益眾生」。

　　另《小窗幽記》中有一段話是如此寫的~「天薄我福，吾厚吾德以迎之；天勞我形，吾逸吾心以補之；天厄我遇，吾亨吾道以通之。」未來將與永斐共同以「厚德」、「逸心」、「亨道」豐富共同的人生，專輯將出版，特撰此序祝賀。

梁永斐自序─心無量、藝無界

《八大人覺經》中第一覺悟─「世間無常，四大苦空，五陰無我，生滅變異，虛偽無主，心是惡源，行為罪藪，如是觀察，漸離生死。」可見萬物會成住壞空，一切如水中月，如空中花，人身難得，雖短暫，但只要時時見心澄性，則處處蓮花盛開，創作亦如是。

一、心無量

心即是佛，佛即是心，佛不外求，明心見佛。
〜佛家語〜

心心心，難可尋，寬時遍法界，窄時不容針。
我本求心不求佛，了知三界空無物。
我欲求佛但求心，只這心，這心是佛。
我本求心心自持，求心不得待心知。
佛性不從心外得，人生便是罪生時。
〜達摩祖師〜

可見「一切唯心造」，心生種種法生，心滅種種法滅，「身正則心正」，「心正則筆正」，可見「心」的修練對一位藝術家是非常重要的，尤其在創作時：是孤寂的，是專注的，面對的是自己，是自己的心，而這「孤寂」及「專注」是充滿著創意、熱力、生命、光明及能量，說真的；書藝的精進應以「修心」為首要工作，而其過程就是要在當下內觀、默照、覺醒、醒悟、徹悟，如此不執著外在妄相，重視自家心性本來的了悟，持續精進不懈，而產生「平等心」、「慈悲心」、「利他心」，方能境界有所突破。

學道先須識自心，自心深處最難尋；
若還尋到無尋處，才悟凡心是佛心。
〜無垢子〜

因此：本人不僅要勤於「筆耕」，更要花更多時間去「耕心」，如此方能「心筆合一」，加上佛學的加持，期能達「筆心佛三合一」的境界，而這境界，是一種「無」，是一種「空」，亦是一種「無礙」，更是一種「無量」。

二、藝無界

創作的過程是艱辛，亦是喜悅的，為了深化書藝創作的內涵，除了研究書法的字體結體外，更大量閱讀西方藝術相關書籍，並特別研究了西方藝術家蒙特里安、米羅、康基斯丁、畢卡索、梵谷、高更、波洛克等以及華人旅法三大藝術家趙無極、朱德群、吳冠中的傳記、作品、技法及風格，讓我剖析出藝術呈現類型約有「寫意」、「寫實」、「抽象」三種，當然可互為運用，而藝術表現方式則是由點、線、面結構而成的空間：點則有濃淡、大小、色彩、形狀，線則有濃淡、粗細、長短、曲直、暢澀、色彩，而面則是點線、黑白及色彩的運用，而這些點、線條、空間、色彩，依先後、層次及水墨技法有效組合互為關係的運用，就會形成了「美」，而這「美」是一種「空靈」、是一種「平衡」，更是一種「和諧」及「圓融」的關係，如果沒有這關係，就顯現不出美，如處理好關係，搭配好空間於字、於人、於物、於境，這種良好關係就是「藝術之美」，自然帶給人美感與喜悅。

我的作品加上了層次及色彩，並且實驗組合「造境」及「化境」，雖然創作較費時，但也豐富了我的生命，而作品的獨特性及衍生性也會大大提高，不僅融合了東西藝術特色，更可融入建築設計及室內設計，亦可創造出有價值的文創品牌及商品。說真的，藝術創作的歷程：是在「體悟無常」、「行動實踐」、「創造價值」，本人將持續研究、實驗、應用，接而創造更大的「新價值」，而這「新價值」也就是一位藝術家一生追求「藝無界」的使命。

本專輯共計108件作品，在此要感謝文化部鄭部長麗君題序，感謝國立臺灣藝術大學廖院長新田的評論，感謝郭董事長國華的贊助與題序，感謝書畫大師李院長奇茂的題字，更要感謝父母親的艱辛培育及家人的支持，專輯才能如期付梓。

Foreword of Minister Cheng Li-Chiun:
Calligraphy in Painting- Gracefulness and Vigor

Cheng Li-Chiun
Minister of Culture

Mr. Liang Yung-fei had been acquainted with art for many years, where he had never stopped with his artistic creations outside of work. This album Calligraphy Art Unbounded is his eighth calligraphy album. As to the title of this album, the calligraphy and paintings of Mr. Liang Yung-fei has recently changed his concepts from "calligraphy with regulations" to "calligraphy without regulations": using traditional calligraphy to be placed layer over layer, and combining colored ink-wash techniques to transform the layers of traditional calligraphy into a painting, breaking the boundaries of traditional calligraphy and art, in accomplishing the state of "calligraphy and painting as one".

To accomplish such innovation and breakthrough, he must have had a solid foundation of knowledge and techniques in calligraphy. Mr. Liang Yong-fei's calligraphy was inspired by his father, Mr. Liang Zhao-jin, in a young age. During his years in school, he was taught and inspired by his teacher Tao Jin-ming, professor Hong Wen-zhen, and principle Chen Ding-Ji, where he built his solid foundation in learning the regular scripts of Ou Yang-Xun, the semi-cursive scripts of Huang Shan-gu, the semi-cursive scripts of Mi Fu and the Two Wangs, the clerical scripts of Zhang Qian-bei, the bronze inscriptions and seal scripts of Wu Chan-shuo. Mr. Liang Young-fei used his time outside of work in reading great number of books about Art, during his service in the public office for more than thirty years, to have deeper understandings in the research of the styles in the works of western artists. He also read and studied Buddhist texts and scripts intensively, which enhances his sensitivity towards the appreciation of all living beings, and gave him his energy for creating his art works that also enabled him to make breakthroughs in artistic calligraphy and painting.

Mr. Liang Young-fei had successfully held eleven solo-exhibitions in ten counties and cities during his national calligraphy art tour exhibition, and was the first Senior Civil Service calligraphy artist to be invited by the National Academy of Civil Service to hold an exhibition within the academy and to make a speech in the "Elite Lecture Hall". What was more admirable was, he published seven calligraphy art exhibition albums including Art Tour in Cultivation of Virtue (遊藝輔仁), of which he separately mailed to different colleges and libraries as a collection, and also was given to members of related calligraphy painting societies and associations for free. His spirit of selfless sharing provides a great deal of help in promoting calligraphy art in Taiwan.

I am very happy to see that Mr. Liang Young-fei had once again accomplished a self-breakthrough in publishing his eighth album Calligraphy Art Unbounded. This album had categorized his works into six chapters, "Traditional Calligraphy Art", "Colorful Bronze Inscription", "Creative Dots and Lines", "Woods of Words", "Land, Mountain and Lake", and "Complete Fulfilled Life". The context is novel and diversified, sophisticated and rich in content, where readers can benefit a great deal on this artistic journey. I hereby congratulate him in writing this foreword.

Chenglichin

Normality and Deviance of Calligraphic Art:
LIANG Yung-Fei's Modern Calligraphy

Liao Hsin-Tien

Dean of College of Humanities, National Taiwan University of Arts

Chairman of Taiwan Art History Association

The Chinese ancient art of calligraphy has a very long and complicated history, which, no doubt, is culturally rich and profound. A brush, a tablet of ink, a square inkstone; the techniques of the movement in writing, lift and press, turn and bend, slow and fast, and the thin half-connecting strokes, brings out the beauty of Chinese ink. Chinese calligraphy had accomplished a great artistic achieve,usingthose simple tools and extending the thousand-years cultural content, calligraphy has gone beyond other types of art in the world. But due to the many regulations within this traditional art, it was considered to lack in new ideas. On the other hand, under the impact of Modernization, Globalization, and the frequent cultural exchange, no art could be in total alienation nor isolation from the world. It is impossible and a pedantic idea to try to pass something down generations to generations without any changes. If art insists on the idea of eternally immutable, it will eventually go to a dead end. The spirit must be passed on, but the fate of inheriting the past and usher in the future is an inescapable mission for the development of any art. The principles of art, "normality" (常) and "deviance" (變): normality as in latitude, deviance as in longitude, intertwining the two will bring art to its maturity. In addition, the relations between normalityand deviance is dialectical, the two should be alternating with each other instead of being divided. The fate of art is to head towards innovation and change, this is within its body's DNA, or else it could not advance with times to maintain its profit status.

As indicated by the name, in the Chinese words for calligraphy, shu fa (書法), the word "fa" (法) has the meaning of law and rules. After all, the basic requirements for the structure of words is to identify and read. Also, the aesthetic judgement of the usage of pen/brush, the formation of characters, the rules, the concepts, etc. has become sui generis, unmovable, which is the state of "normality" (常). With the reliable and consensus of brush stroke structures and theoretical basis, the many unordinary changes occur in the writings of the brush could then be compared. Furthermore, these accumulation of differences could then be given a meaning, which is "deviance" (變). This principle seems to be a simple idea, but it corresponds with a famous saying, "A new artistic conception derives from the legal principle,an extraordinary principle comes amongthe bold and unconstrained style"by Su Shi (蘇軾), as art reaches its ultimate performance. Here, it indicates that there's no need for outer help for artistic innovation. Innovation comes within the artistic process itself, an epiphany. When I "looked a thousand times or more in quest of one"but unable to find the artistic direction nor the answer of what I seek, I then "suddenly looked back and find the one there where lantern light is dimly shed." (Xin Qiji's " To the Tune of Green Jade Table" 辛棄疾〈青玉案〉): The juncturefor art creations is right in front of our eyes, within the context, within our hearts, a place not far. Usually, what limits and stops us from creating art is not the laws and regulation, but the implied effect of inertia under the operation of rules and regulations-in other words, creators are limited by themselves, not other reasons that shrivels art (but failures or those who follow the old routine always blames the other reasons to absolve the responsibility from themselves). In conclusion, there is a big gap of challenge between tradition and innovation, this dilemma is usually the "lock of the heart", one should learn to inspect oneself and be brave to break the lock. To adopt a contemporary phrase, this is the bravery of boundary spanning. Of course, there are prices to pay when one fails in taking artistic risks, but the sweeter the taste of success will be. Therefore, it is plausible to believe in the courage to try, in search to breakthrough and exceed "normality" (常).

The spirit of experiment is what makes calligraphy an artistic expression. Experiment is "deviance" (變), to be unsatisfied with the current state, to sometimes be outside the norm(sometimes there is no harm to oppose for the sake of opposition, after all, Art is a kind of unrestrained and vigorous game), which corresponds to the art criticism "abnormality and uprightness" (反常合道) by Su Dong-Po (蘇東坡). This Zen compliment was from the advice Su Shi (蘇軾) gave to Liu Zhong-yuan (柳宗元), "Quaint is the model of poem, abnormality and uprightness is quaint". At least the artistic abnormality gives the effect of quaint, and isn't quaint one of the goals of art? Why couldn't calligraphy art have a little more heretical point of views? Why couldn't it be a bit more rebellious? Why couldn't it be a more deviant? Especially calligraphy, which has accumulated so much "normality", it

needs "deviance" to make it more live, to modernize this tradition. Frankly speaking, if calligraphy artinsists on coming out with its ancient gesture, it will lose its opportunity for present audience to understand and to appreciate. When the platform for communication is lost, calligraphy could end up in a museum as a cultural heritage, becoming a memory in history and not a part of our modern cultural life. If it comes to this, we, as successors to culture, will be regretful and guilty. Another thought, those who aspires to calligraphy cannot only focus on passing down the legacy and keep the same doctrine for life; if not, maybe they could open their minds and hearts in encouraging and allowing possible changes in calligraphy, and can appreciate other styles or expressions in calligraphy. In short, it is not a healthy artistic historical perception to "devote totradition, diminish the present", but the perspective of "adoring the present and restrain tradition" should be amend or balanced a bit more.

The calligraphic art of Liang Yung-fei is the few typical examples that shows the dialect between tradition and innovation discussed previously. He is one of the Taiwanese calligrapher who is brave in making experiments between the two; we can see from his work that he enjoys and is confident with these experiments. Overall, his works are full of vitality and creativity, beneath his lively brushstrokes and his playful expression of ink, intends the serious issue of the innovation of calligraphy.

To prove that there is a meaning to the wavering (not hesitant) calligraphic art, Liang Yung-fei uses his fluent and confident calligraphy skills to explore and develop a new path of modern calligraphy. In the author's humble opinion, the difference between modern calligraphy and traditional calligraphy is, the former brings in western visual art elements into traditional calligraphy to create a new creative form. For example, the introduction of color, created a dialogue for the theory "Chinese ink dividing into five colors" (墨分五色) (from the Tang Dynasty Chinese painter Zhang Yan-yuan's (張彦遠)The Paintings of the Past Dynasties (〈歷代名畫記〉): there are five shades of color in ink): When color is introduced to the black world of calligraphy, what situation will come about? Will it "loose its flavor"? Also, it will no longer be purely writing calligraphy, but rather becomes closer to painting composition, challenging the physical and mental state of the viewers (is it calligraphy or painting?): in categorization, it's calligraphy or painting, or "painting calligraphy" (using calligraphy as painting) or "calligraphy painting" (use painting as calligraphy)?

A modern calligrapher who reflectively thinks about the creation of modern calligraphy is responsible and adventurous, because he/she does not use tradition as an excuse. But due to this, he/she also needs to face the comments of the conservatives, even criticism that comes out of nowhere. In Taiwan,before these calligraphers who seeks breakthroughs in their creations, there had been many who falls, and the next follows (so the phrase "to have neither predecessors nor successors" does not apply to the artistic world). According to Huang Zhi-yang's (黃智陽)Distinct feature and Values of Taiwan's Modern Calligraphy in Beginning Period, during the development of modern calligraphy in Taiwan, there had been Wang Chuang-wei's (王壯為) disordered shadow calligraphy (亂影書), Wang Wang-sun's (王王孫) large red character calligraphy (大字彩丹書), Shi Zi-chen's (史紫忱) color calligraphy (彩色書法), Chen Ding-chi's (陳丁奇) light ink calligraphy (淡墨書法), few character calligraphy (少字書法), hiragana calligraphy (假名書法), Zhang Long-yen's (張隆延)flying white calligraphy (飛白書), Lu Fu-ting's (呂佛庭) text painting (文字畫), Chu Go's (楚戈) rope calligraphy (繩書), Fu Chuan-fu's (傅狷夫) childlike calligraphy (童稚書寫), etc. One can imagine the criticism they receive, but this also underlines the fact: even those traditional, old style calligraphers shows the ambition for the "desire for change" (思變), not to mention the modern calligraphers who undertake the multiple, diverse, changeable cultural impacts. From the cases listed above, even though modern calligraphy has gone onto the innovative path, some of the innovative changes had already becomepart of tradition. The juncture of "mutation" for calligraphy usually comes from the "change in image"— imaging calligraphy to exceed the limits of characters has become the mainstream attempts for modern calligraphy: to move towards imagery. Another, characterizing the western abstract art to form an oriental style, represented by the Fifth Moon Painting Society(五

月畫會) and Eastern Painting Society (東方畫會) (artists including Qin Song (秦松), Chuang Che (莊喆), Lee His-chi 李錫奇, etc.) during the Chinese modern painting movement in the 1960s: to move towards characters. Thus, we can see the two ends of this spectrum: painting attempts to converse and acculturate modern western artistic trends into our own local art paintings using Chinese characters (particularly using ancient characters, like the Bronze script (金文), Oracle bone script 甲骨文, etc.); whereas, calligraphy seeks for innovation through modern artistic forms, in attempt to communicate with the world's art. Unfortunately, the results were not fair, the former was a success and had already became the standard for Taiwan's modern art history. As for the latter, it was a mixed reception that it got both praised and blamed, and is not yet conclusive till today. We can imagine the pressure creators of modern calligraphy must bear, to persist in going down this road with all these mixed, inconclusive reception, hoping and believing that this road will lead to success. In this regard, Liang Yung-fei must bear the solitary of " going alone into thousand mountains ", and have the courage in " a thousand foe won't bent my will " in his practice for modern calligraphy. Art is solitary, yet solitary is flavorful.

The development of Liang Yung-fei's calligraphy style in his series creation, hasreached a stable state compare to the predecessors of calligraphy who attempts in innovating calligraphy through deviance. In overall, the quality of his work shows the matureness in his style, and also shows his confidence. Even though, in every piece of his work, shows interesting playfulness in his smoothly movement strokes, we can comprehend the manner of ducks paddling underwater in his work; under the ease and relief surface, there lies traces of his efforts in dedication and devotion.

He uses the features of ink, crisscrossing lines of light and dark shades as his background, to createmovement and changes in writing;he reverses the structure using white as black, using dark shade of ink as the background in contrast to form light shade colors into words.
He uses the color styles of Miro or Mondrian to fill in the different deformed shapes within the gaps of ancient words, and adds the techniques of automatism such as dripping paint, to create a rhythmical image forming childlike interests.

He deforms characters to extreme expansions, extrusions, overlaps, forming a momentum of sea of text. Then arranges straight horizontal areas of colors to break the inertia expressions of texts, emerging a delightful taste in reformation; here he breaks a new path.

He stretches his lines in an exaggerating matter, this " forest of words " seems to invite us to visually wonder within the stiches of lines, the strategy of using images as words, or words as images is clearly visible.

He takes apart characters and creates new techniques, reconstructing to form a new visual vocabulary that still keeps charm of calligraphy art.

Liang Yung-fei's "playful calligraphy" (戲書) shows the spirit of modern calligraphy art:Combiningtradition and innovation, repeating dialect of normality and deviance, interpreting the blending of new and old; is full of energy of " abnormality and uprightness", is a "disruptive creation", is a "blur of creation".His calligraphy is not only about deviant, to turn away from the orthodox, or the shallowness of opposing for opposition.

He who worked at a governmental department for a long time is "wild in heart". He of course knows that he must face the questioning of modern calligraphy as if it carries an original sin: Is this calligraphy art? Liang Yung-fei often uses classic sayings from Buddhist scriptures as the content of his works. Maybe the realm within the saying of " There is no wisdom tree; nor a stand of a mirror bright. Since all is void, where can the dust alight?" by the Sixth Master (六祖慧能) contrasting with the saying "The body is the wisdom tree. Your heart is the stand of mirror bright. Frequently wipe it. Don't let it be dusty" by Shenxiu (神秀), is the Zen response to this question.

Foreword of Chairman Guo Guo-Hua:
Calligraphy Art Unbounded and Expanding in Value

Guo Guo-Hua

Yung-fei, styled himself as Qi-Yen, was born in Gao-shu Township, Pingtung County, in 1962.He is my good classmate in graduate school. He was the chief of the Department of Arts Development in the Ministry of Culture, and is now a Counselor of the Ministry of Culture. He holds the spirit of "the practice of Samantabhadra", and the willpower of "decathlon" till today. Within these six years, he had accomplished his national calligraphy art tour exhibition, where he held eleven solo-exhibitions in ten counties and cities. His studies of Buddhism and his spirit in exploring Eastern and Western Art, the aesthetics of architect, and design, are very admiring. This hardcover album Calligraphy Art Unbounded, is his eighth album, which I sponsored for printing two thousand copies, to share with fellow countrymen and artists, in hope to promote calligraphy art and to help in international communications.

I. Calligraphy Art Unbounded

From all the albums Young-fei published, we can see that his early works are still within the frame of traditional calligraphy, where "characters stand alone, words are still words". Later on, when he began to study the bronze inscriptions of the Western Zhou dynasty and the works of Western artists, he gradually began to see characters as elements for creation rather than the subject, and started to put effort in colors and structures. Through combinations of fonts, light and dark ink, techniques, lines, color, etc. to give his artworks more meaning in aesthetic structures and in philosophy, which shows that his work is no longer pure calligraphy, containing "words within words", "paintings within characters", "scenes within character paintings". Through the usage of ink-wash painting techniques and colors, he presented his unique styled works that consists "with oriental calligraphy as principal and supplementing with western art". This "new fusion" is"natural and sincere in fusing different styles", is a "combination of East and West, and appropriate in size", is a "combination of virtual and reality, balanced and harmonious ", is a "disruptive breakthrough, containing the spirit of Zen". Which corresponds to a passage in Speculations in Solitude at Tiny Window, "a scholar needs an unconquerable sincere heart to be ingenious within the superficial changes". The philosophy of this sentence is the "sincere heart", to make calligraphy art be "ingenious without dilemma", which reveals the far-reaching glorious future for " Calligraphy Art Unbouned".

II. Expanding in Value

Young-fei's works transformed from "traditional calligraphy" to "colorful calligraphy art" that tallies with the present, and possess in "uniqueness" and "innovation". Within these couple years, I had asked for approval in authorizing his works to be used in architect designs and interior designs, where I also chose his works in making the cups named "Joy", "Completion", "Harvest", "Flourish", which received favorable notices. His work has great potentials with outstanding results, where I should consider other uses of his works in the future, and to promote his work internationally, to apply on other cultural creative products. I will continue to sponsor him, to walk beside him, to use actions in "promoting aesthetics", to "practice good deeds", and to "benefit all living beings" together.

Also, another passage in the book Speculations in Solitude at Tiny Window, "If god does not give me good fortunes, I build-up my virtue to cultivate my fortunes; if god exhausted me physically and mentally, I will maintain a comfortable spirit to repair my body; if god placed my life in dilemma, I will devour myself in my religion to walk out of the dilemma. If I am able to do the things above, what else can god do to me". I will carry the "great virtue", "leisure heart", "prosperous path" together with Young-fei, to enrich both of our lives. I wrote this foreword to congratulate him on this soon to be published album.

LIANG Yung-Fei's Preface
Immeasurable in Heart, Unbounded in Art

Liang Yung-Fei

The first realization of the Eight Realizations of the Great Beings: "To understand that the world is impermanent. The four elements are empty, it will lead to suffering if one does not understand. Living beings are only a collection of the five aggregates of form, sense, thought, actions, and consciousness that accumulate through time,which has no independent self. Life and deathis nothing but a series of transformations. It is an illusion and impermanent. The mind is the source of all evil and the body is a marsh of sin. If we contemplate these truths, we can gradually become free of Sansara, the abyss of suffering." From here we see that all living creations goes through formation, existence, destruction, and emptiness; like moon in water, flower in sky. Life is scarcely attainable, even though life is short.As long as we clarify our hearts, we can see lotus blooming everywhere.It is the same for art creations.

I. Immeasurable in Heart
The heart is Buddha, then Buddha is my heart; there is no need to look for Buddha in the outside world, because Buddha comes from the clear heart within us.
~A Buddhist saying~

Heart of the past, present, and future is hard to find; when one's heart is open it can fit the whole dharma realm, but when it's narrow, it can't even fit a needle.
I look for my heart and not for Buddha, I understand that there are no three realms when I have a clear mind and heart because I know it's in my heart.
I seek Buddha but I seek heart instead, for this heart, this heart is Buddha.
I was seeking heart, but my heart took over control; one cannot knowingly hold the intentions of the heart, as it will over-do what one seeks and loose the true heart.
One cannot seek the nature of Buddha from outside the heart; when the intentions of the heart is shown, one cannot see the nature of Buddha, whereas sin has appeared in front of you.
~Bodhidharma~

This shows that "everything is made with the heart" "when one believes in an idea, the heart will make it true; when one

extinguishes an idea, the heart will make the idea disappear", when one is honorable, their heart is upright, when one's heart is upright then they can write straight. Therefore, the discipline in "heart" is very important to an artist, especially in creating artworks. Creating artworks is solitary, concentration, facing one's self and one's heart alone. This "solitary" and "concentration" is full of creativity, power, life, light, and energy. In fact, the primary task in improving calligraphy art is the practice in the "discipline of heart", to carry out insight meditation, silent illumination, awakening, realization, and enlightenment within the process of the practice. In order to exceed the boundaries, one should not grasp delusions, but to value the comprehensions that comes from within, to continue on advancing oneself, to form an "impartial mind", "merciful heart", "altruistic heart".
To the path of further studies, one must know their own heart and mind; the deep part of our heart and mind is the hardest to find; if one seeks till there is nowhere else to look, then one will understand that the natural state of mind is the mind and heart of Buddha.~Immaculate Buddha~

Therefore, I not only need to practice my brushwork techniques, but also need to spend more time on the practice in the heart and mind, to be "mind and brush as one"; furthermore, with the blessing of the study in Buddhism, I hope to reach the realm of "brush, mind and Buddha as one", the realm that is "none", is "empty", is "unhindered", and is "immeasurable".

II. Unbounded in Art
The process in art creation is difficult, but joyful. In order to deepen my connotation in the creation of calligraphy art, I studied different styles and word-structure of calligraphy, and also read a great number of books regarding western arts; specifically studied the biographies, works, techniques and styles of western artists: Piet C. Mondrian, Joan Mir?, Wassily Kandinsky, Pablo Picasso, Vincent van Gogh, Paul Gauguin, Jackson Pollock, etc. and Chinese artists who lived in France: Zao Wou-Ki, Chu Teh-Chun, Wu Guan-Zhong. From my studies, I analyzed that there are three types of artistic presentation: freehand, realistic, abstract, which of course, the

three can be used together; and art is expressed by dots, lines, and surfaces to form space. The usage of dots consistsin the dense in shade, size, color, and shape; and lines consist in the dense in shade, thickness, length, curves, smoothness and color; as for surfaces, it is made with dots, lines, black and white, and colors. In layering these dots, lines, space, and colors in an effective combination forms "beauty", where this "beauty" is "spiritual" and "balance", as in relationwith concordance and harmonious. Without these relations, this beauty cannot be presented. If the combinations of the space in characters, in people, in figures, in scenes can be placed and layered effectively, the "beauty of art" will show within this harmonious relationship that will bring beauty and pleasure to viewers.

I added layers and colors, and also in attempt to combine "creative artistic conception" and "sublimation", in my work.Even though this process is time-consuming, but this also enriches my life and enhances the uniqueness and derivativeness of my work. This not only combines the features of Eastern and Western art, but can also be combined with architect designs and interior designs, which is also valuable for cultural and creative industry in making brands and products. To be honest, the process in artistic creation is to "understand the state of impermanent", "put practice into action", "create value" I will continue with my studies, experiments, and application to create "new values" to my works. This" new value" is also a life-time mission for an artist to reach the state of "unbounded in art".

This album consists 108 pieces of my works. I would like to thank the Minister of Culture Cheng Li-Chiun for my preface, the Dean of National Taiwan University of Arts Liao Hsin-Tien for the art review, the calligraphy master Lee Chi-Mao for the inscription, and I would especially like to thank my parents who put a lot of effort in nurturing me, and my family who had supported me to make this album possible.

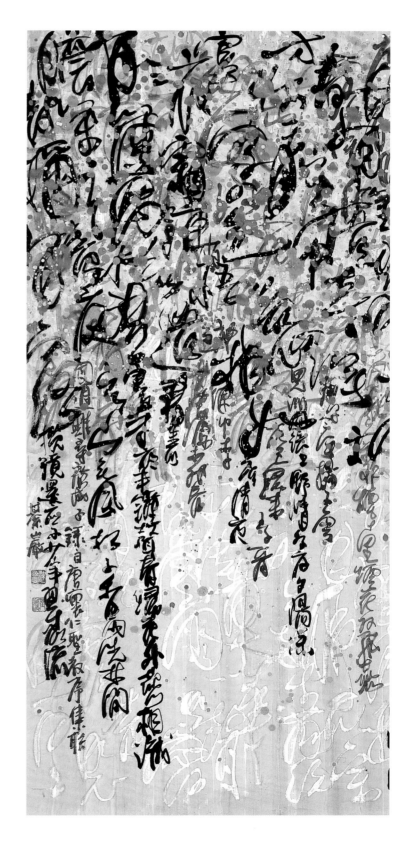

傳統書藝篇

Chapter I. The Art of Traditional Calligraphy

用傳統書法之字體為創作基本元素，並加入少許的水墨色彩，呈現出不同書法特色，而書寫的內容計有—《佛說四十二章經》、《大方廣佛華嚴經》、《佛遺教經》、《妙法蓮華經》、《信心銘》、《唐懷仁聖教序集聯》、《漢碑集聯》、《老子》、《莊子》、《荀子》。

Using traditional Chinese calligraphy characters as the basic elements for artistic creations, also adding a tint of ink-wash features to present different characteristics in calligraphy. The content of the calligraphy writings contains: "The Sutra in Forty-Two Sections said by Buddha", "The Flower Adornment Sutra", "The Sutra on the Buddha's Bequeathed Teachings","The Wonderful Dharma Lotus Flower Sutra", "Faith in Mind Sutra", "A Compilation of Characters from the Han dynasty Ritual Vessels Stele", "A Compilation of the Sacred Teachings Preface from Huairen in Tang dynasty", "Laozi", "Zhuangzi", "Xunzi".

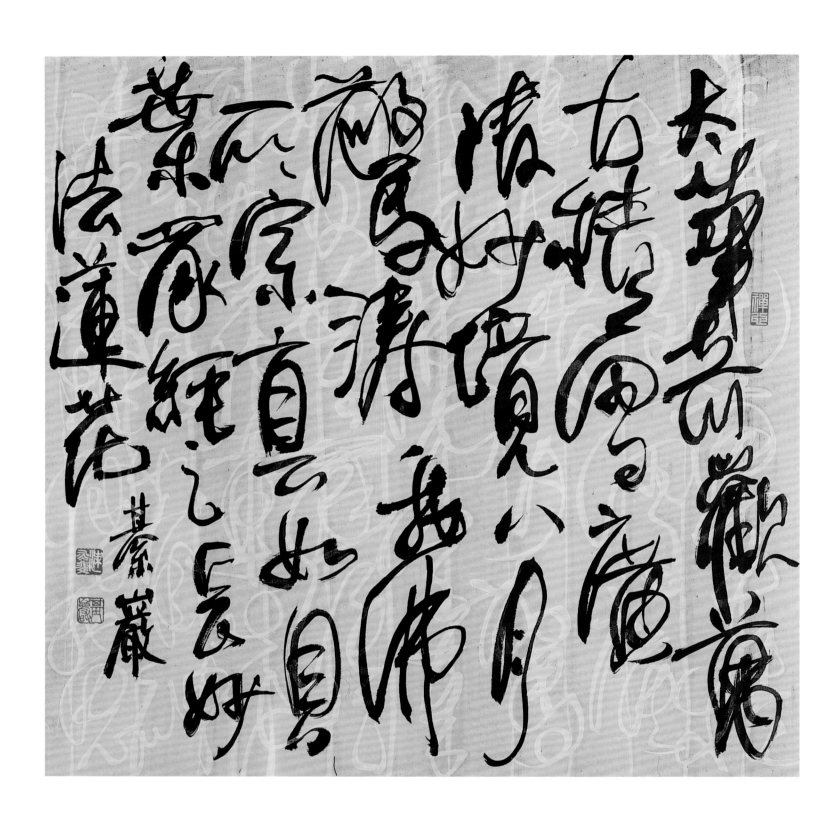

A Compilation of the Sacred Teachings Preface
from Huairen in Tang Dynasty

《唐懷仁聖教序集聯拓本》行書 46 × 46 cm

太華奇觀萬古積雪　廣陵妙境八月驚濤
我佛所宗真如貝葉　眾經之長妙法蓮花

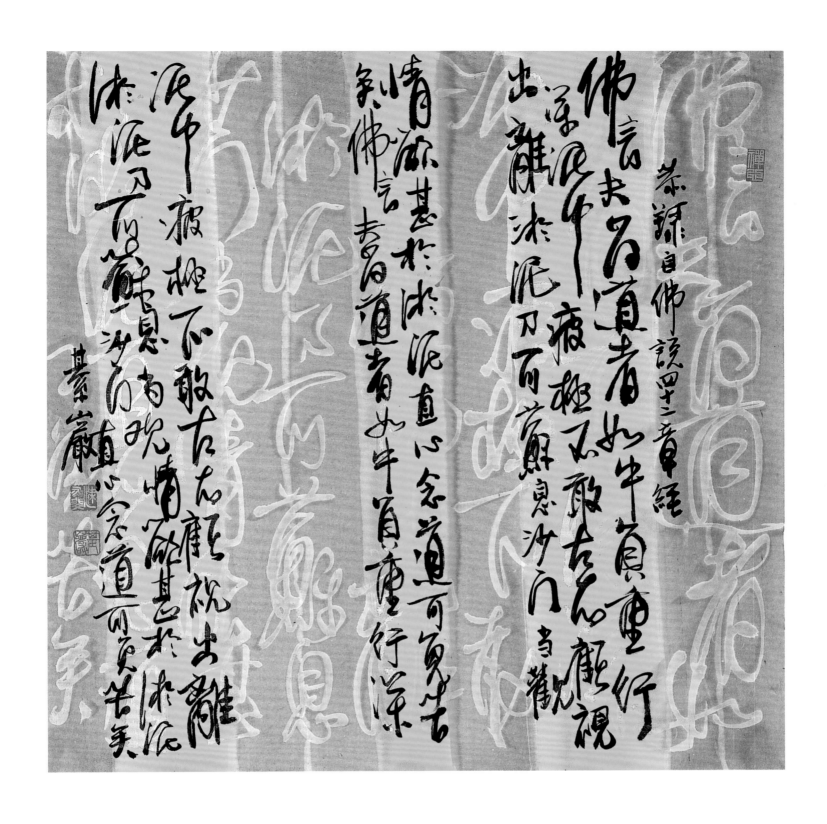

The Sutra in Forty-Two Sections by Buddha

《佛說四十二章經》行書 88 × 46 cm

佛言：夫為道者，如牛負重，行深泥中 ，疲極不敢左右顧視；出離
淤泥乃可蘇息，沙門當觀情欲，甚於淤泥，直心念道，可免苦矣。

之樞轄動靜不竭窮

離炁納榮衛坎乃不

用聰兌合不以談希

言順鴻濛

修行之人應重視之　空默

節目口等同契耳目口為外三寶

20

The Kinship of the Three-
Clerical Script four pieces
《參同契》隸書四屏
180 × 45 cm × 4

聰開闔皆合同己

游向規中旋曲以視

發通真人潛淵淵浮

耳目口三寶閉塞勿

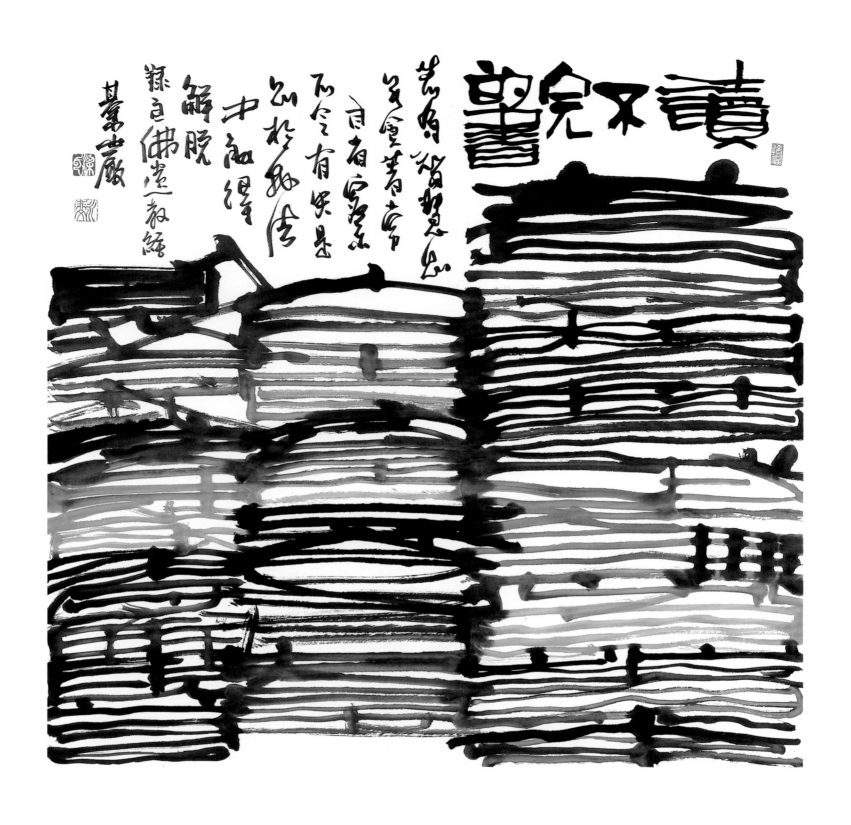

Unfinished Books- The Buddha's Last Bequest

《讀不完的書—佛遺教經》

篆隸組合 69 × 69 cm

若有智慧，則無貪著，常自省察，不令有失，
是則於我法中能得解脫。

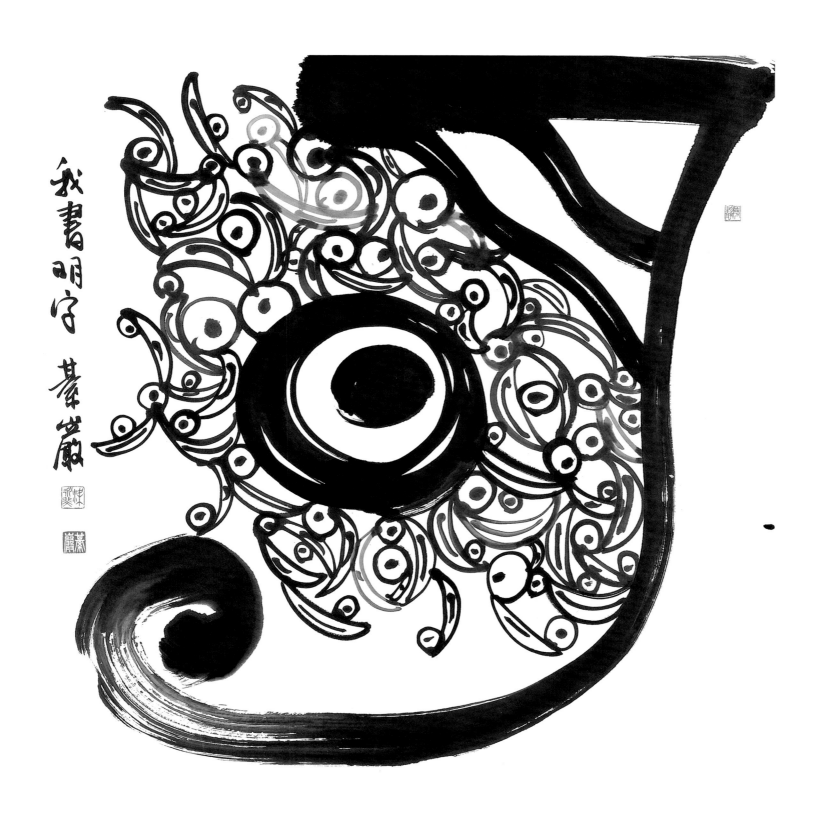

The word "Ming"

《我書明字》 金文

69 × 69 cm

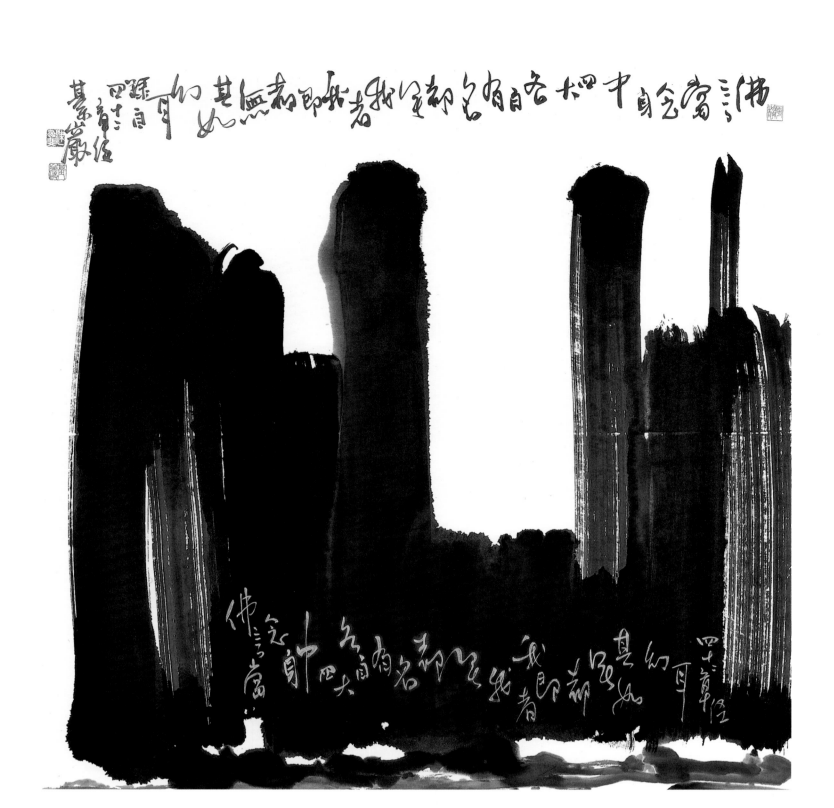

The Sutra in Forty-Two Sections by Quin-shan

《群山頌四十二章經》行書 69 × 69 cm

佛言：當念身中四大，各自有名，都無我者，我既都無，其如幻耳。

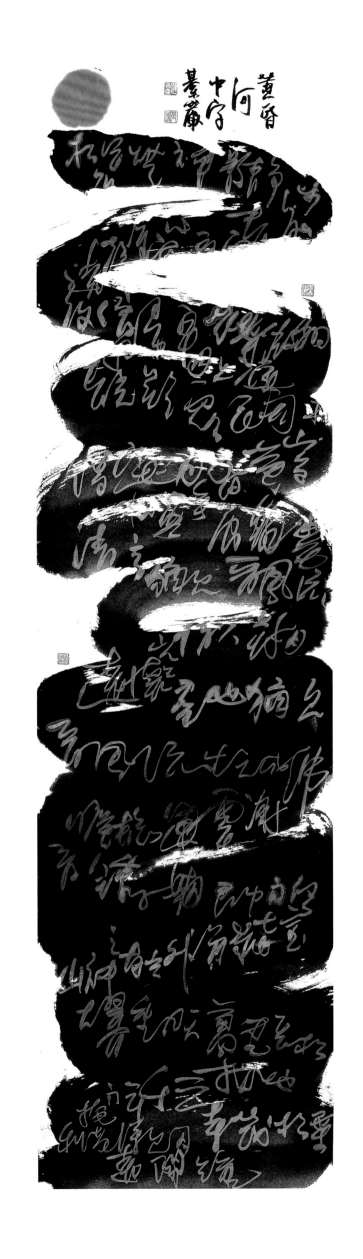

Words in the Dusk River
《黃昏河中字》
行書　137 × 36 cm
錄自唐懷仁聖教序集聯

25

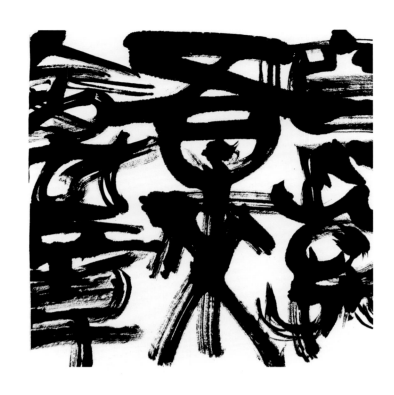

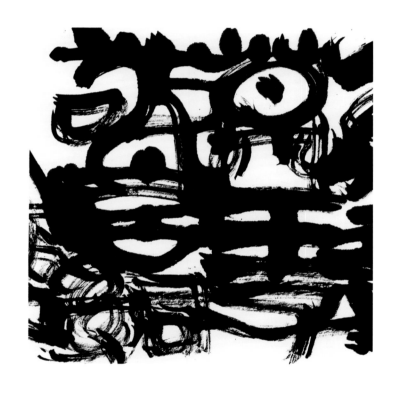

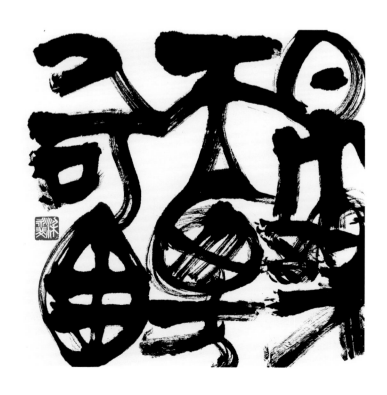

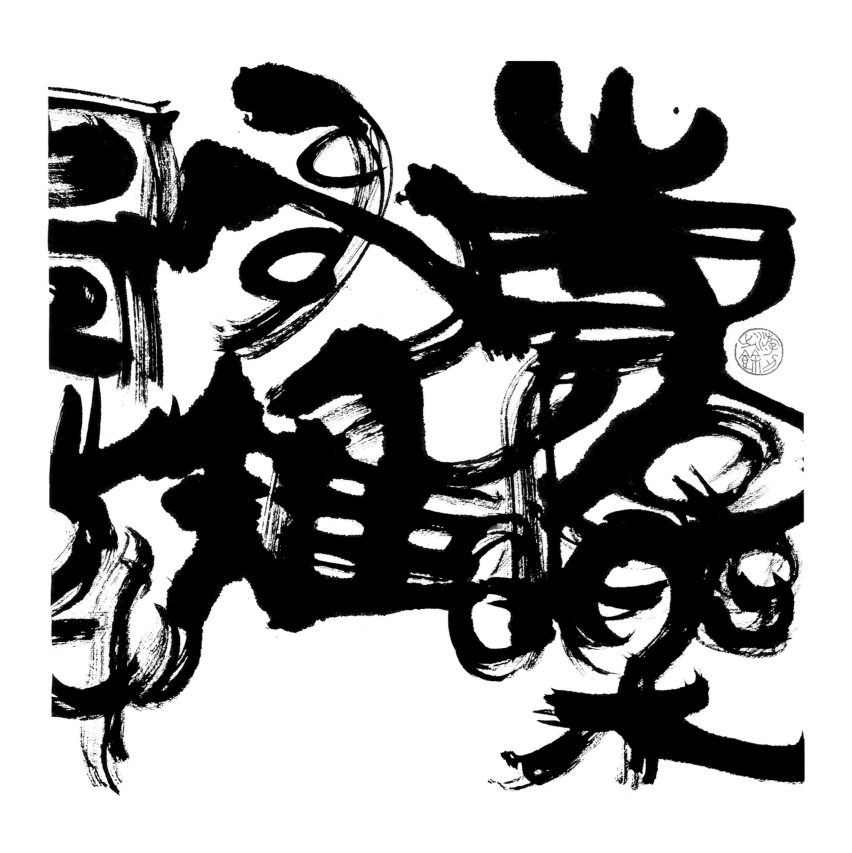

Stone Drum Scripts of Zhou dynasty
《周石鼓文集聯》篆書 138 × 34cm
侍游樂射雉　寫草悟來禽　章草王子敬
官詞白樂天　西方人可思

佛於無邊大劫海　為眾生故求菩提
種種神通化一切　名稱光天悟斯法
寂靜解脫天人主　十方無處不現前
光明照耀滿世間　此無礙法嚴幢見
諸佛境界不思議　一切眾生莫能測
普令其心生信解　廣大意樂無窮盡

若有眾生堪受法　佛威神力開導彼
令其恒睹佛現前　嚴海天王如是見
一切法性無所依　佛現世間亦如是
普於諸有無依處　此義勝智能觀察
佛神通力皆能現　各各差別不思議
此智幢王解脫海　愛樂慧旋之境界

過去所有諸國土　一毛孔中皆示現
此是諸佛大神通　愛樂寂靜能宣說
一切法門無盡海　同會一法道場中
如是法性佛所說　智眼能明此方便
十方所有諸國土　悉在其中而說法
佛身無去亦無來　愛樂慧旋之境界

狂心境界錄自大方廣佛華嚴經　慕嚴

The Flower
Adornment Sutra-
Clerical Script four
pieces
《大方廣佛華嚴經》
隸篆四屏
70 × 20 cm × 4

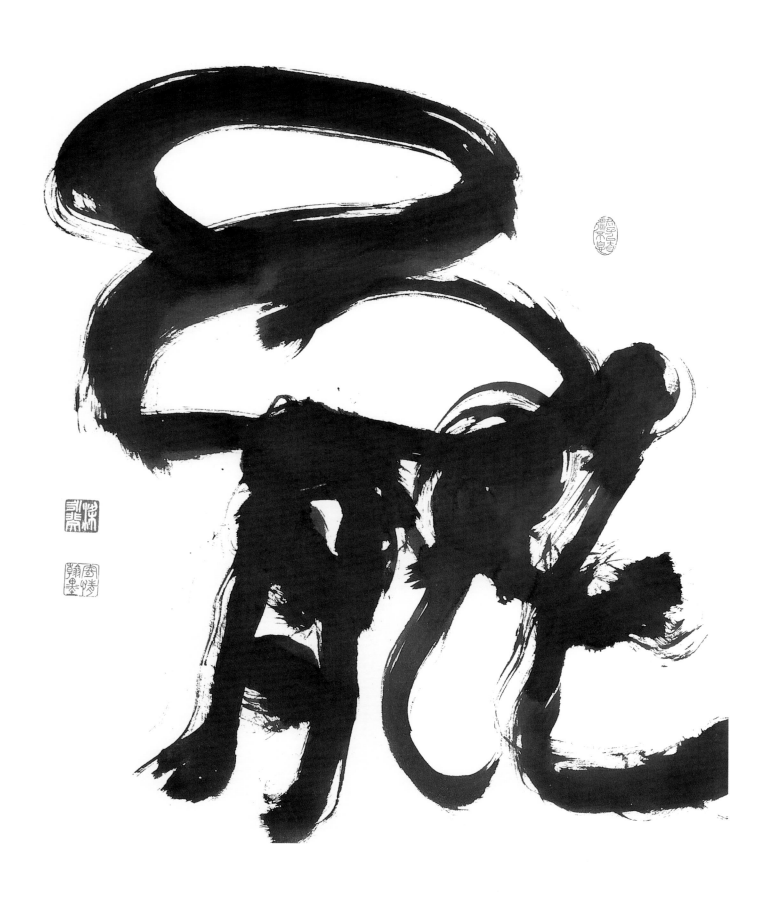

Able (Neng)

《能》篆書 69 × 69 cm

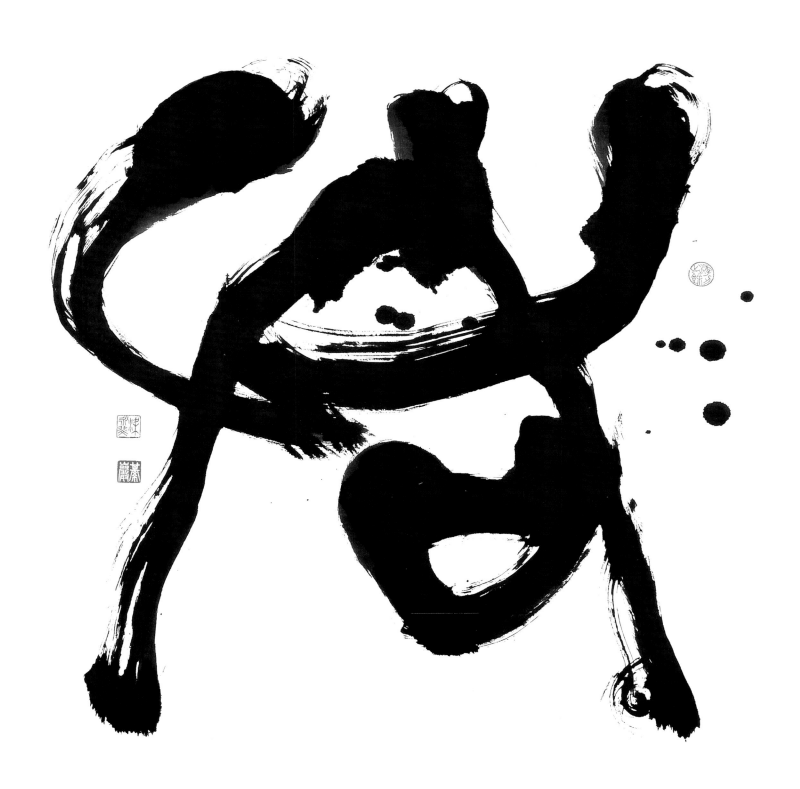

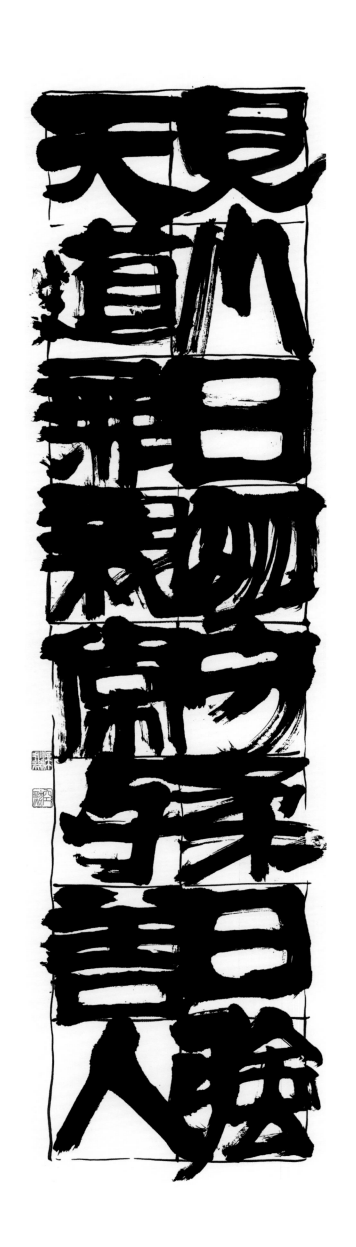

Laozi: Dao De Jing

《老子道德經》隸書 137 × 34 cm

見小曰明、守柔曰強、天道無親、常與善人

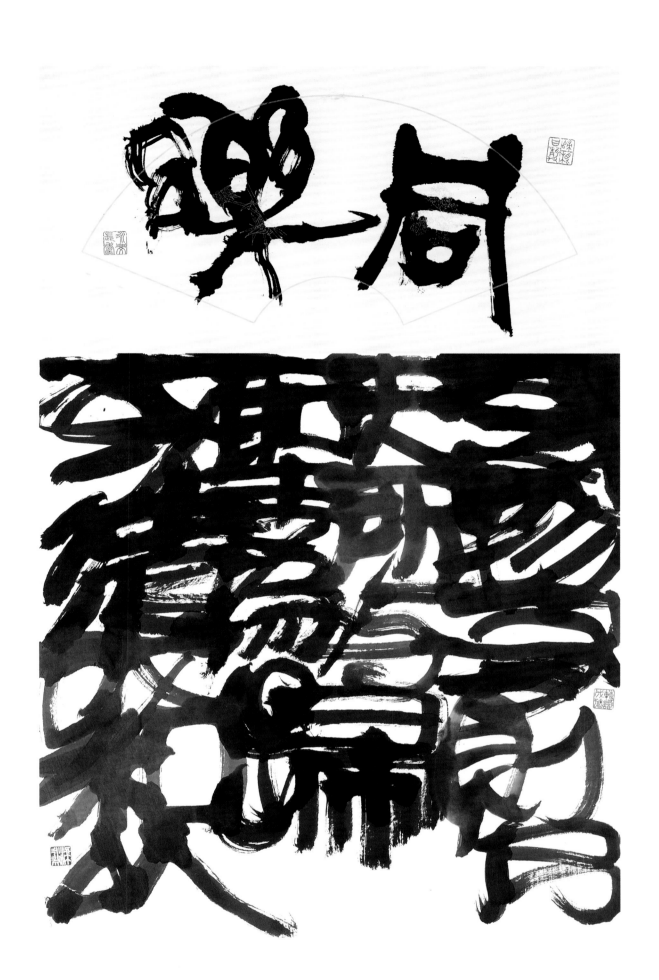

Share in Joy-Combination of
Clerical Script and Large Seal Script
《同樂》篆隸組合　90 × 60 cm
篆—同樂
隸—有物有則乃天所與　或清或和以聖為歸

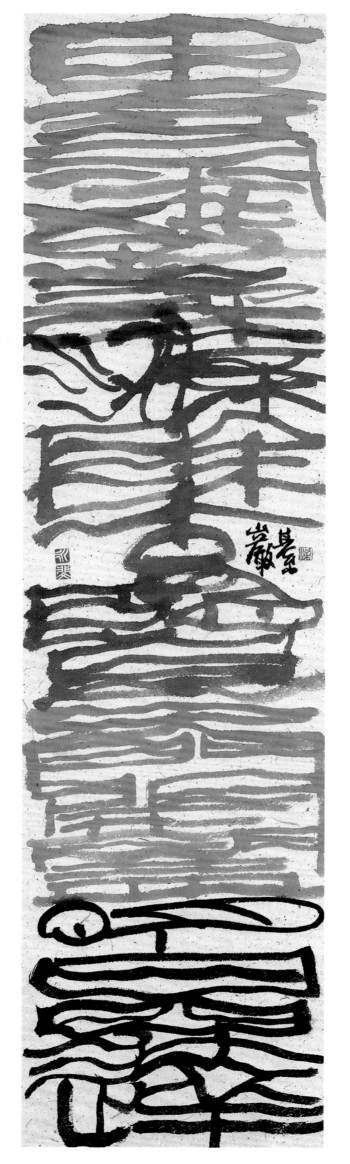

上善若水　不爭無尤　功成不居　專氣致柔　滌除玄覽　天門開闔　明白四達
無知無欲　虛而不屈　動而愈出　多言數窮　不如守中　緜緜若存　用之不勤　天長地久

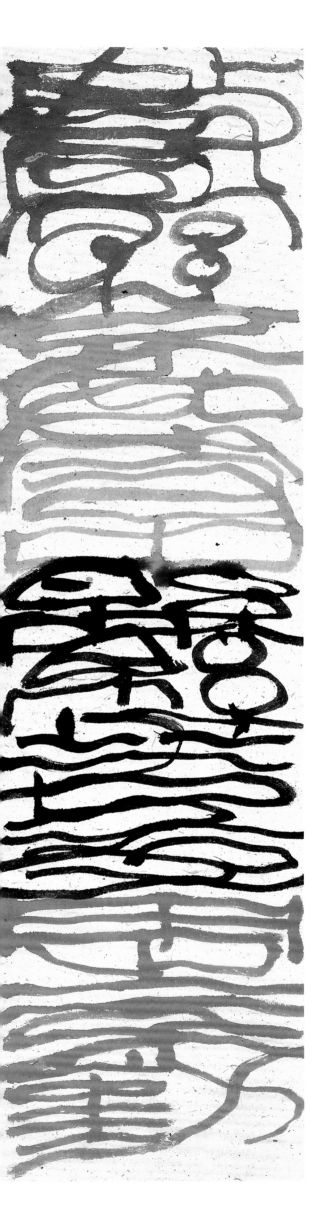
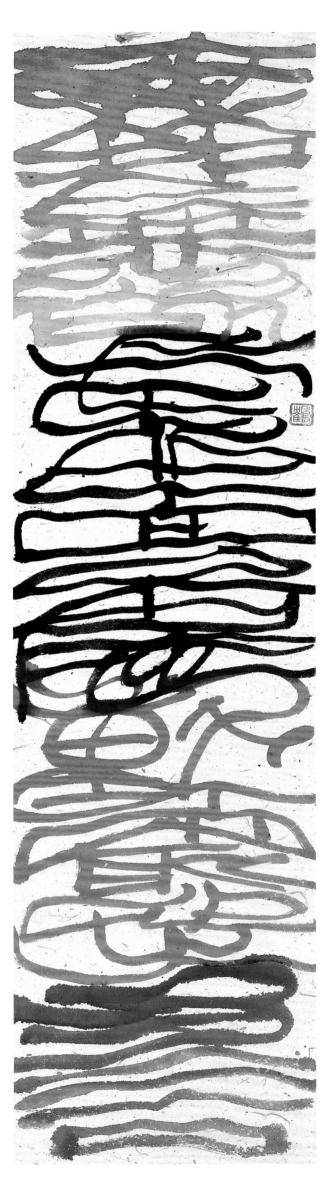

Laozi: Dao De Jing

《老子道德經》篆隸四屏

72 × 18 cm × 4

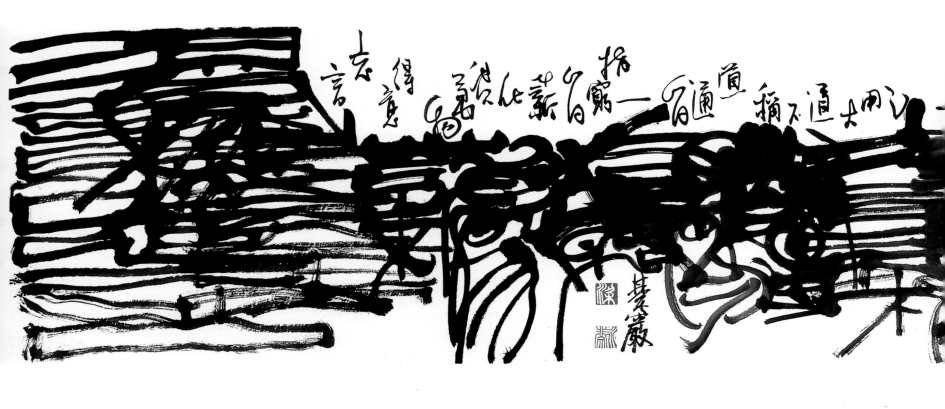

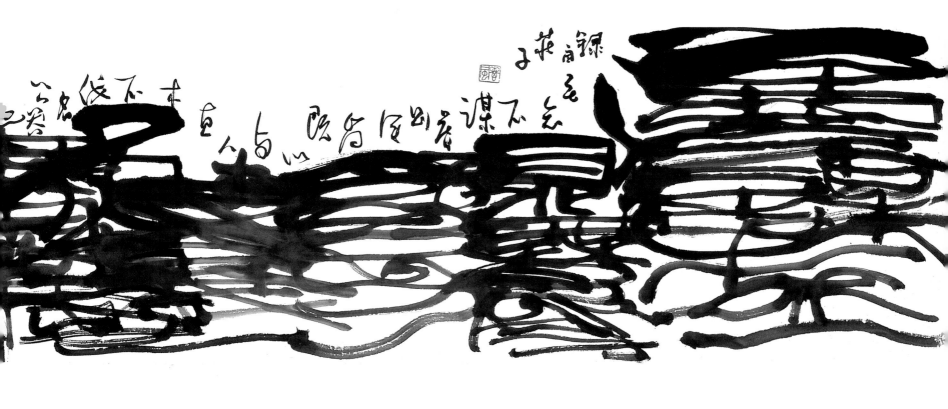

Zhuangzi

《莊子》篆隸組合 137 × 25 cm

至知不謀　虛則無為　既以與人　直木先伐
名公器也　無用之用　大道不稱　道通為一
指窮為薪　化貸萬物　得意忘言

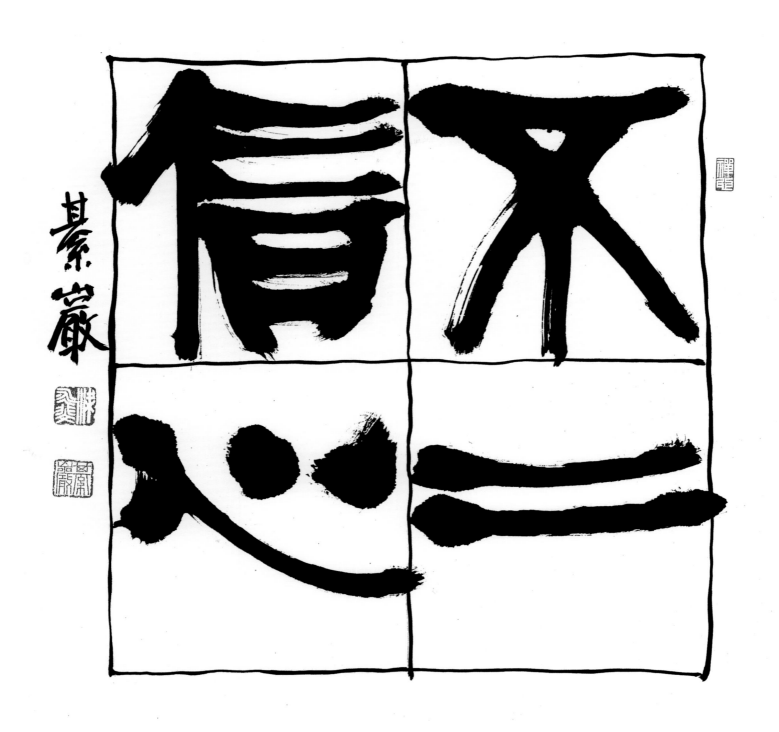

Non-dual Faith

《不二信心》 隸書　46 × 46 cm

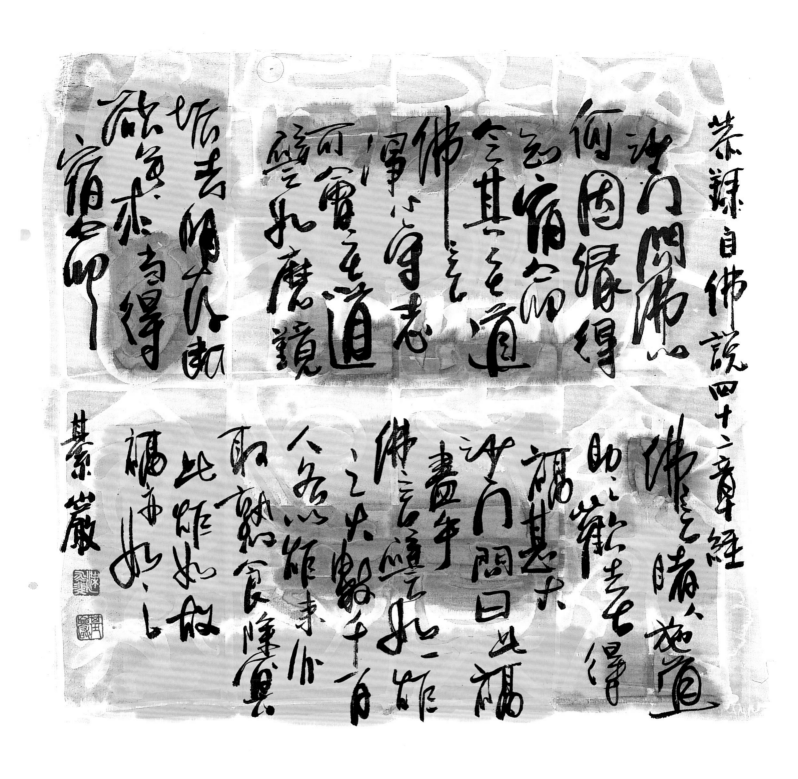

恭錄自佛說四十二章經

佛言睹人施道
助之歡喜得福
甚大沙門問曰此福
盡乎佛言譬如一炬
之火數千百人
各以炬來分取
熟食除冥
此炬如故
福亦如此

沙門問佛
何因緣得
宿命
今其道
佛言淨心守志
可會至道
譬如磨鏡
垢去明存
欲知去明即
垢盡求古得
欲知道命~

紫嚴 [印] [印]

The Sutra in Forty-Two Sections by Buddha
《佛說四十二章經》行書 46 × 46 cm

39

The Sutra in Forty-Two Sections by Buddha

《佛說四十二章經》 行書 35 × 72 cm

佛言：愛欲莫甚於色，色之為欲，其大無外，賴有一矢，
若使二同，普天之人，無能為道者矣。

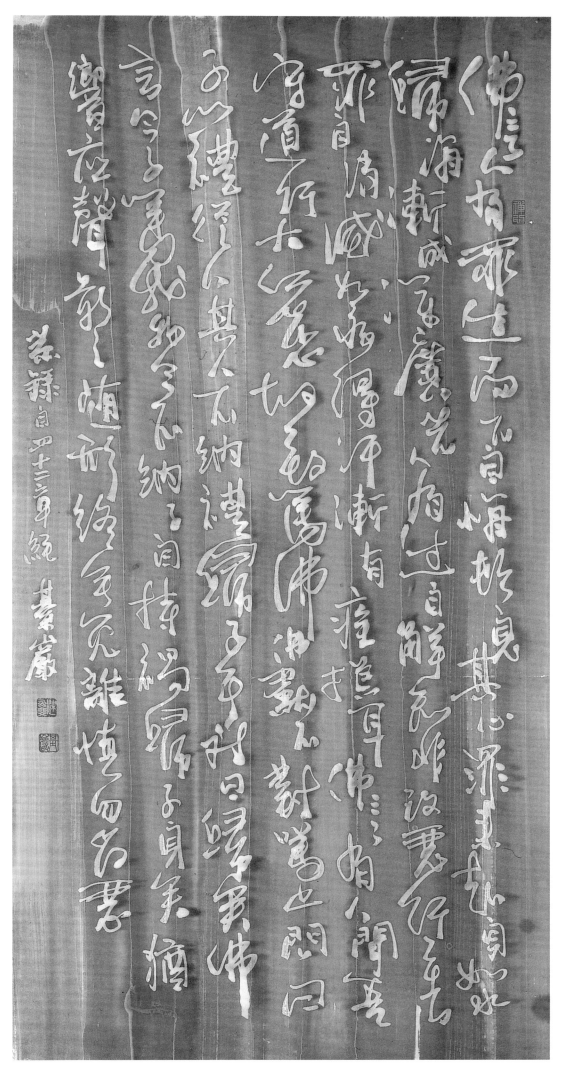

The Sutra in Forty-Two Sections by Buddha

《佛說四十二章經》行書　46 × 46 cm

佛言：人有罪過，而不自悔，頓息其心，罪來赴身，如水歸海，漸成深廣，若人有過，自解知非，改惡行善......

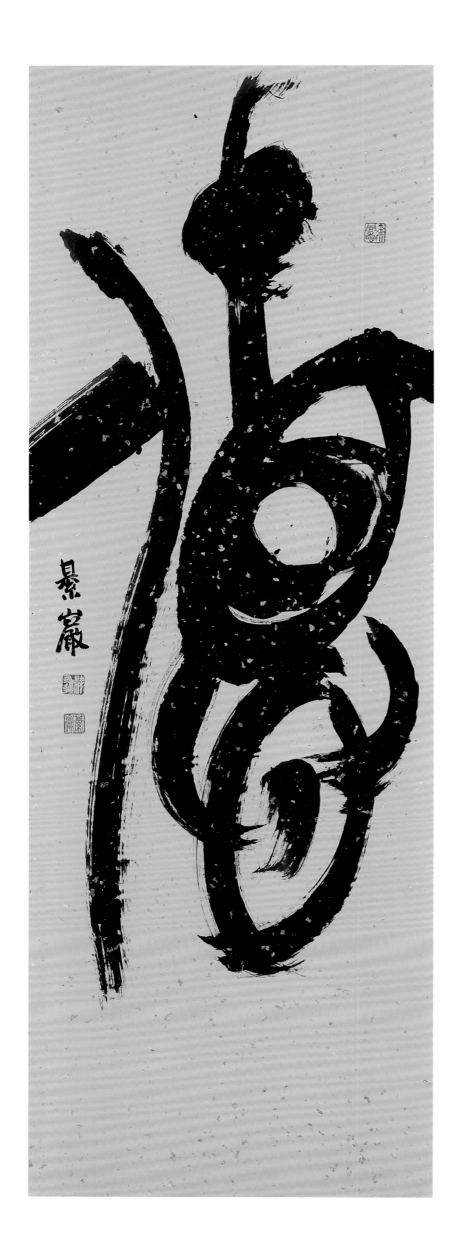

Virtue (De)

《德》篆書 137 × 45 cm

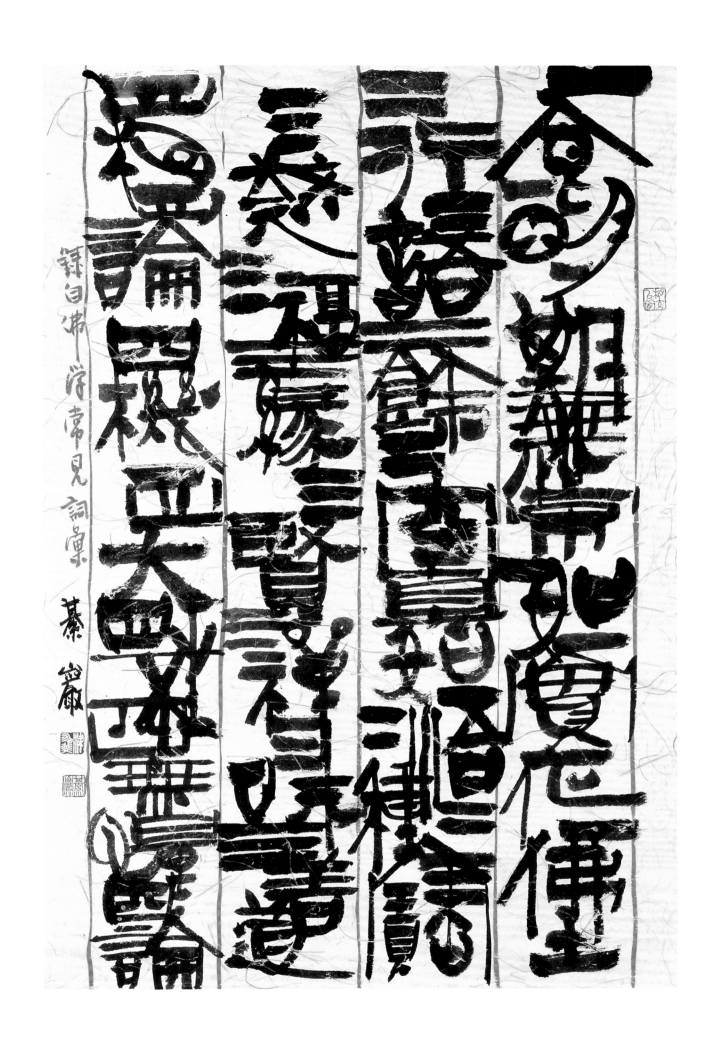

Common Vocabulary in Buddhism

《佛學常見詞彙》隸篆 100 × 70 cm

一食、一明、一期無常、一如、一實、一化、一佛土、二行、二語、二餘、二空真如、二悟、二種三寶、三惑、三福、三緣、三賢、三禪、三昧、三善道、四相、四論、四機、四大、四生、四不、四無量心、四論。

繽 紛 金 文 篇

Chapter II. The Inscription of Colorful Bronze

用西周金文為創作的元素，進行不同的一字、多字組合的實驗
「造境」，並重視線條的粗細、長短、曲直、暢澀、拙巧…等交
錯出不同的空間，且在不同形狀的空白處加上色彩，構成整體
似蒙特里安的空間結構美學，有些作品則用水墨技法強化其效
果。創作元素的內容計有一（周毛公鼎集聯）、（周王孫鐘集
聯）、（周散氏盤集聯）、（周秦公敦集聯）、（周克鼎銘集
聯）、（周歸夆敦集聯）、（佛説四十二章經）。

Using the bronze inscriptions of the Western Zhou dynasty as
elements for artistic works, in experimenting with the "creative
artistic conception" by composing single characters and a
combination of characters; also putting considerations in the
thickness, length, curves, smoothness, skillfulness, etc., to form
different space and dimension; and adding colors to the different
shaped blank areas to form the aesthetic structures similar to Piet C.
Mondrian. Some works uses the techniques in ink-wash paintings
enhancing the effects. The content of these works consists of "The
Compilation of Characters of Mao Gong Ding from the Zhou
Dynasty", "The Compilation of Characters of Wang Sun Bell from
the Zhou Dynasty", "The compilation of Characters of San p'an from
the Zhou Dynasty", "The compilation of Characters of Qin Gong
Dun from the Zhou Dynasty", "The compilation of inscriptions of
Zhou Ke Ding from the Zhou Dynasty", "The compilation of Gui
Jiang Dun from the Zhou Dynasty", and "The Sutra in Forty-Two
Sections said by Buddha".

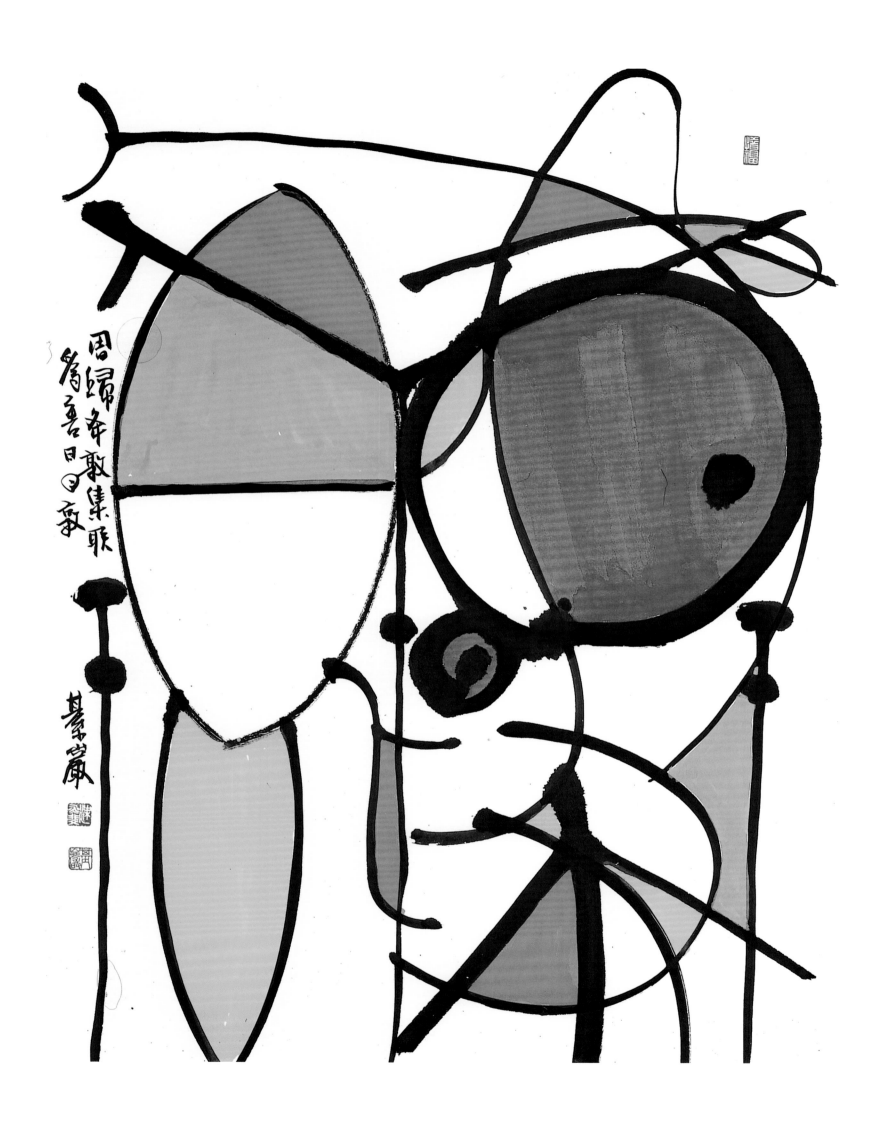

Support《扶持》
用金文為善日日敦組合
70 × 55 cm

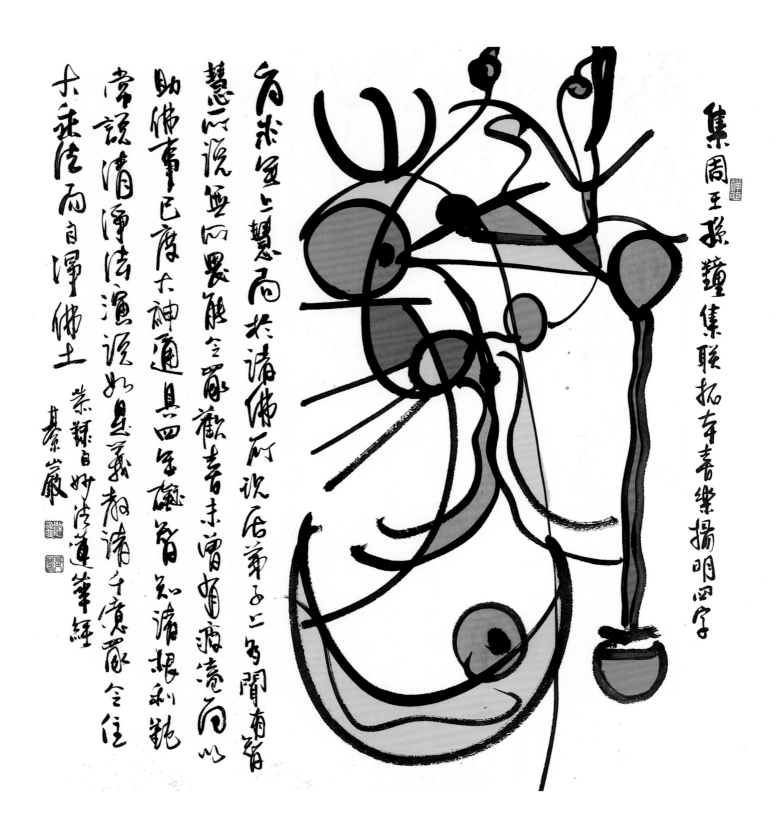

集周王孫鐘集聯拓本喜樂揚明四字

有求無上慧而於諸佛所現居弟子上多聞有智慧

慧而說無以畏能令眾歡喜未曾有疲倦

助佛事已度大神通具四無礙智知諸根利鈍

常說清淨法演說如是義教諸千億眾令住大乘法

大乘佛法而自淨佛土

莊嚴自妙法蓮華經

The Compilation of Characters of Wang Sun Bell
from the Zhou Dynasty and the dialogue of the Lotus Sutra
《周王孫鐘集聯與妙法蓮華經的對話》 69 × 69 cm

金文—喜樂揚明

經文—為求無上慧 而於諸佛所 現居弟子上 多聞有智慧 所説無所畏 能令眾歡喜
未曾有疲倦 而以助佛事 已度大神通 具四無礙智 知諸根利鈍 常説清淨法
演説如是義 教諸千億眾 令住大乘法 而自淨佛土

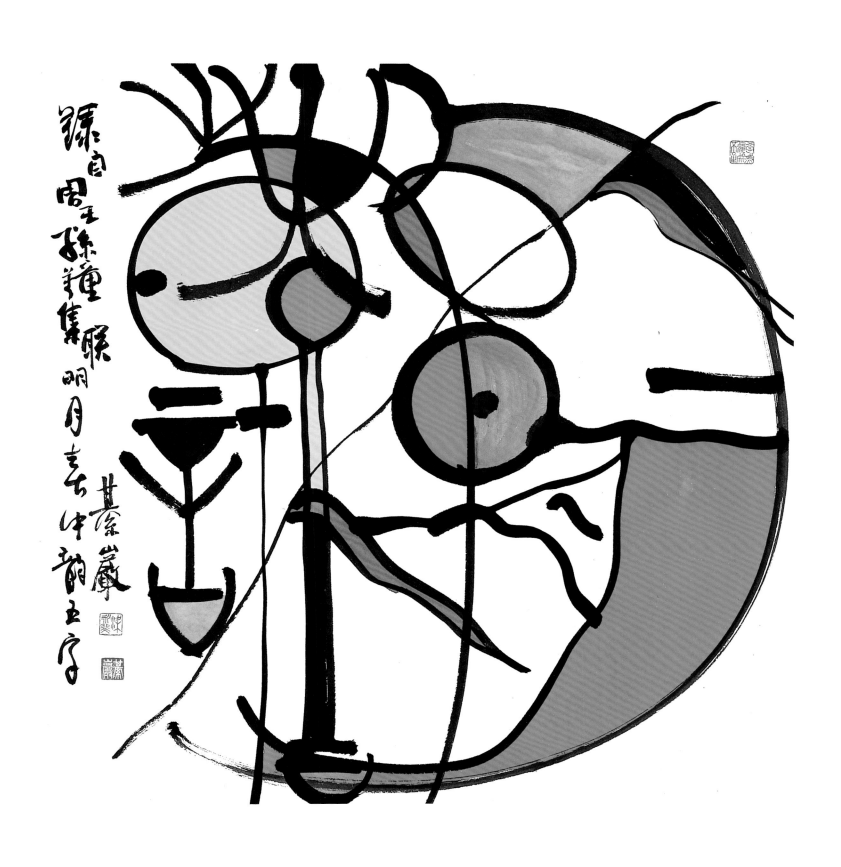

he Rhyme of Delight in the Bright Moon

《明月喜中韵》金文組合 69 × 69 cm

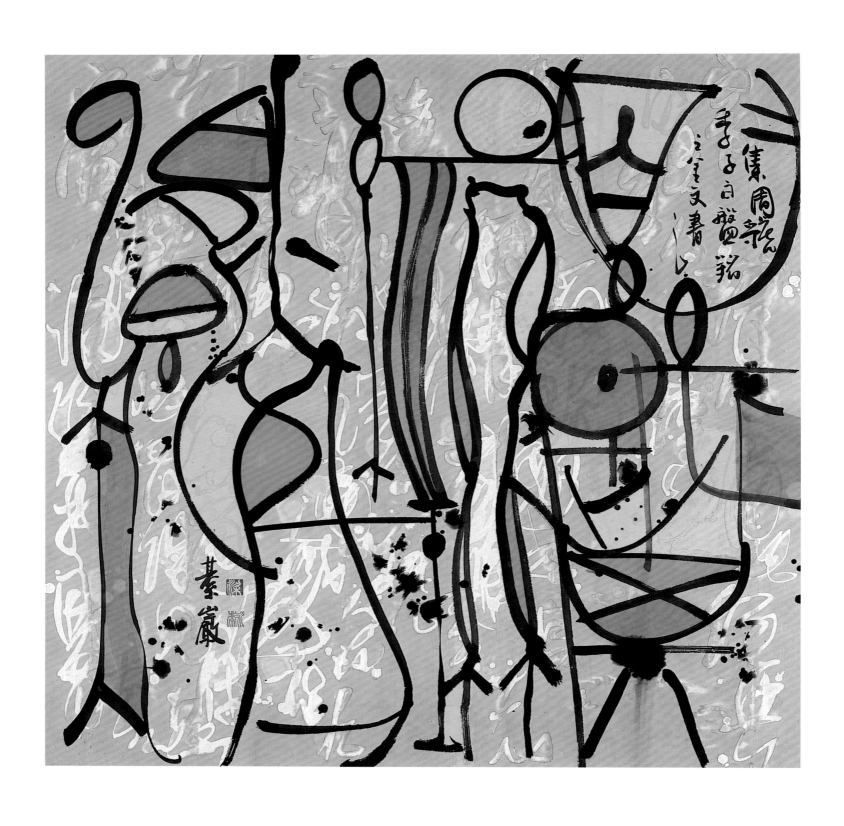

10 Characters collected from Buddha classics

《萬顯是其經白光方鄉矢》金文 69 × 69 cm

集周號季子白盤銘

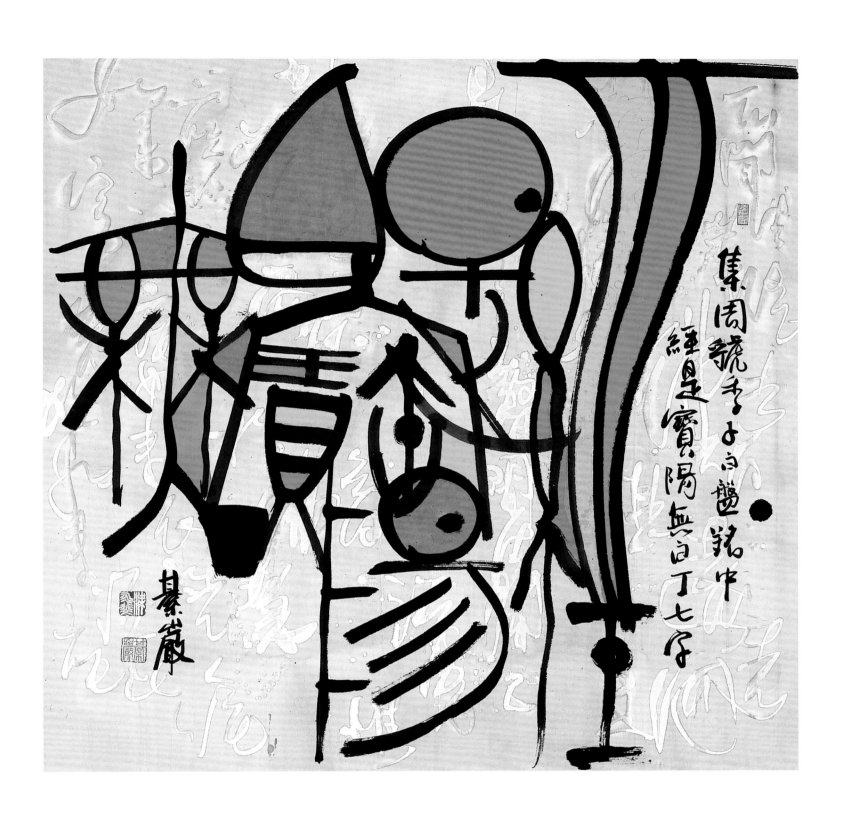

集周虢季子白盤銘中
經是寶陽無白丁七字

7 Characters collected from Buddha classics
《經是寶陽無白丁》金文 69 × 69 cm
集周虢季子白盤銘

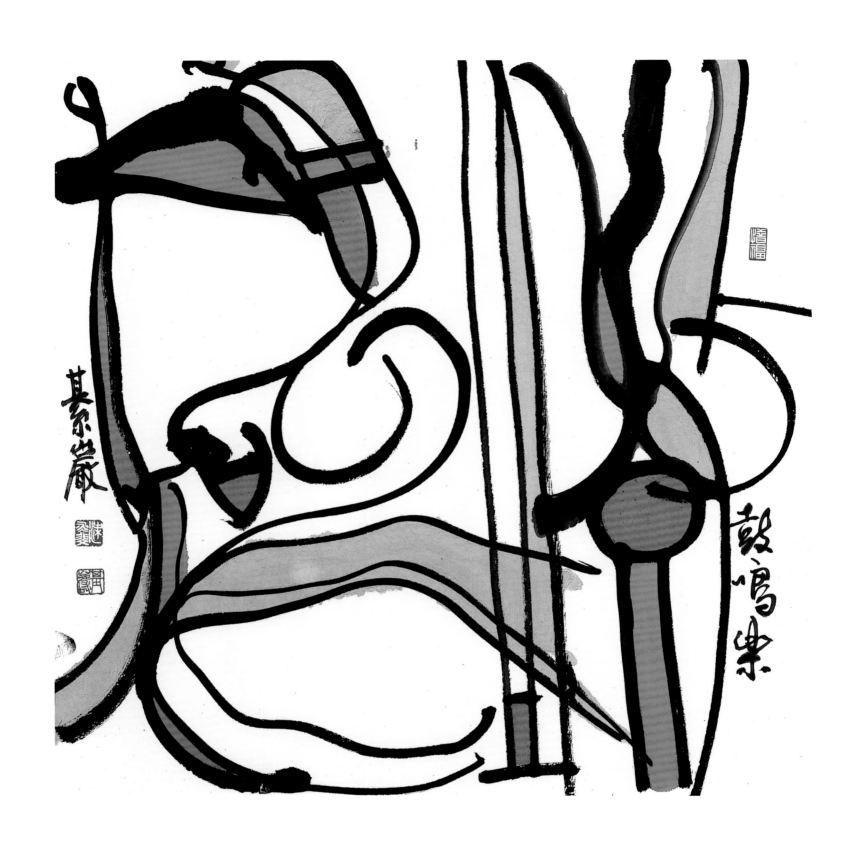

Drumming Music
《鼓鳴樂》金文 46 × 46 cm

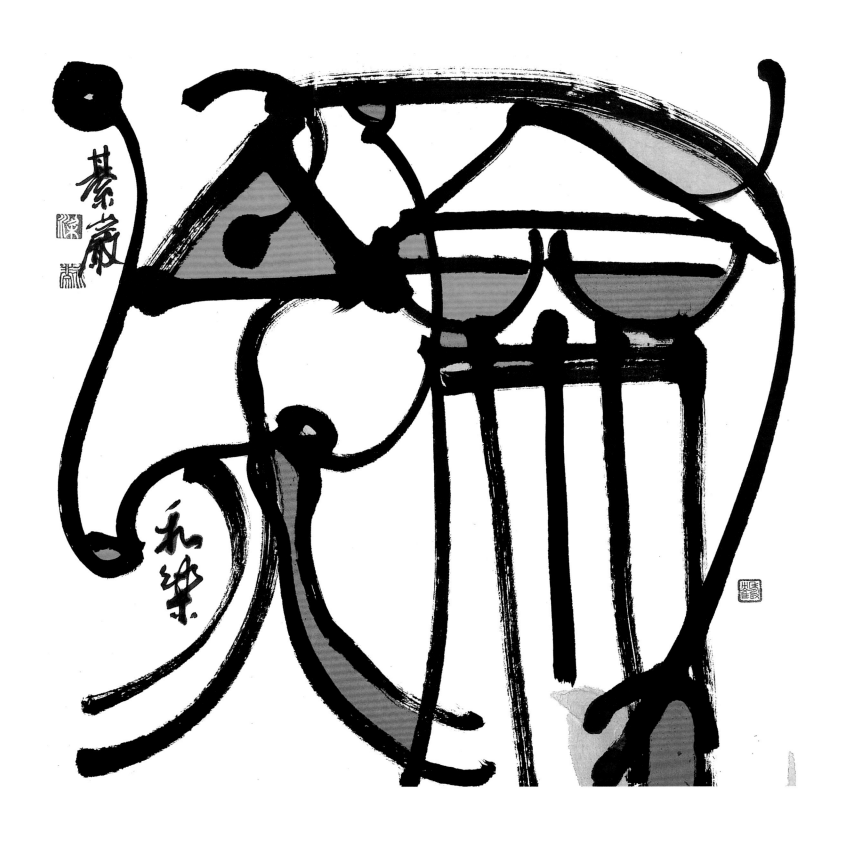

Harmonious

《和樂》篆書 46 × 46 cm

The Dance between Bronze Inscriptions and
Semi-cursive Script
《金文與行書共舞》 70 × 95 cm

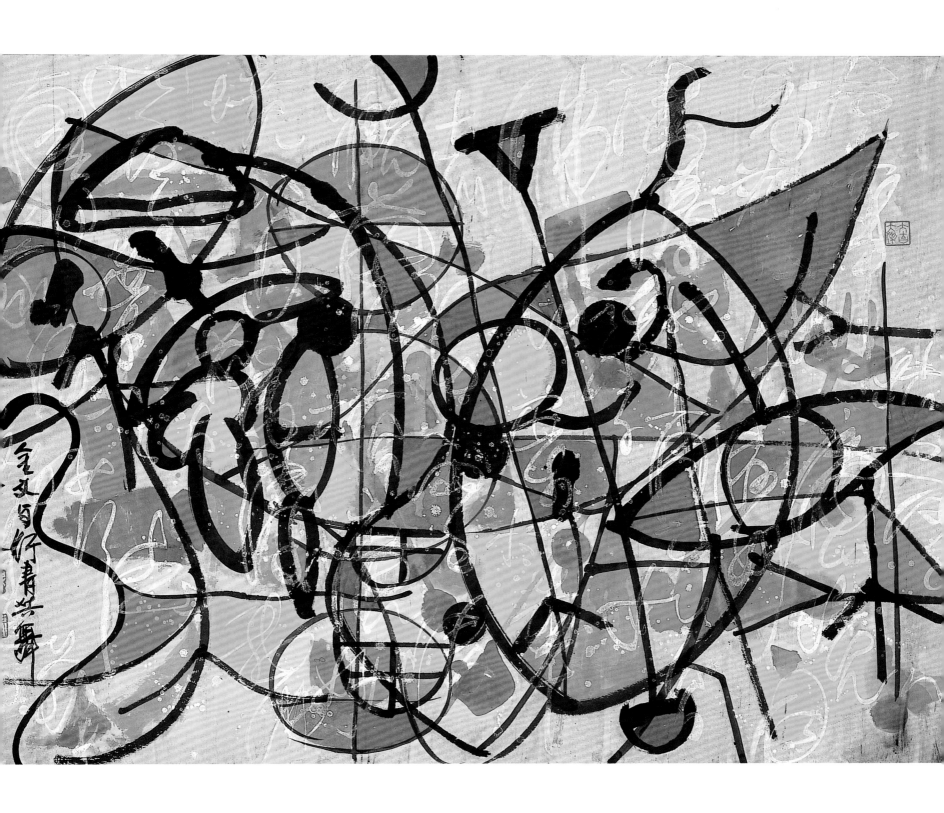

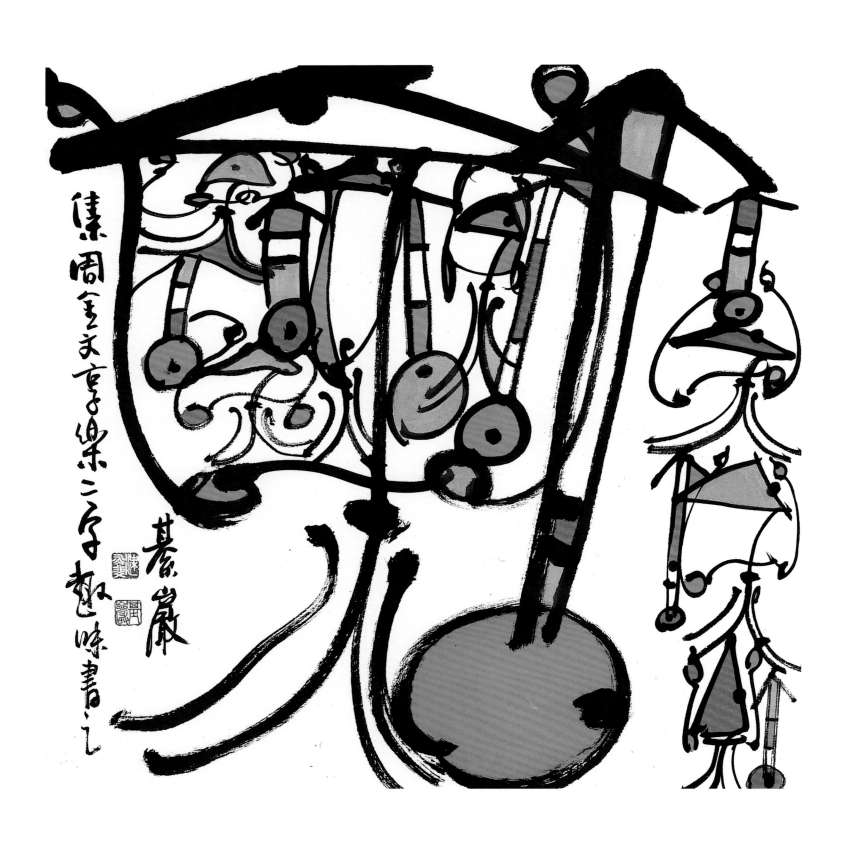

集周金文亨子樂二字敏睞書之
基巖

A Life of Well and Happiness
《一生亨樂》金文　46 × 46 cm

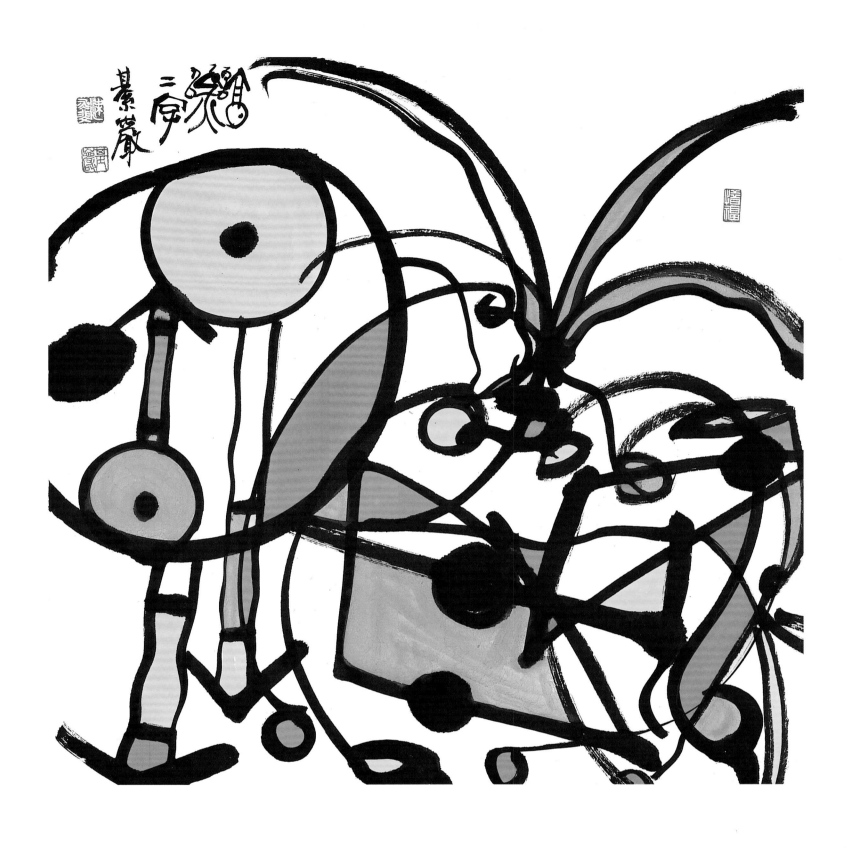

Well and Happiness

《亨樂亨樂》金文　46 × 46 cm

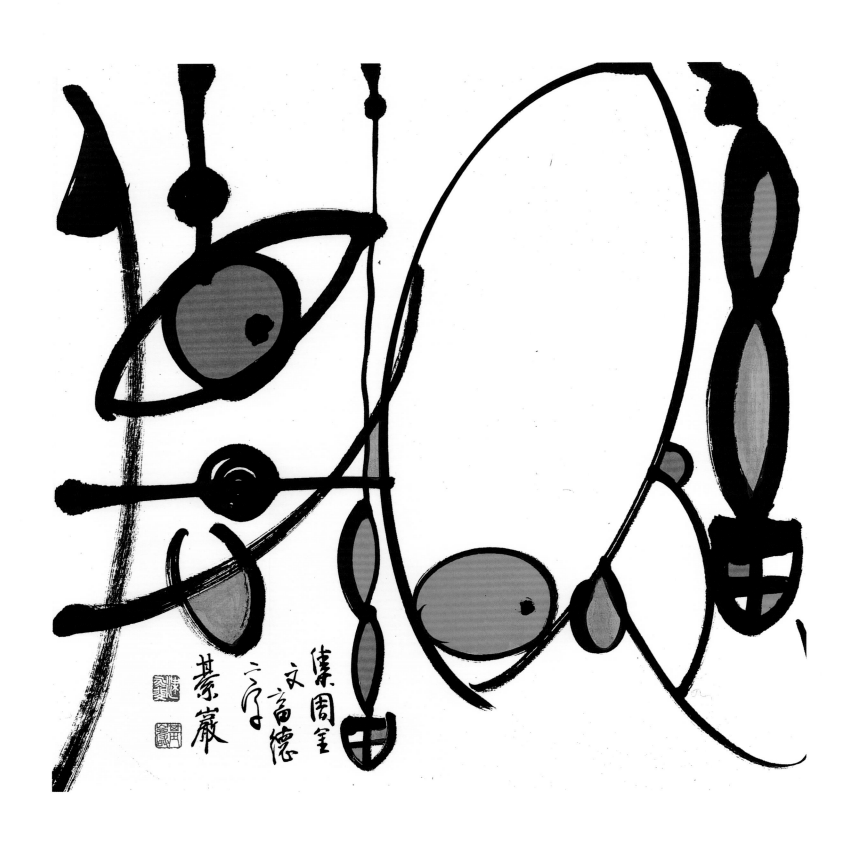

Cultivating Virtue

《畜德畜德》金文 46 × 46 cm

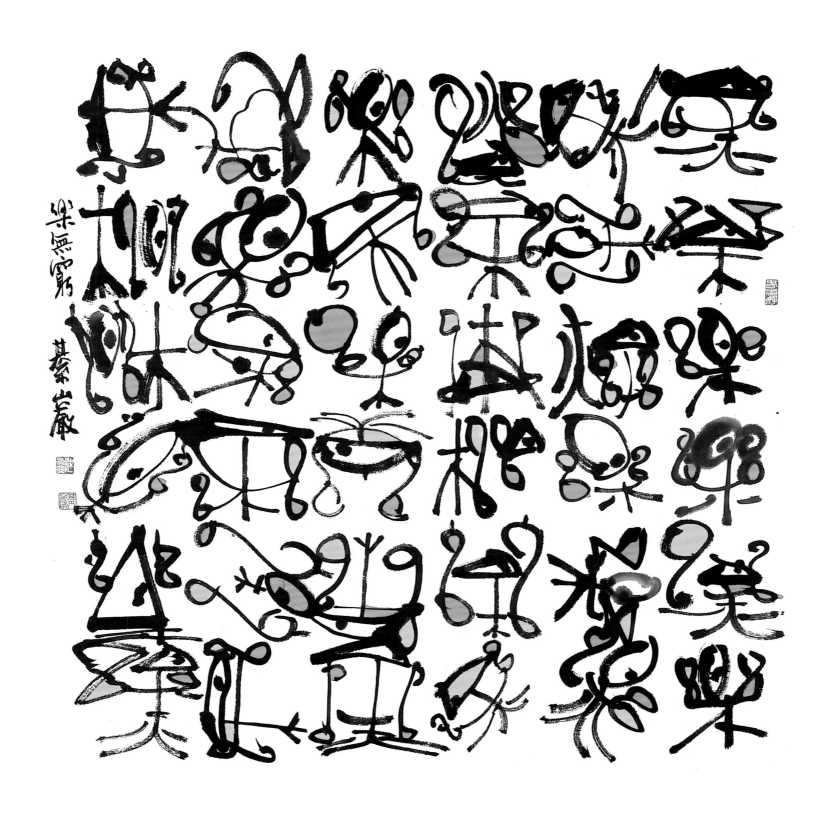

Endless Joy

《樂無窮》篆書　46 × 46 cm

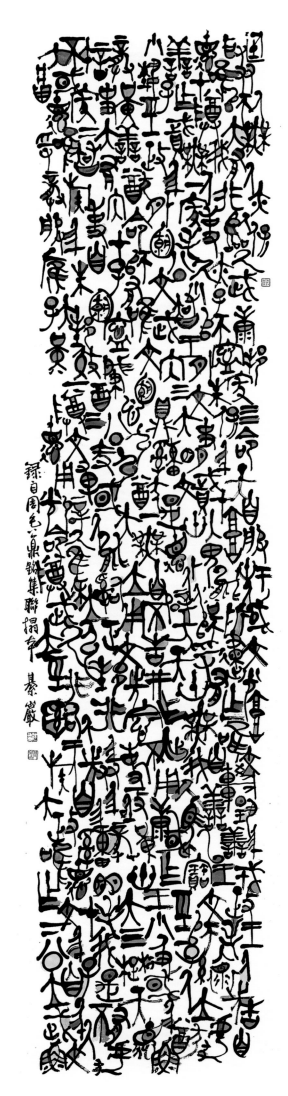

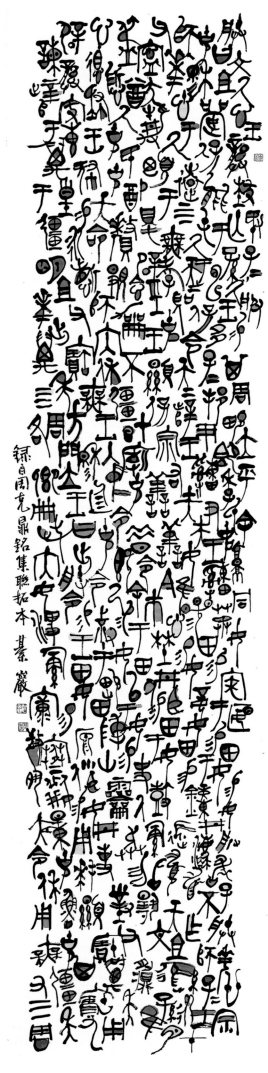

The compilation of inscriptions of
Zhou Hu Ding from the Zhou Dynasty
《周曶鼎銘集聯》金文 180 × 45 cm

The compilation of inscriptions of
Zhou Ke Ding from the Zhou Dynasty
《周克鼎銘集聯》金文 180 × 45 cm

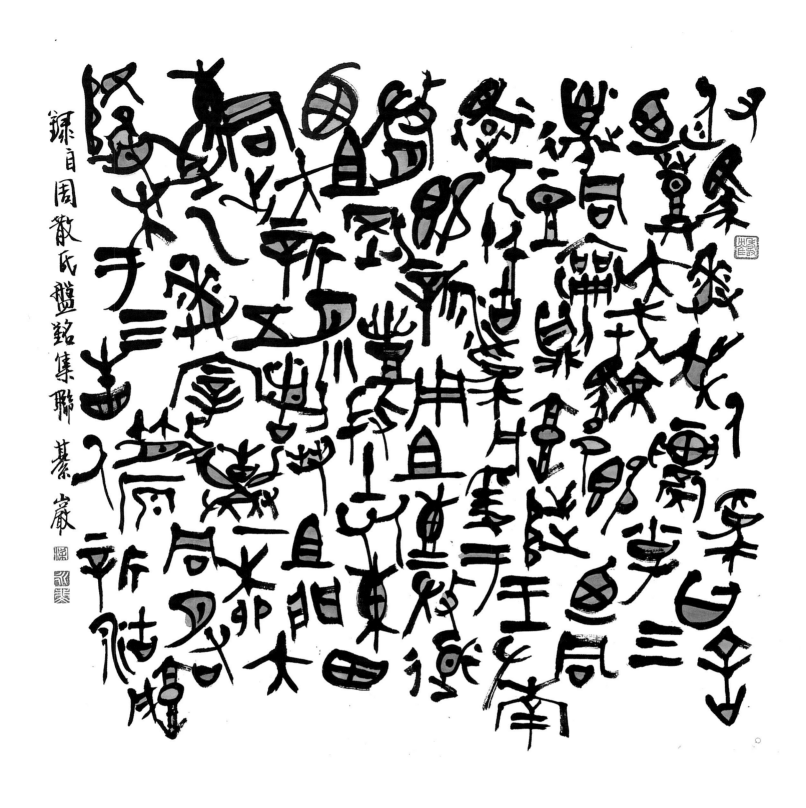

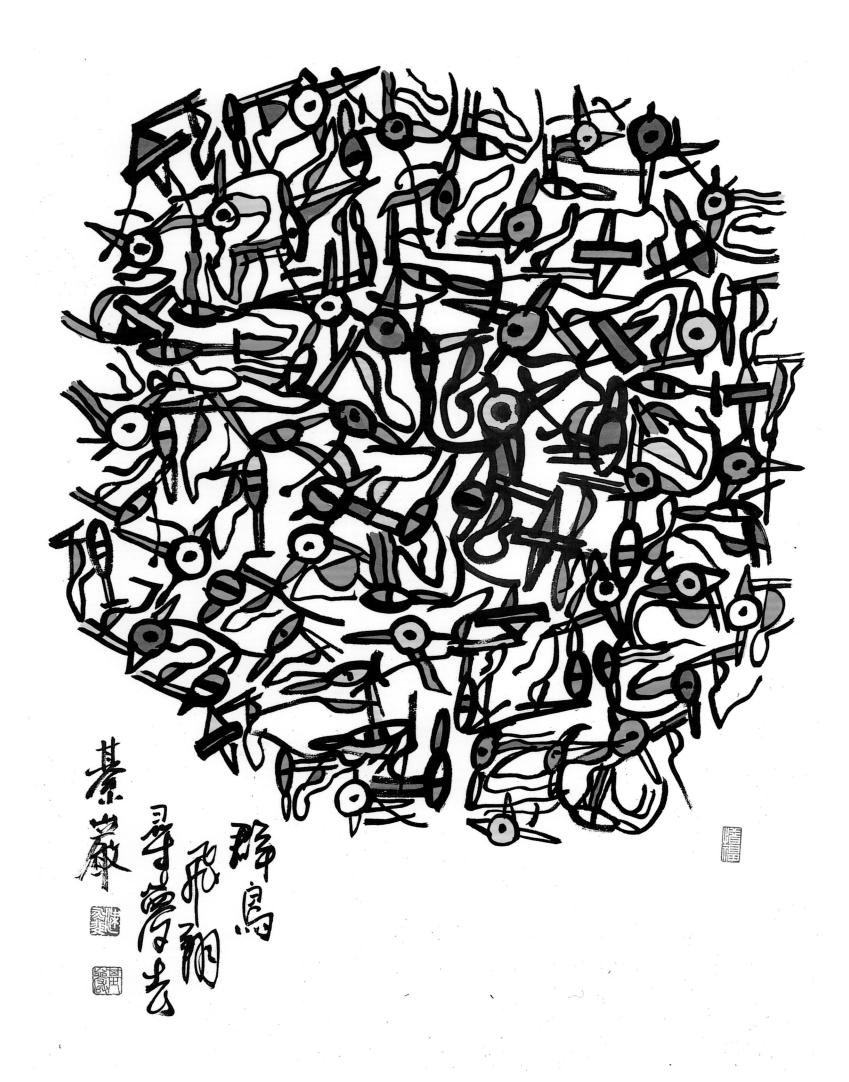

群鳥飛翔尋夢去

A Flock of Birds Flying in Search for Dreams
《群鳥飛翔尋夢去》用金文既字組合 60 × 46 cm

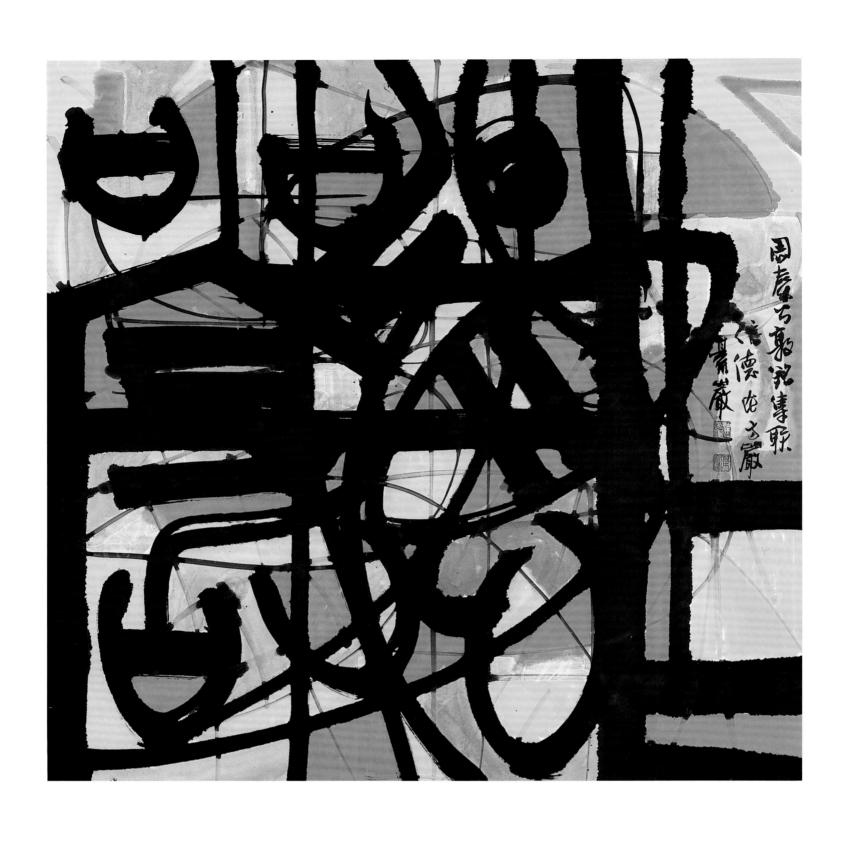

To Give and Share with Others
《作德在方嚴》金文 69 × 69 cm

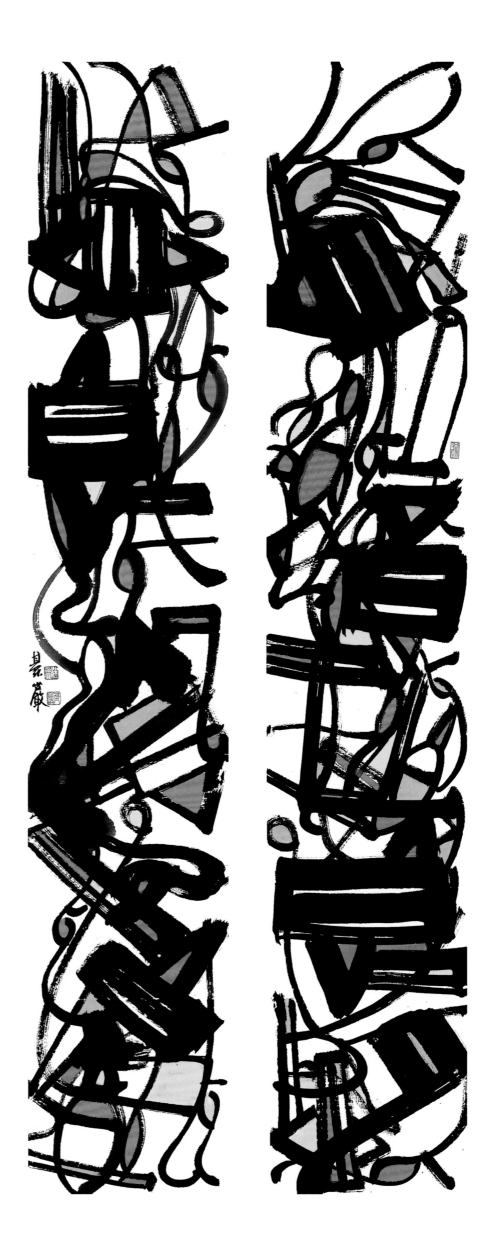

Virtue is to be
Serious and Discipline
《既之與人》金文二屏
140 × 25 cm × 2

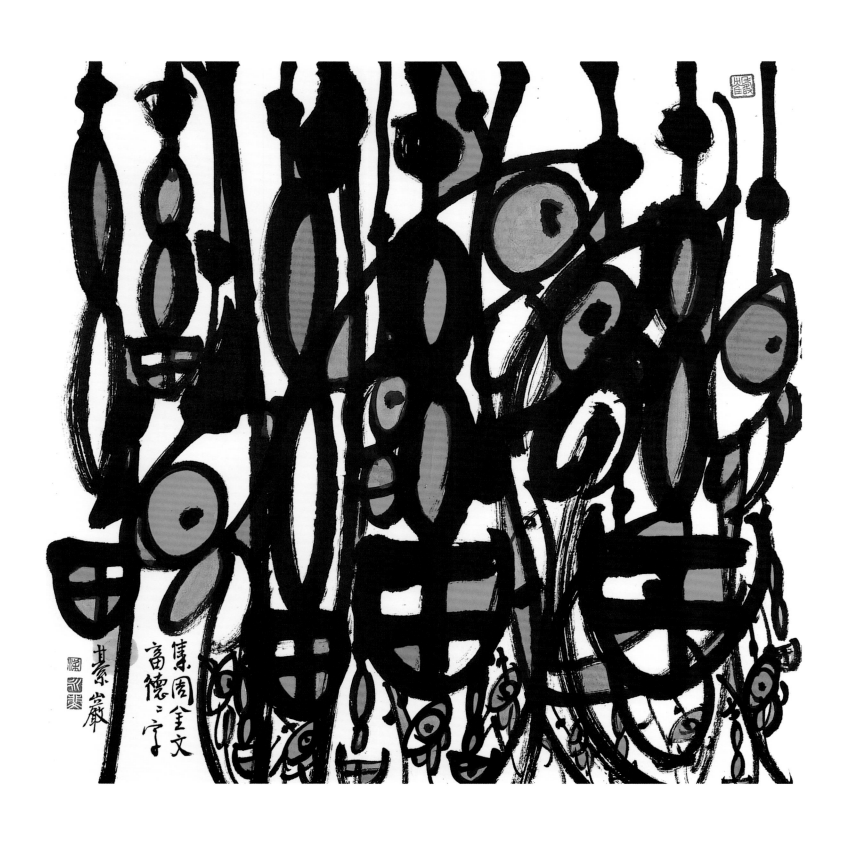

Cultivating Virtue for Life

《畜德一生》金文　46 × 46 cm

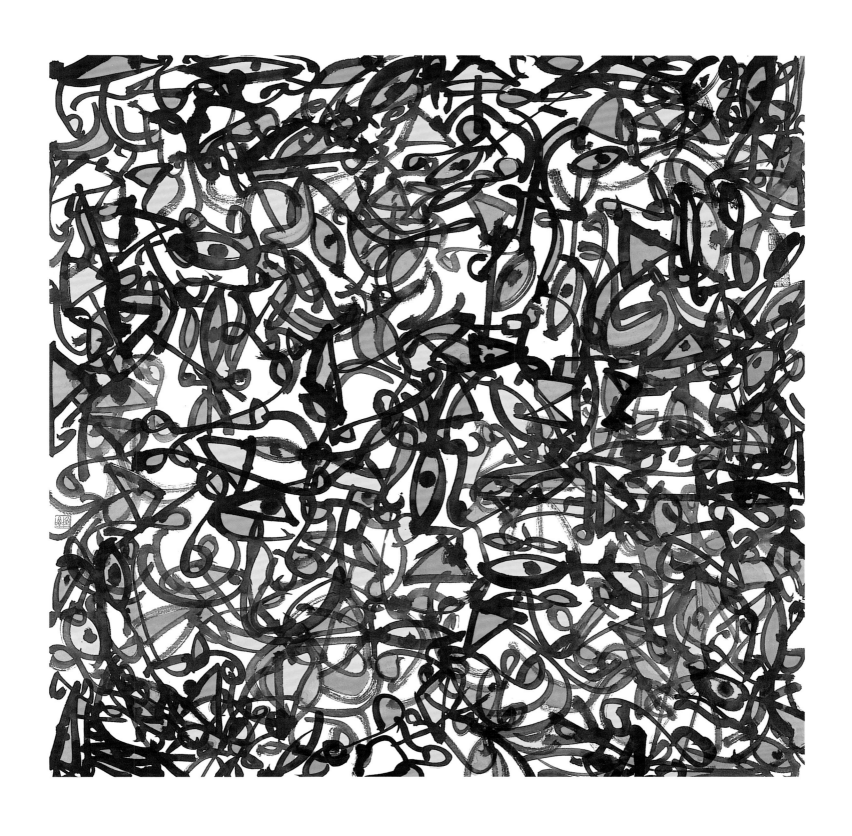

Funfest
《同樂會》金文篆書
69 × 69 cm

點線創意篇

Chapter III. Creative Dots and Lines

妥善運用點、線、色彩、文字等創作元素，並透過水墨特性及美妙音樂節奏，創作出其具有層次、律動、生命的「新境」，是一種「書藝＋音樂」的美學。

To properly use dots, lines, colors, characters, etc. as creative elements, and also through the features of ink-wash painting techniques and beautiful musical rhythms, to create the aesthetics of "calligraphy art plus music" that consists with layers, rhythms, and "new scenes" of life.

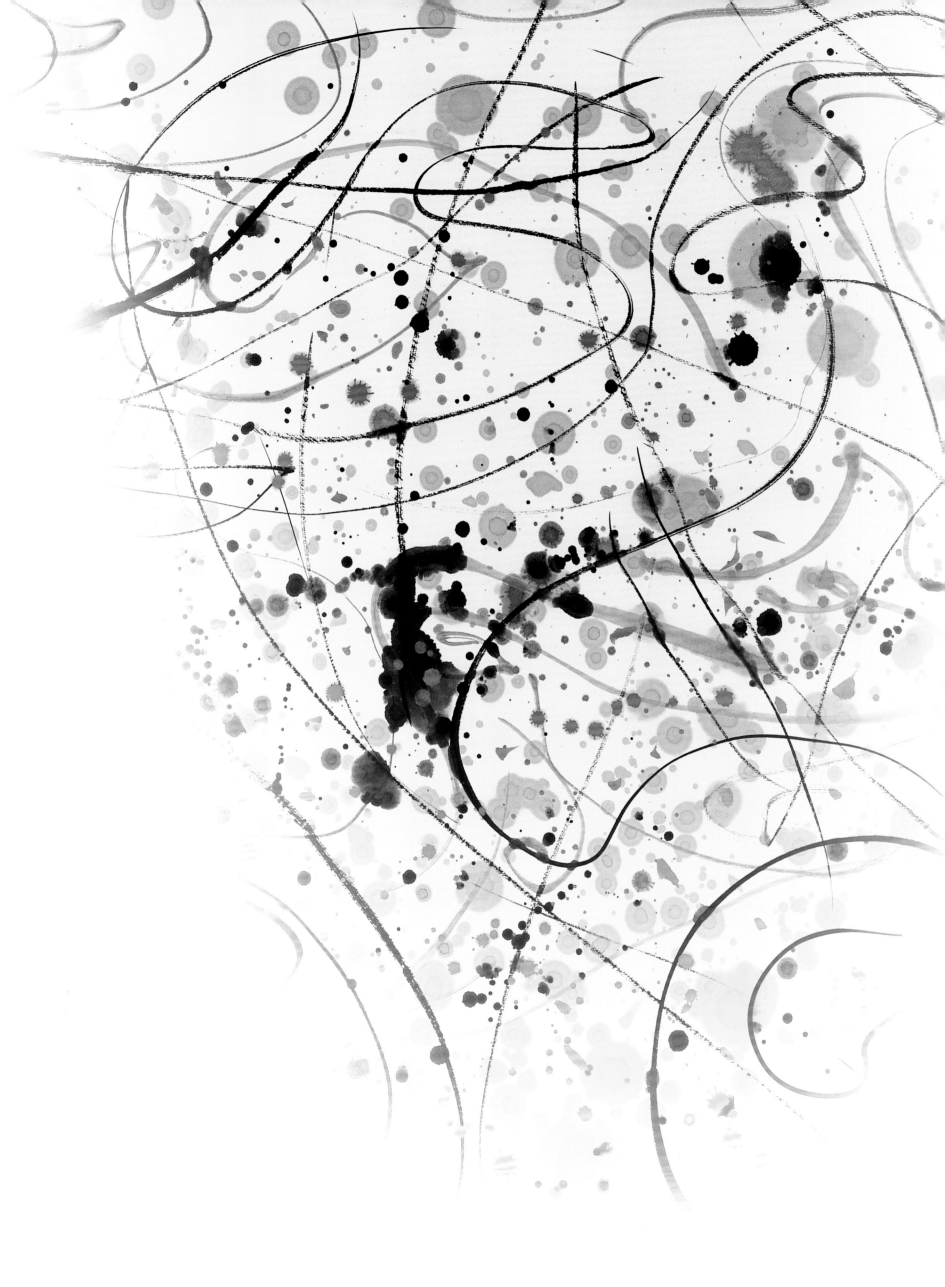

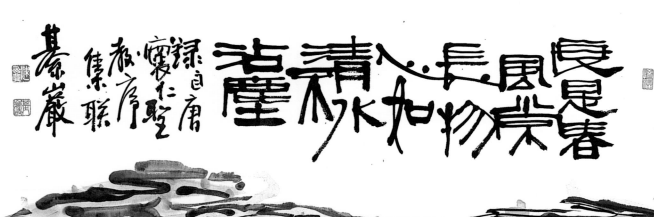

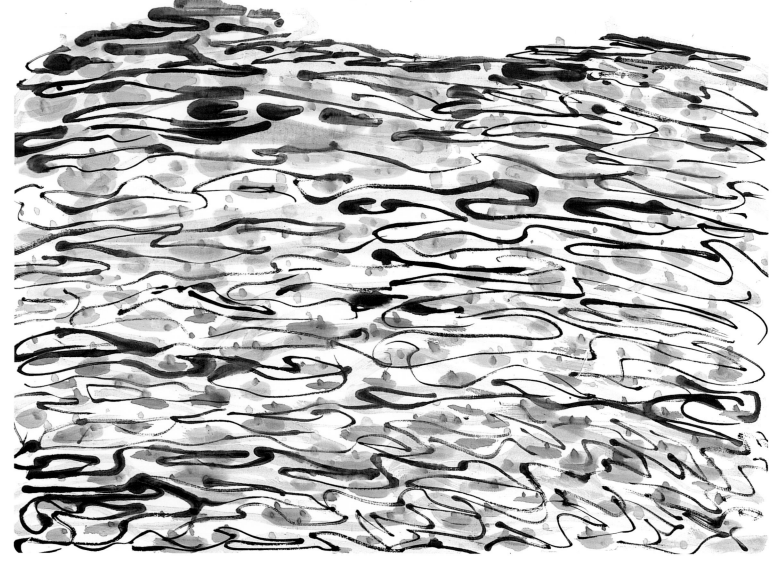

Viewing Lotus

《觀荷》 69 × 69 cm

度是春風常長物　心如清水不沾塵

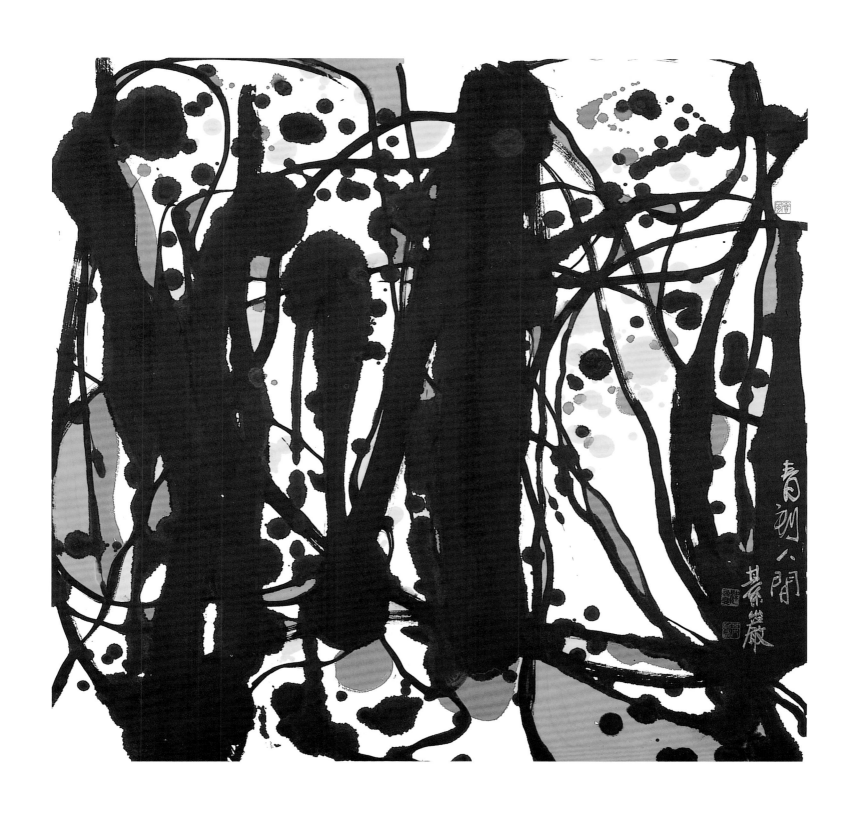

Coming of Spring

《春到人間》69 × 69 cm

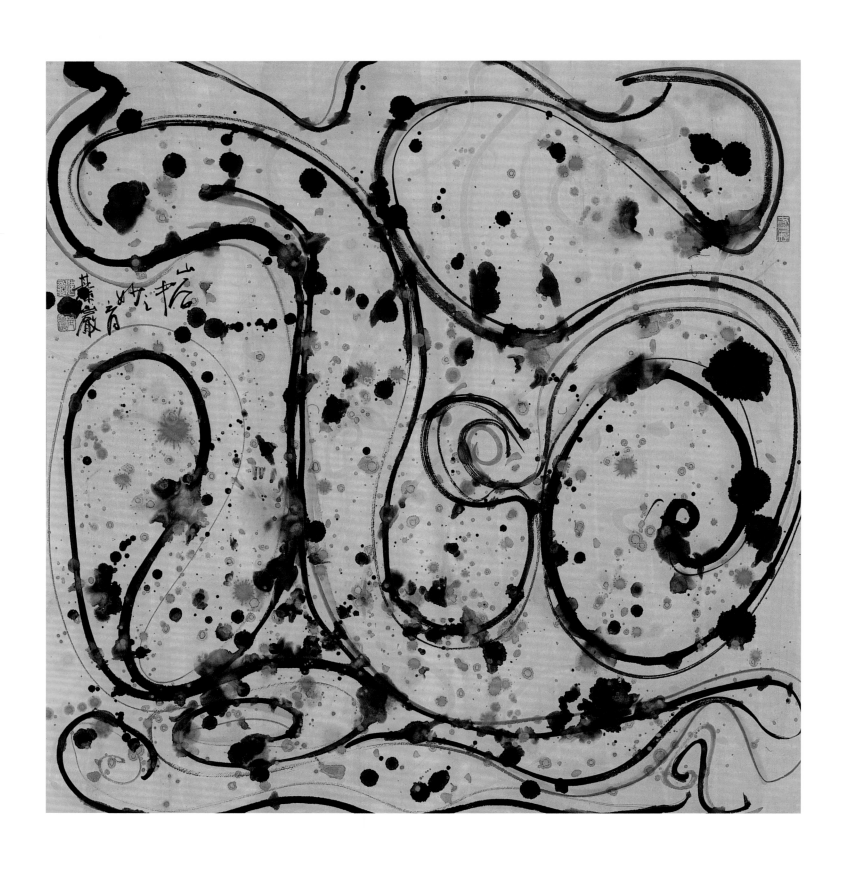

Beautiful Melodies from the Valley
《山谷中之妙音》 69 × 69 cm

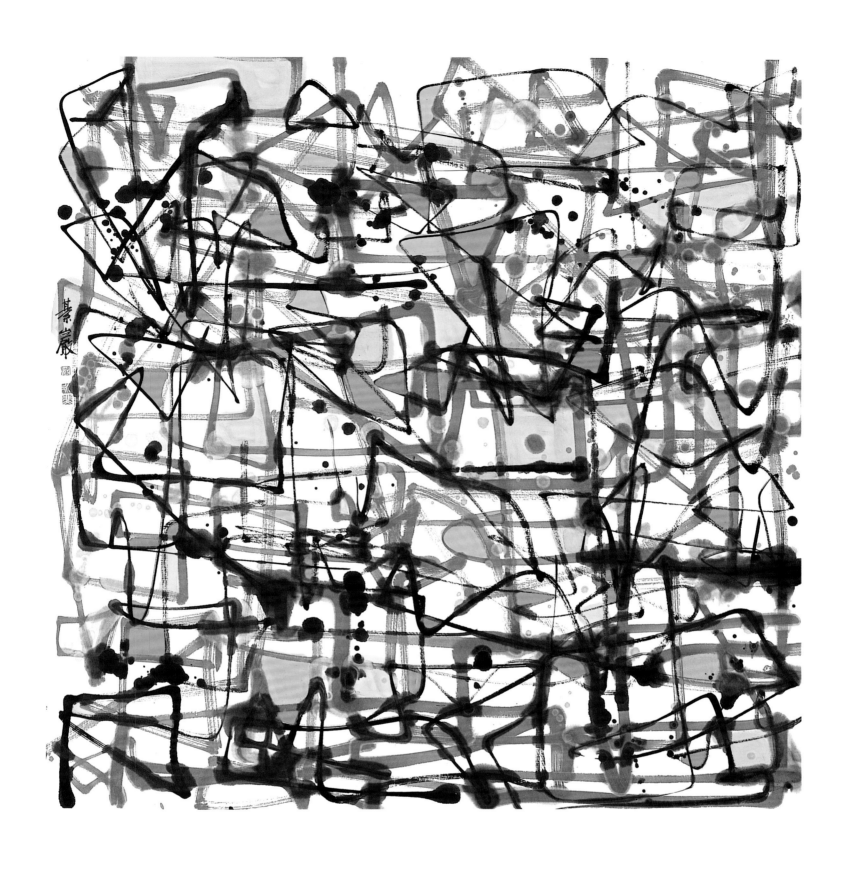

City of Music

《音樂城市》 69 × 69 cm

Summer

《夏至》 69 × 69 cm

心遊翠綠山林間　紅花爭豔染大千
細雨無聲潤萬物　煩憂盡忘好時節

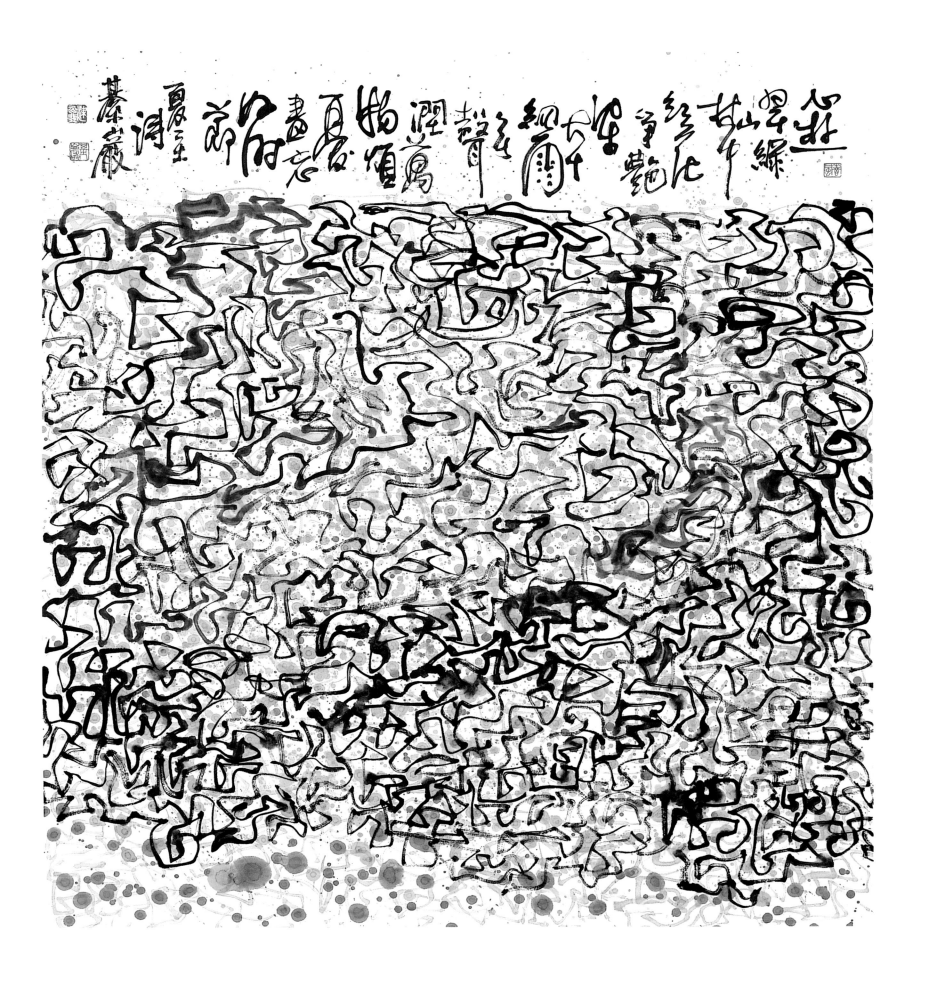

75

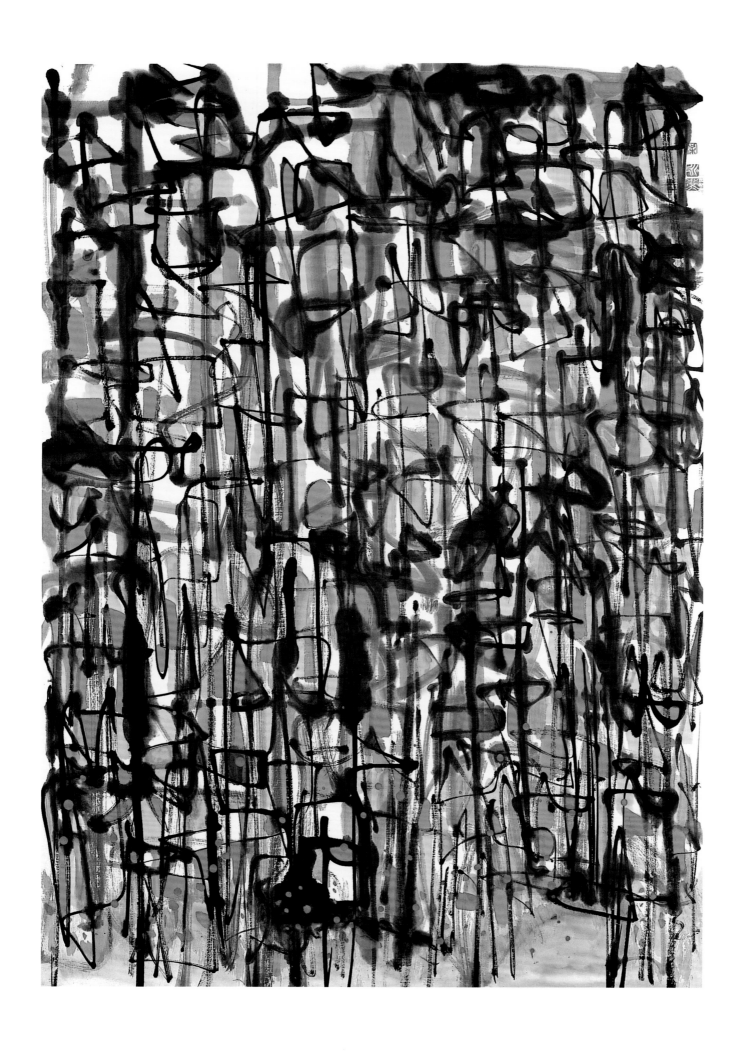

Spring

《春至》 70 × 46 cm

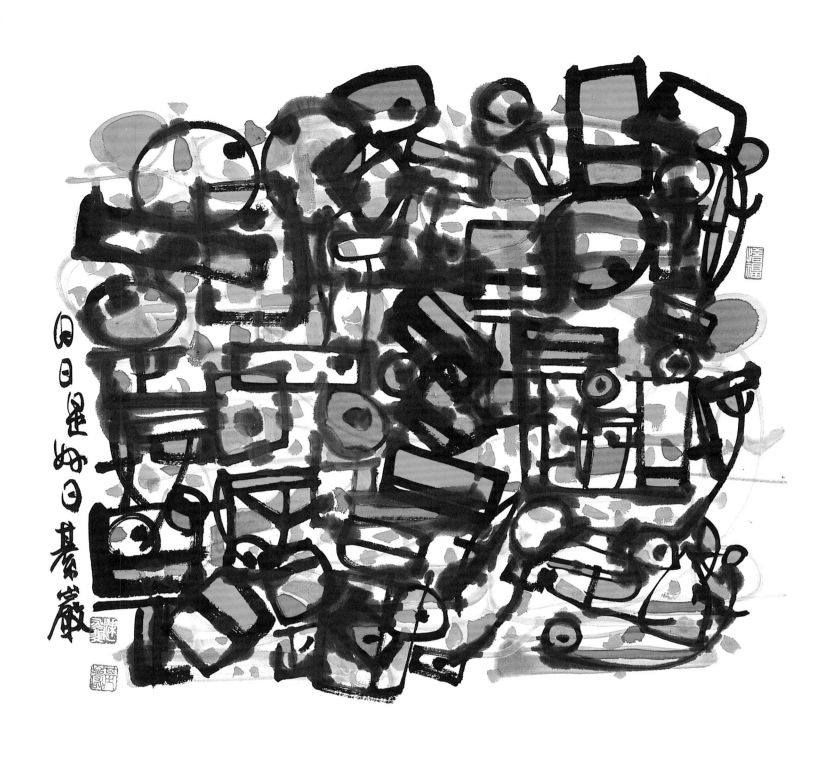

Everyday is a good day

《日日是好日》 隸篆組合

46 × 46 cm

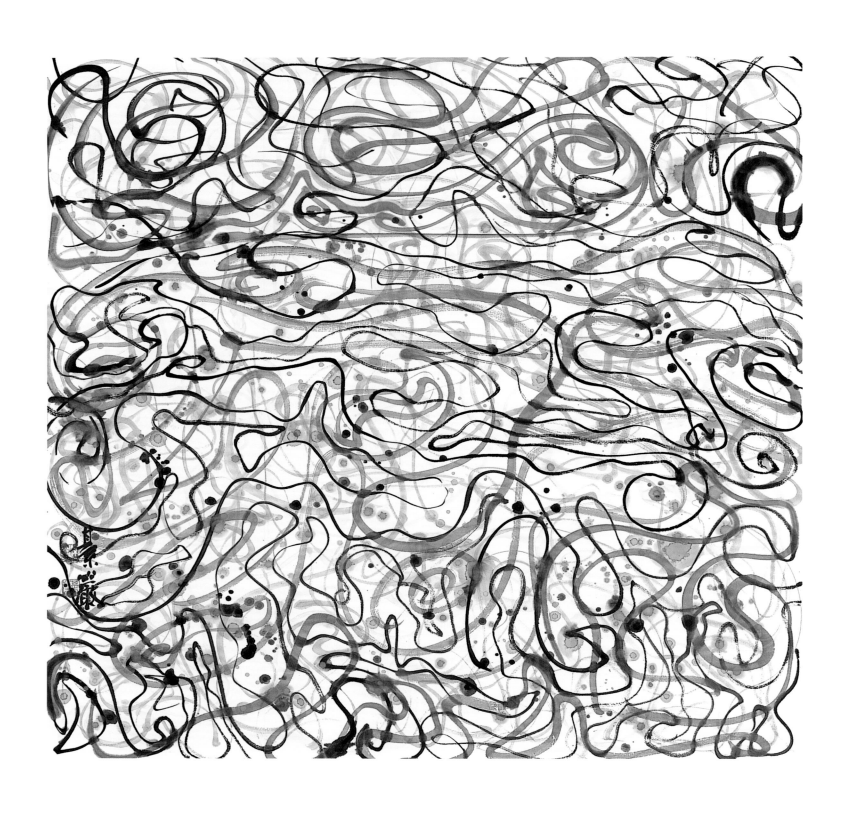

Song of the Land

《大地之歌》69 × 69 cm

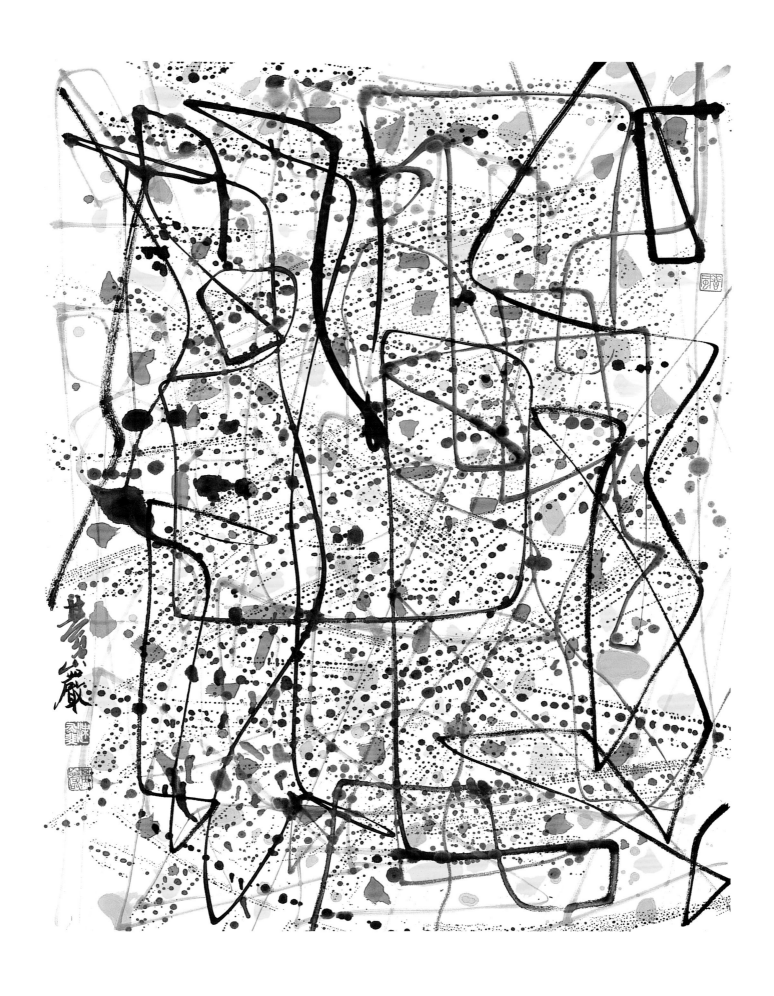

Traveling City
《旅行城市》 60 × 46 cm

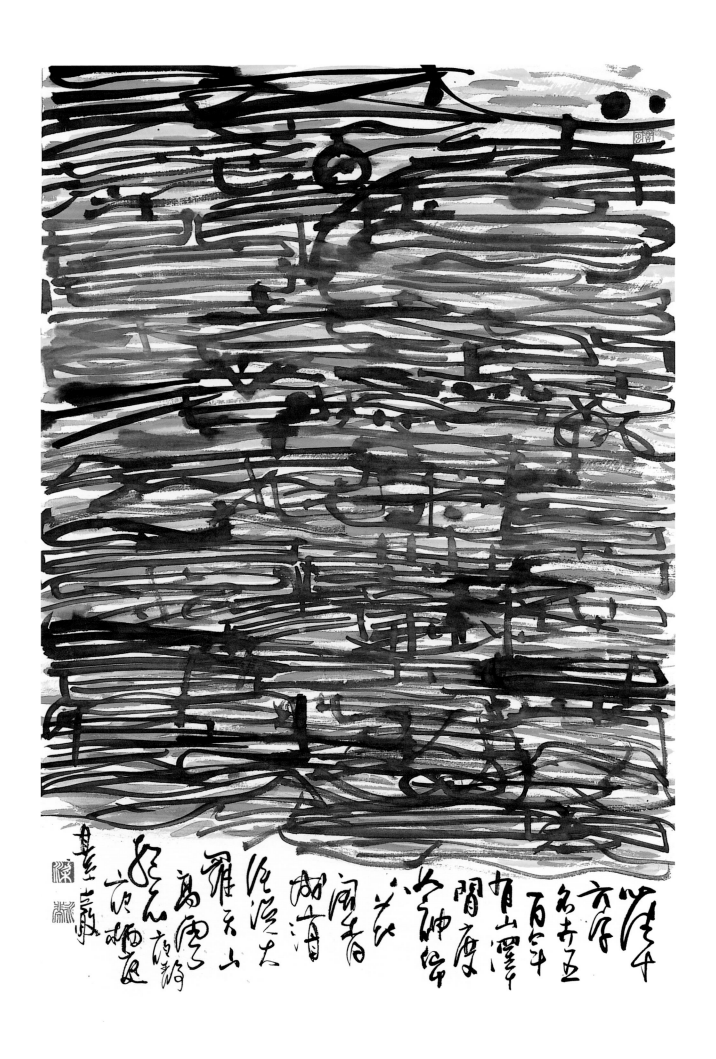

Impression Clerical Script

《印象隸書》 70 × 46 cm

心法十六字　名世五百年　有山澤間度　如神仙中人
花開香成海　經說大羅天　山高雲抱石　夜靜月栖庭
錄自唐懷仁聖教序集聯

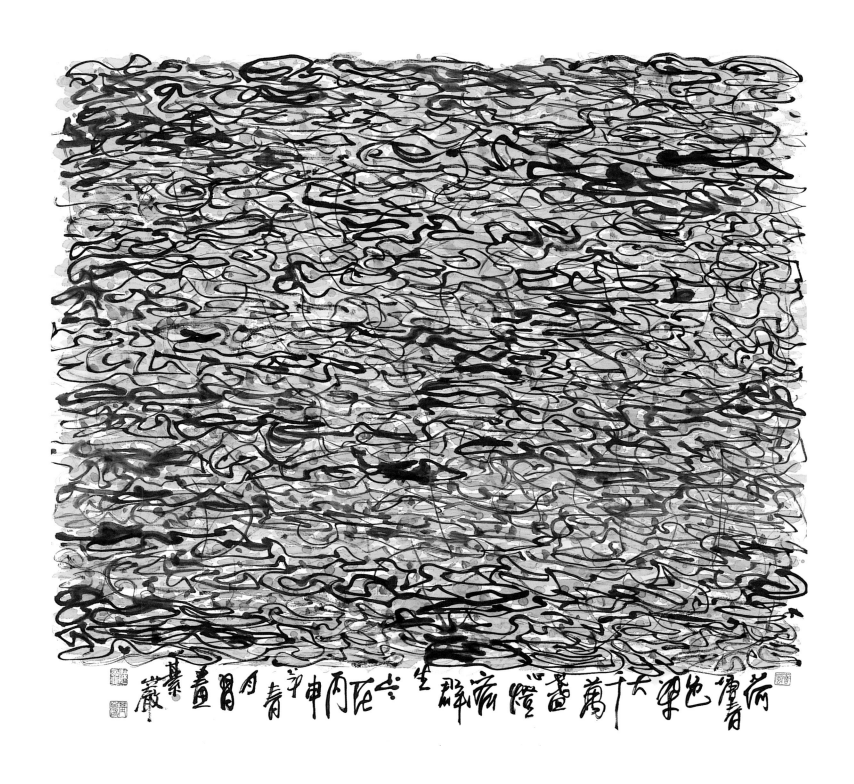

Light of Hearts

《心燈》69 × 69 cm

荷塘春色染大千　萬盞心燈濟群生

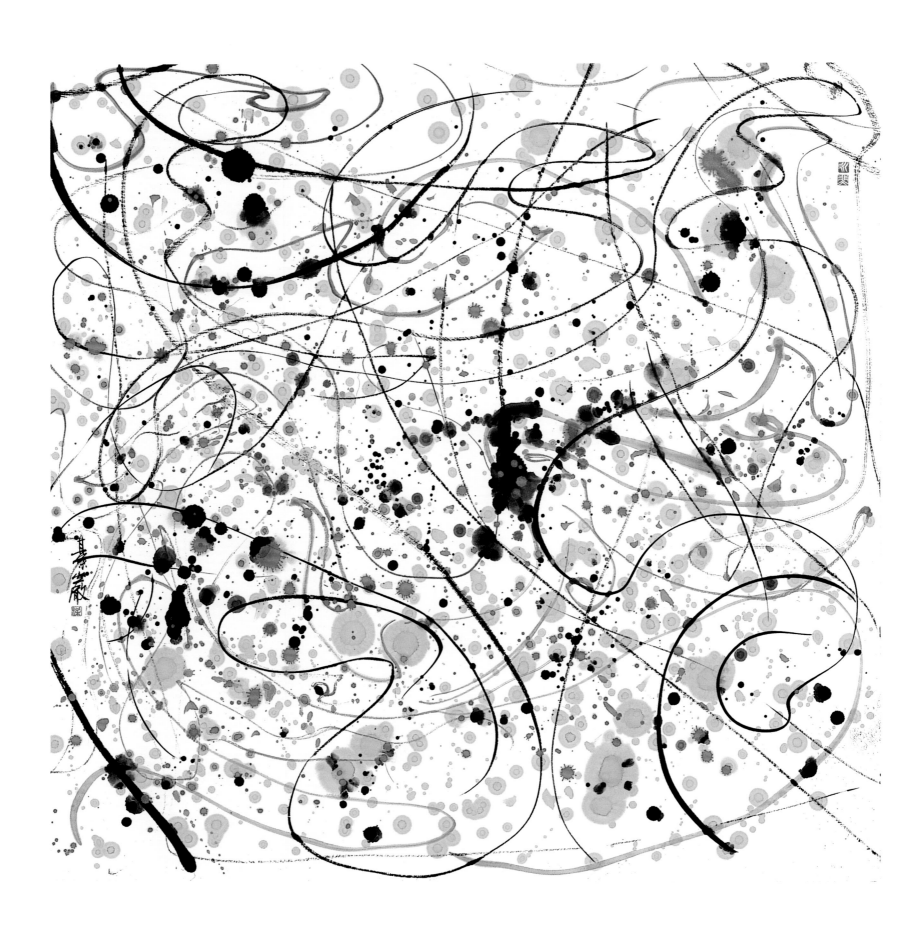

Leisurely between Heaven and Earth
《逍遙天地間》 69 × 69 cm

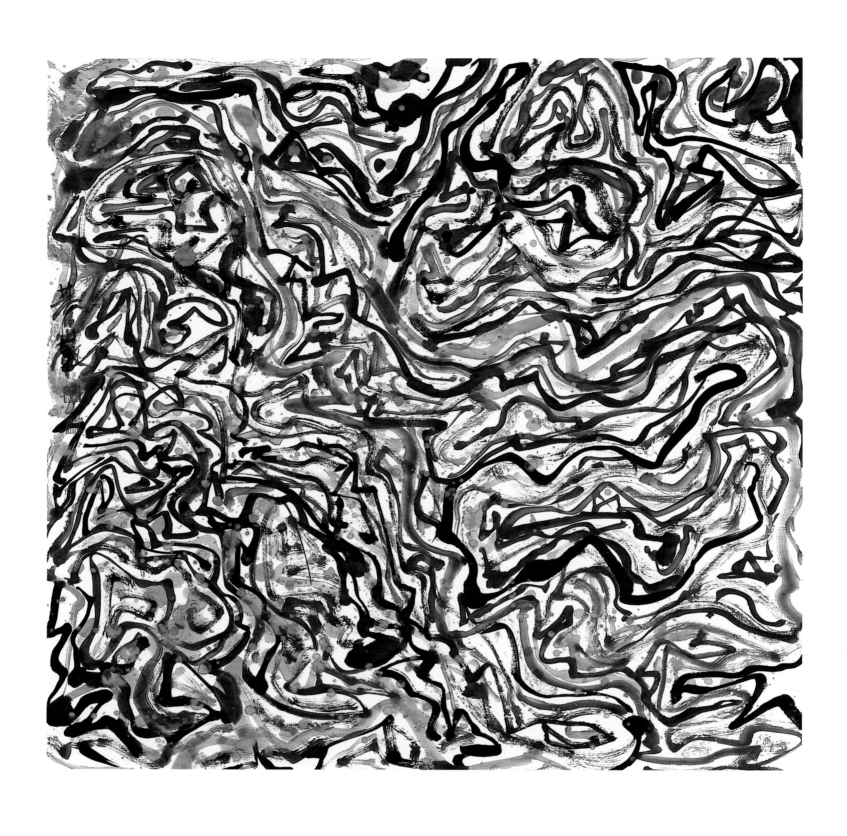

Wondering Heart in the Mountains and Woods

《心遊山林》 69 × 69 cm

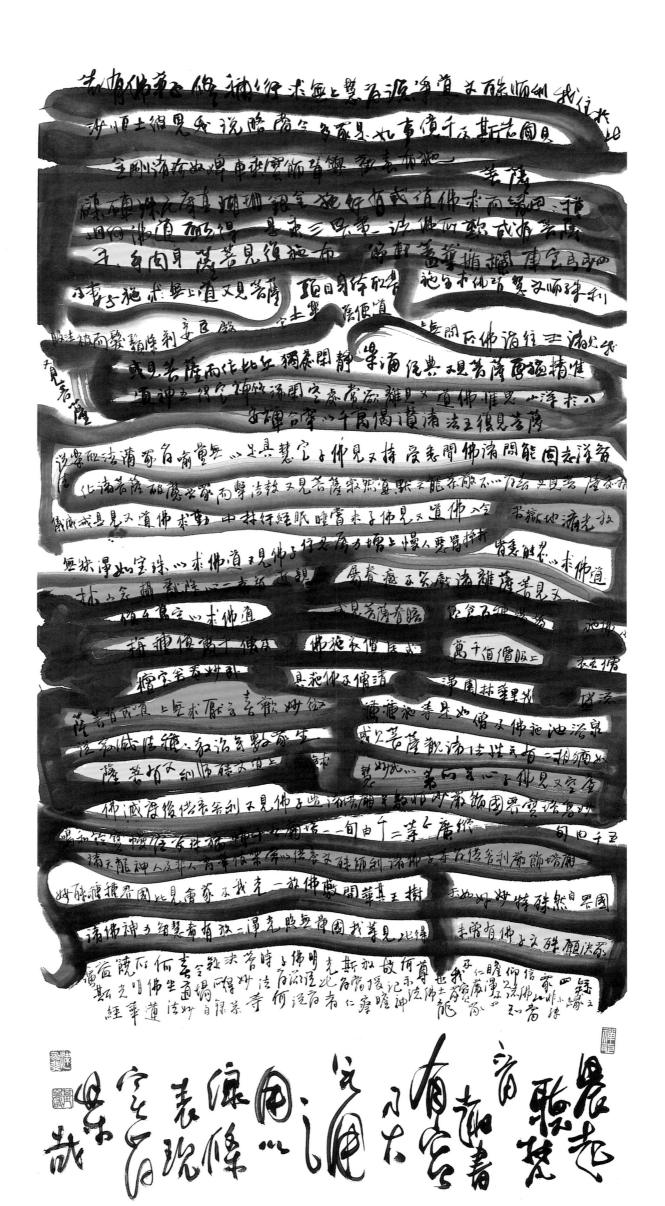

The Road to
Buddhahood
《成佛之路》
88 × 46 cm

文 字 成 林 篇

Chapter IV. Woods of Words

運用字體的特性及線條的變化為創作元素，並善用字體組合及彩墨技法進行多層次的處理，創作出各種樹林的樣態，期「以書入畫」，接而臻達「書畫合一」的理想境界。

Using the features of fonts in characters and the changes in lines as creative elements. Also using the combination of character fonts and the multi-layer color ink techniques, to create different gestures of woods, to form "calligraphy into paintings", and further exceeds the ideal state of "calligraphy and painting as one".

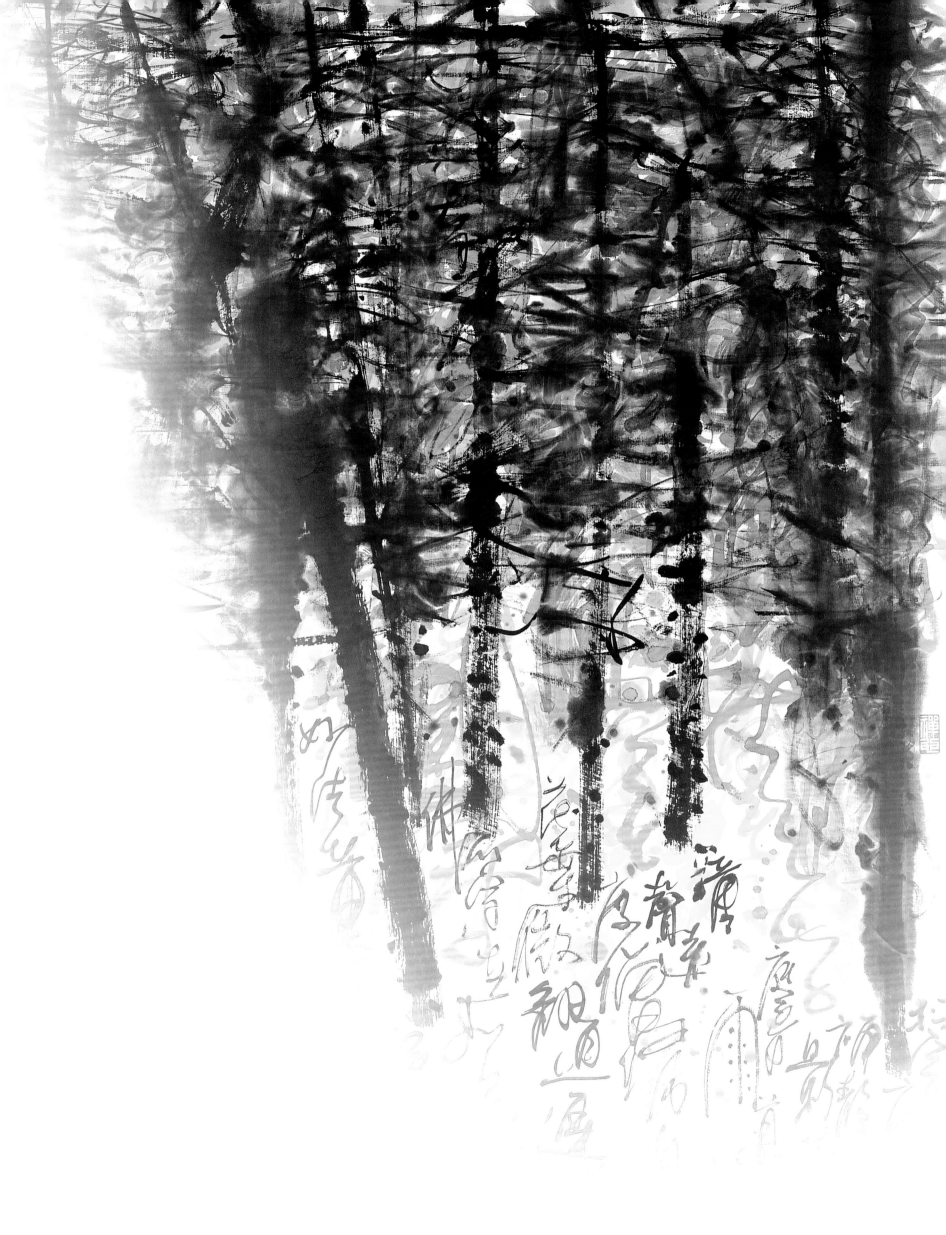

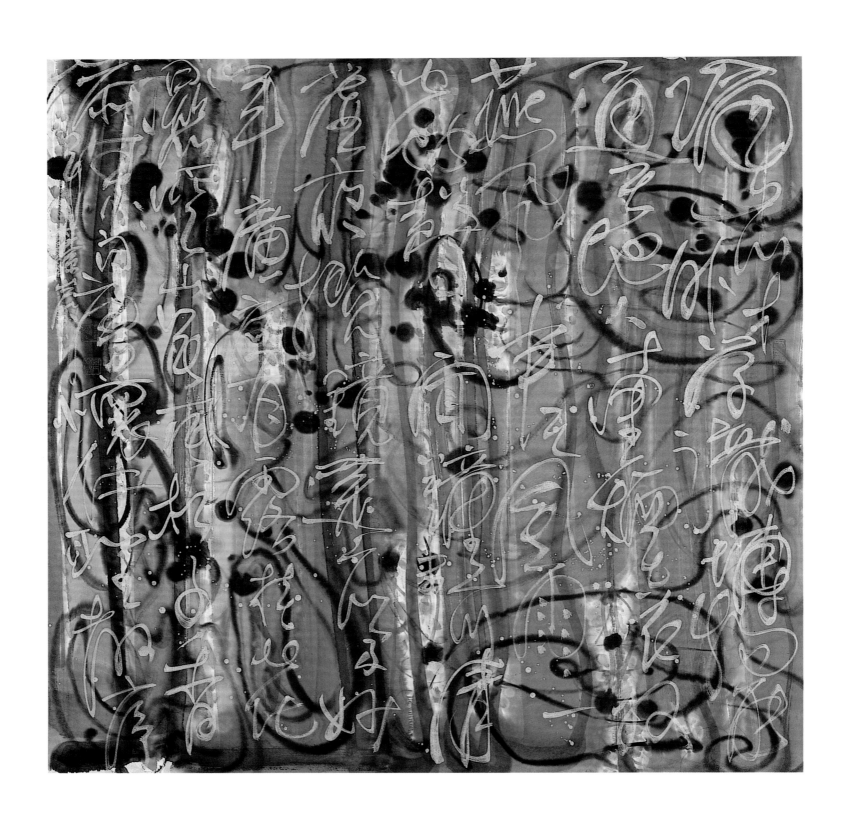

The Golden Woods

《黃金樹林》 行書　69 × 69 cm

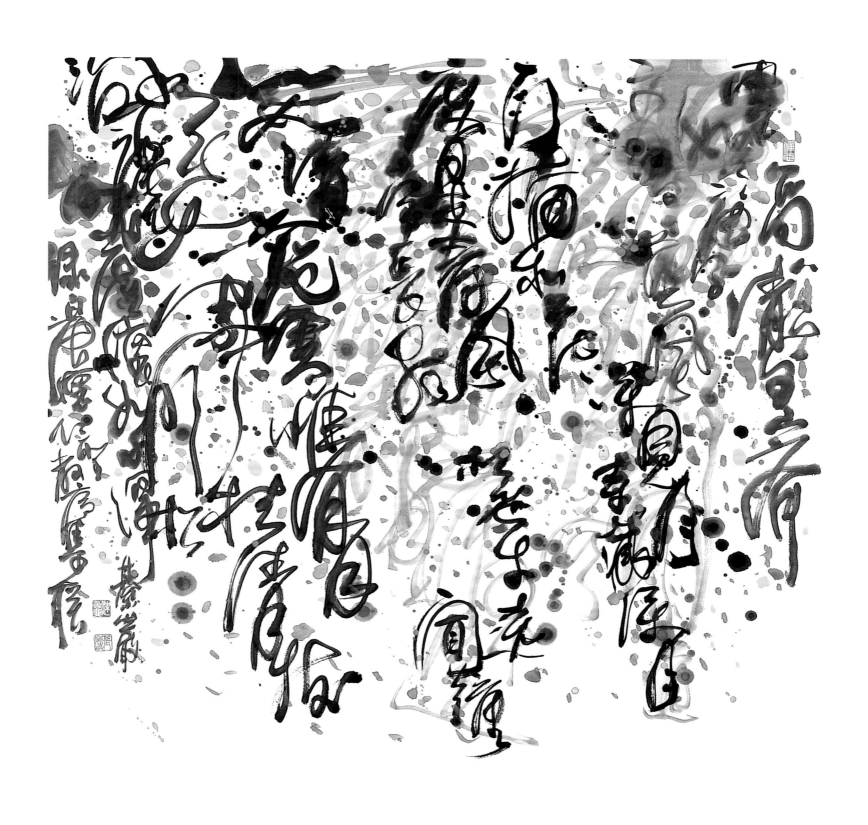

Colorful Seasons

《繽紛季節》 行書 69 × 69 cm

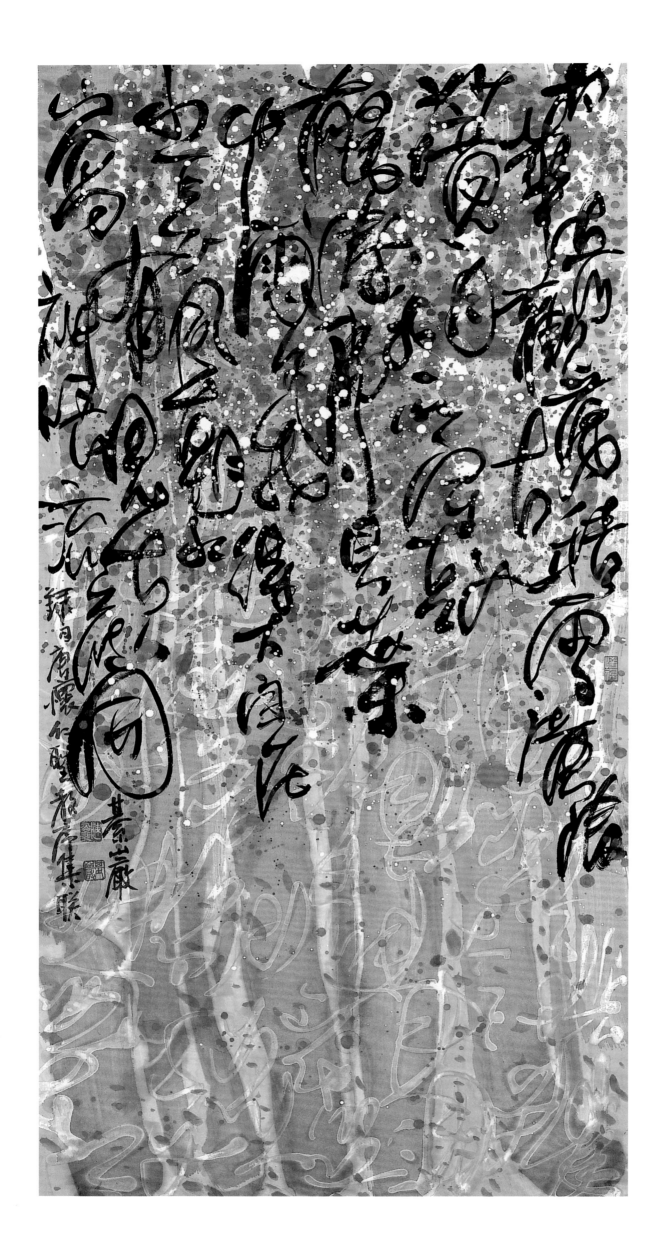

Blooming Flowers
《繁花盛開》
行書 90 × 46 cm

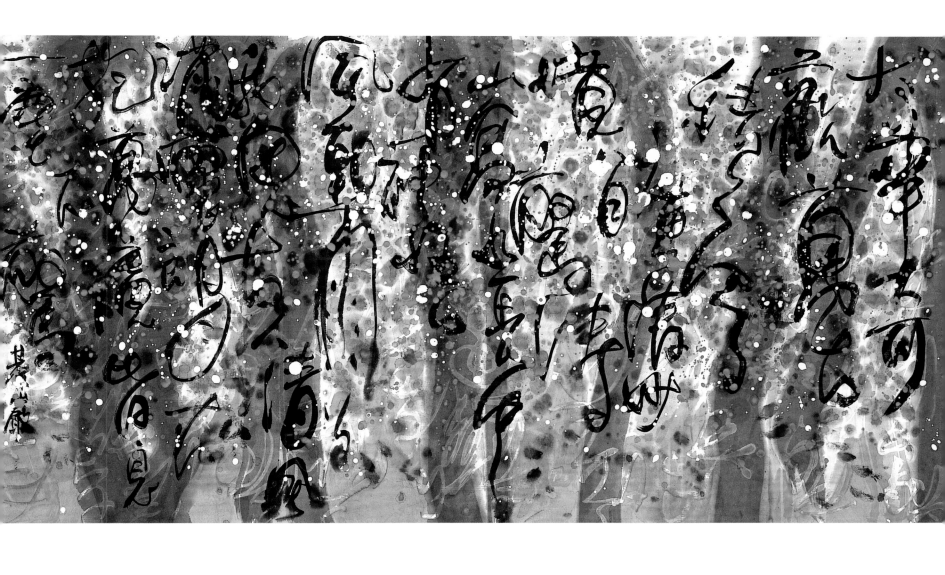

Spring Travel Along the Lake
《湖邊春遊》行書　46 × 90 cm

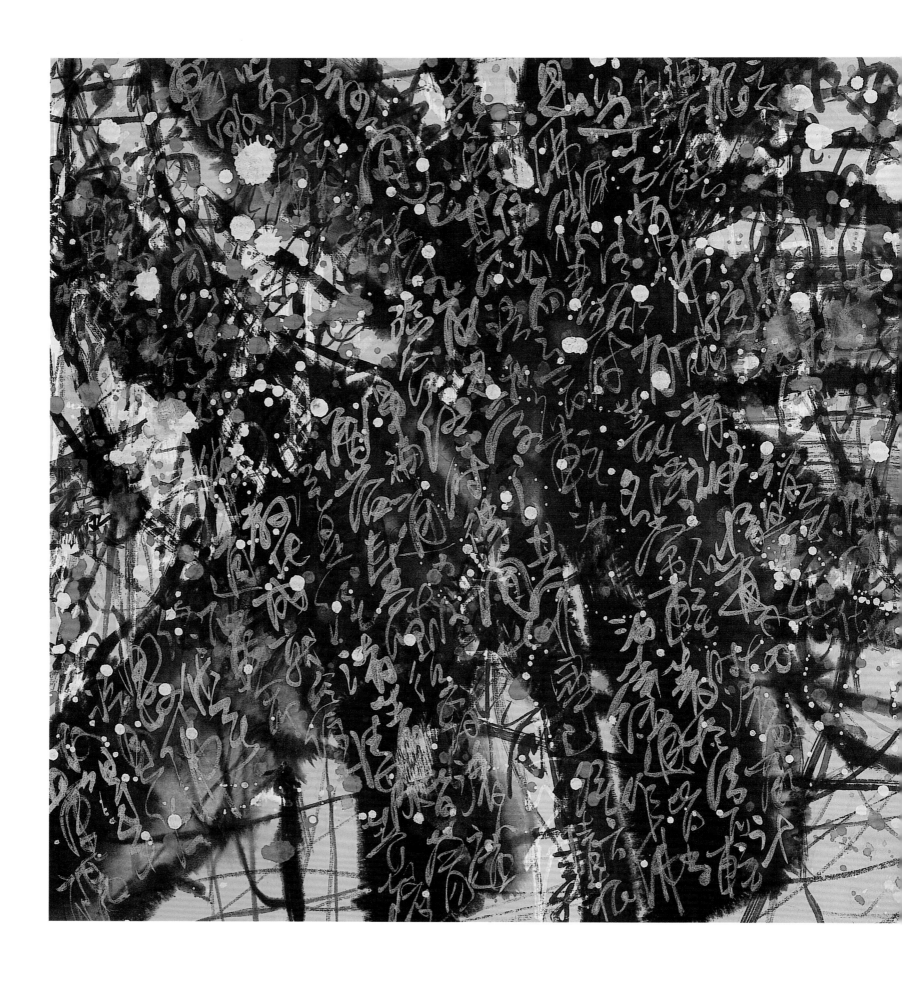

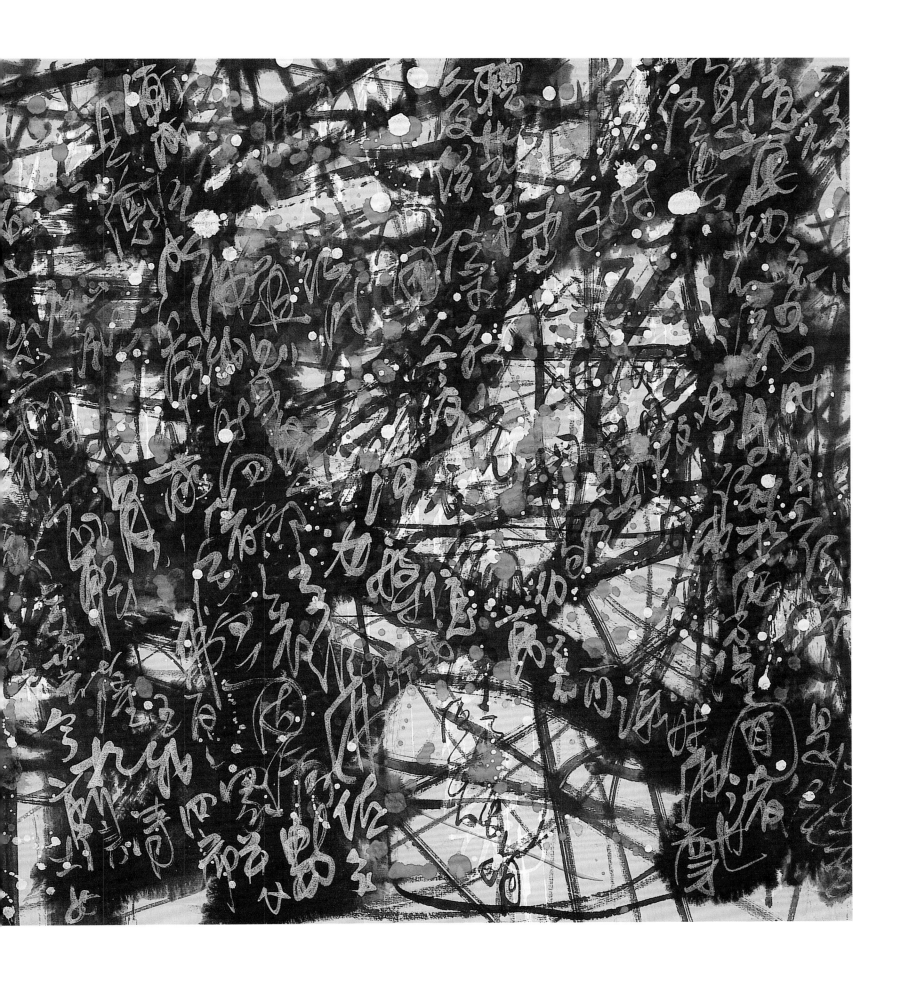

Old Plum Flower in the Snow
《老梅映雪》 行草組合 44 × 88 cm
錄自佛家語

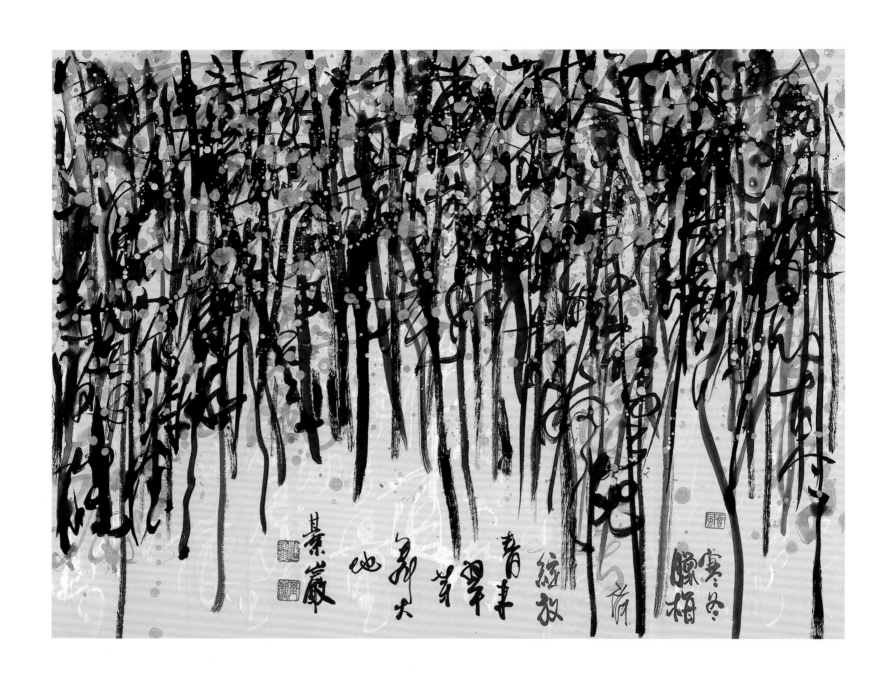

Winter Sweets

《臘梅》行草組合 45 × 65 cm

寒冬臘梅齊綻放　春來翠芽舞大地

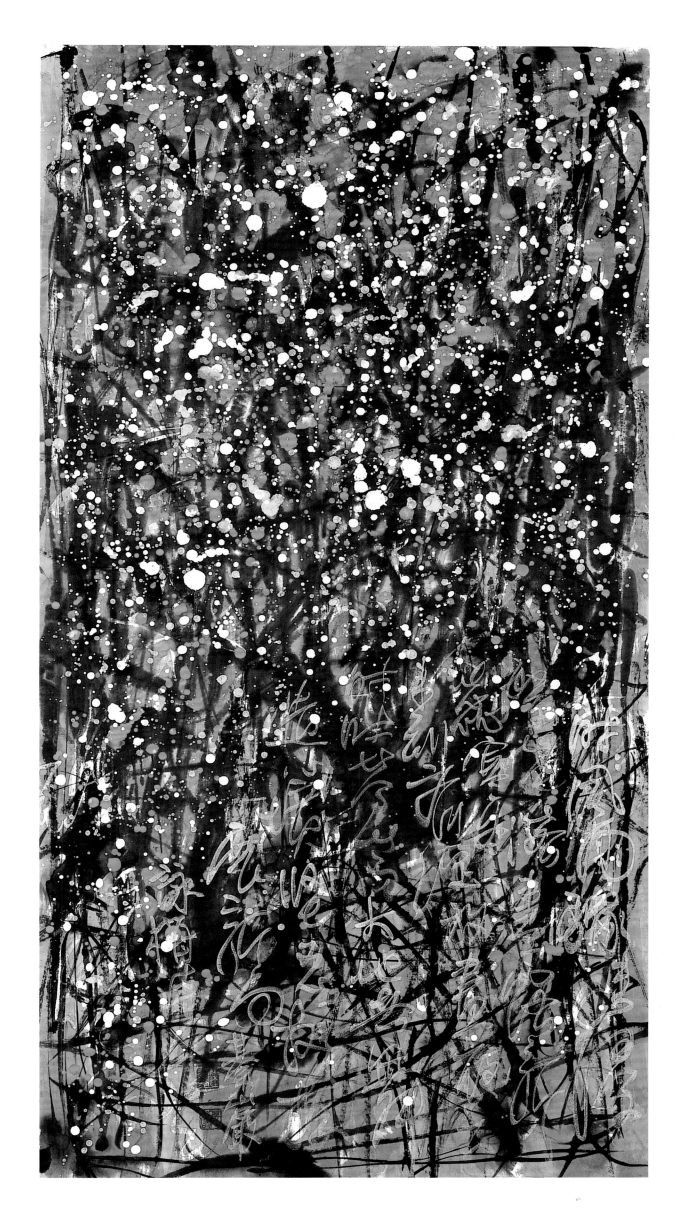

Plum Blossom
《詠梅》行書
88 × 46 cm
時時風雨驟來侵
繁花落盡露翠芽
寒冬來到齊綻放
晝夜六時吐芬芳
大地共舞造心境
堅忍挺拔展新局

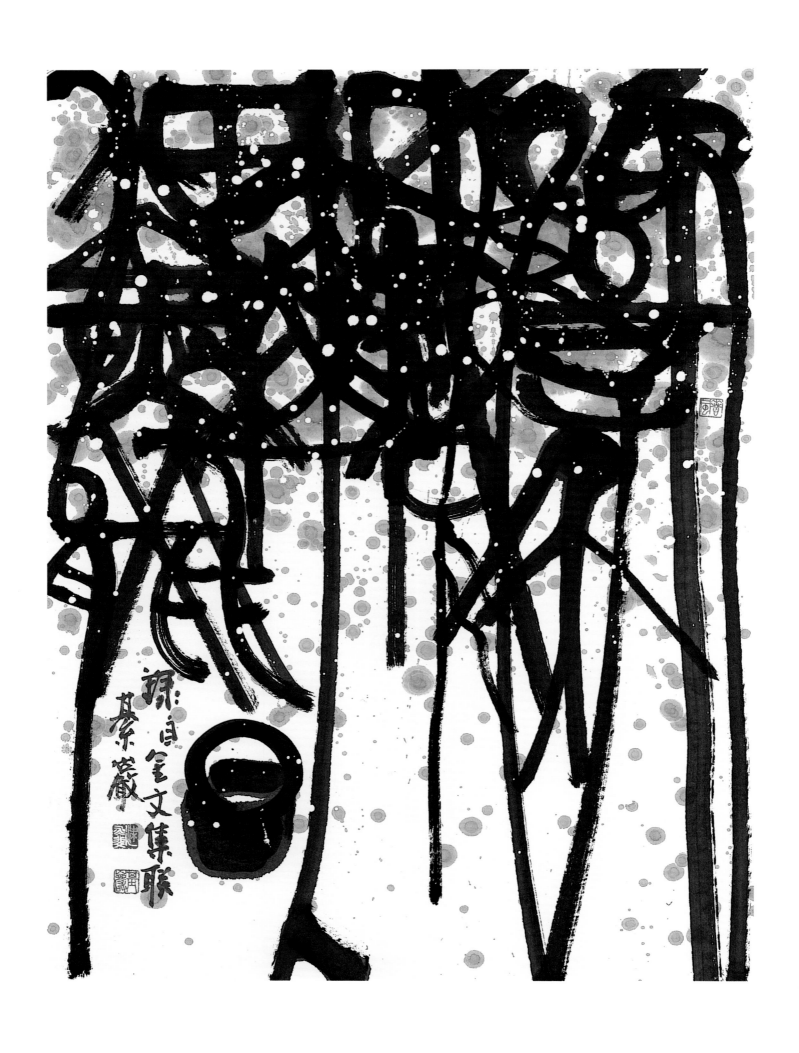

Winter Solstice

《冬至》金文組合 60 × 46 cm

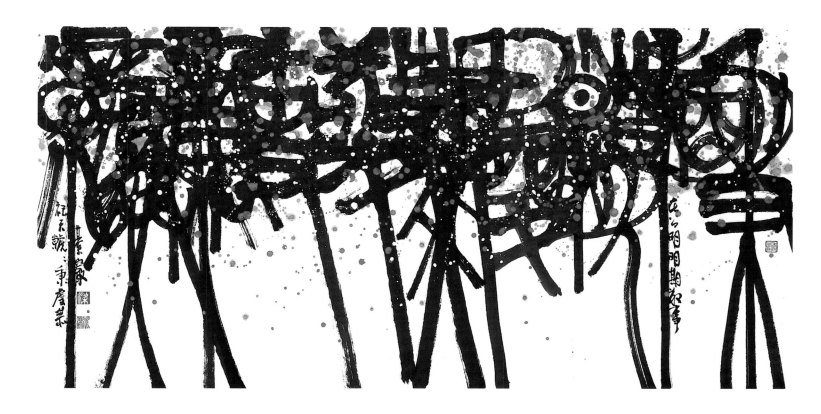

Beginning of Spring
《春意》 金文組合 46 × 88 cm

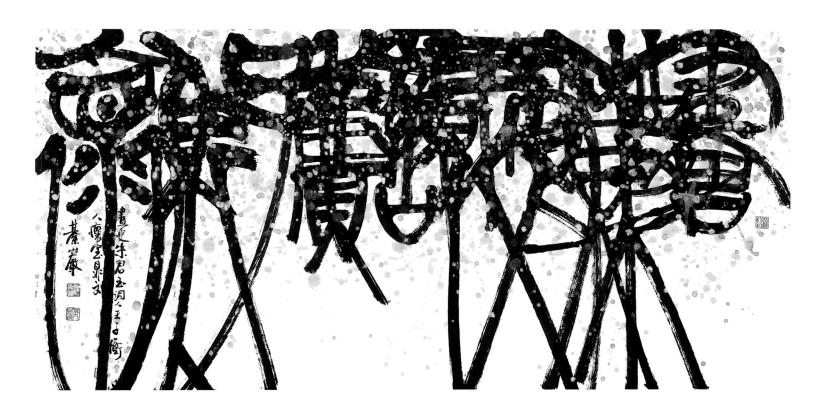

Autumn《秋節》 金文組合 46 × 88 cm

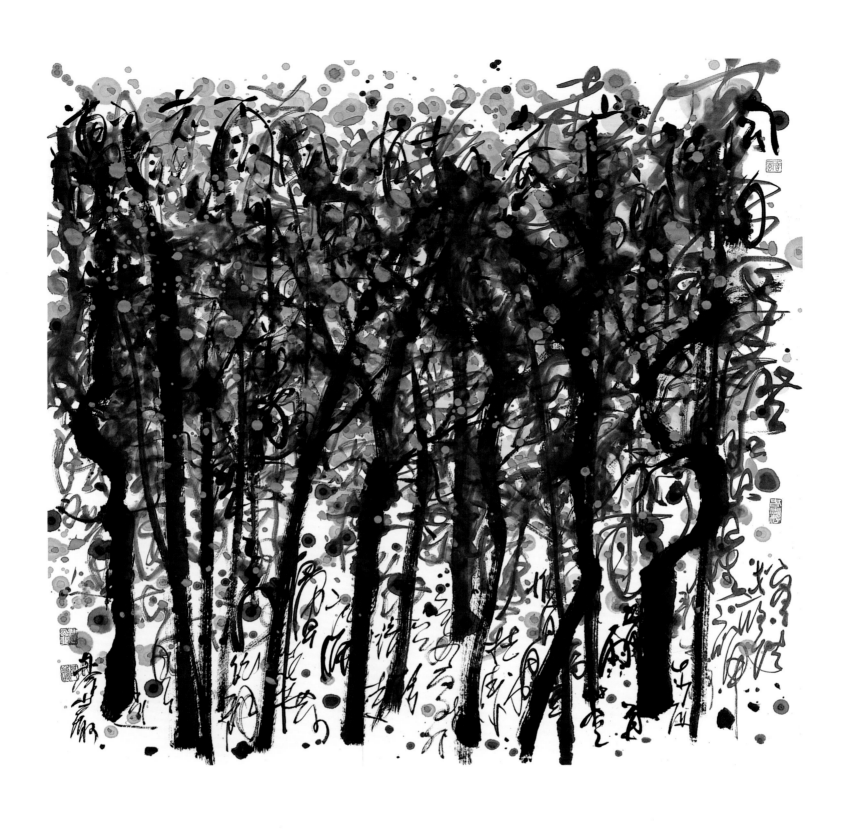

Greeting Blooming Flowers

《喜迎花開》行書 69 × 69 cm

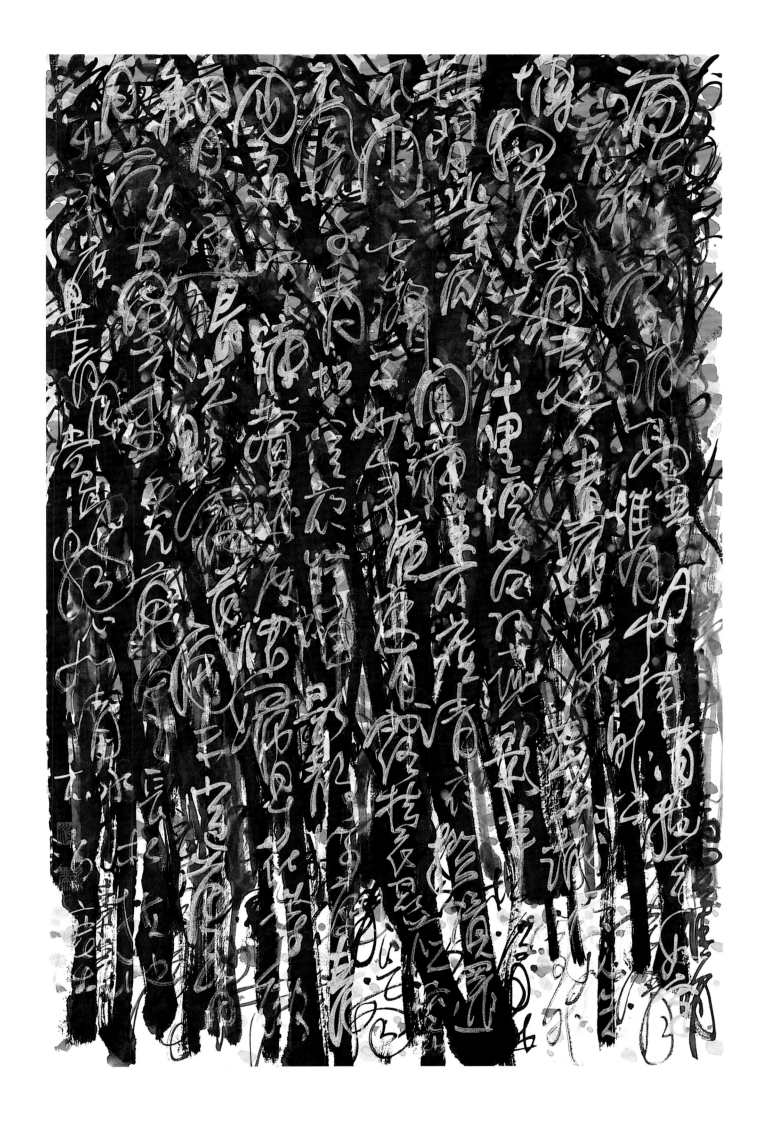

The Golden Forest

《金字森林》行書 70 × 46 cm

錄自唐懷仁聖教序集聯拓本

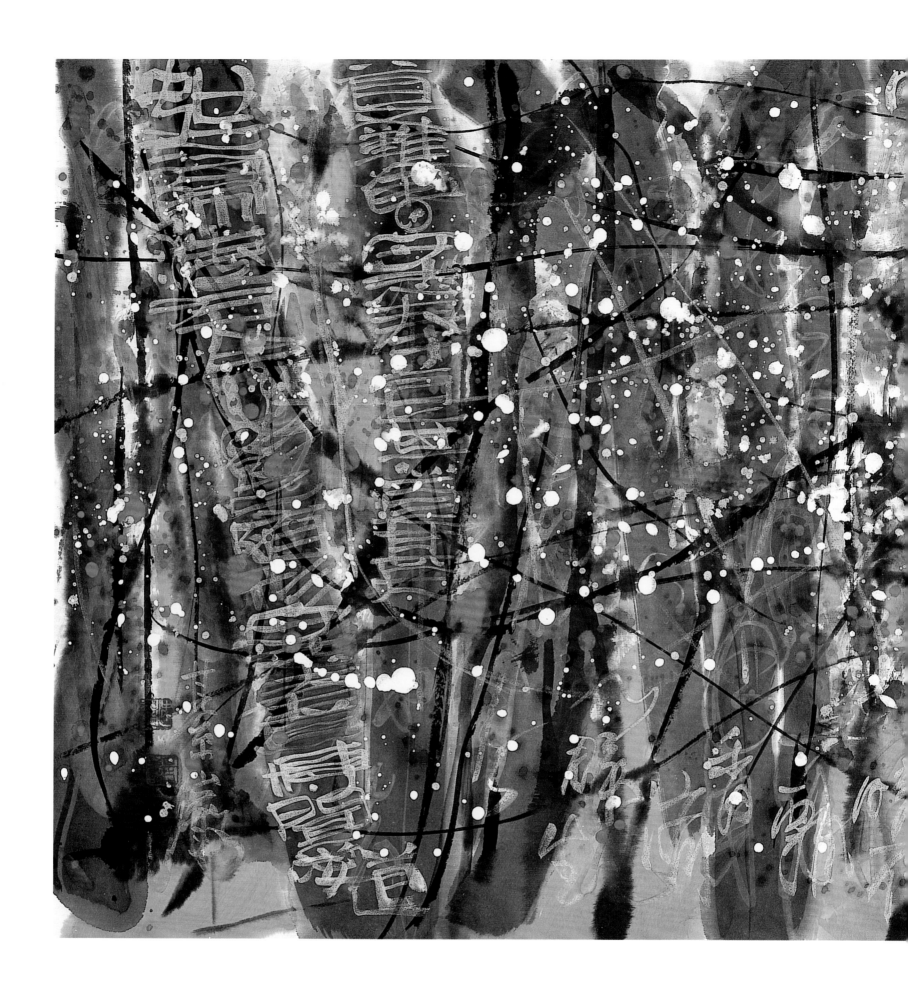

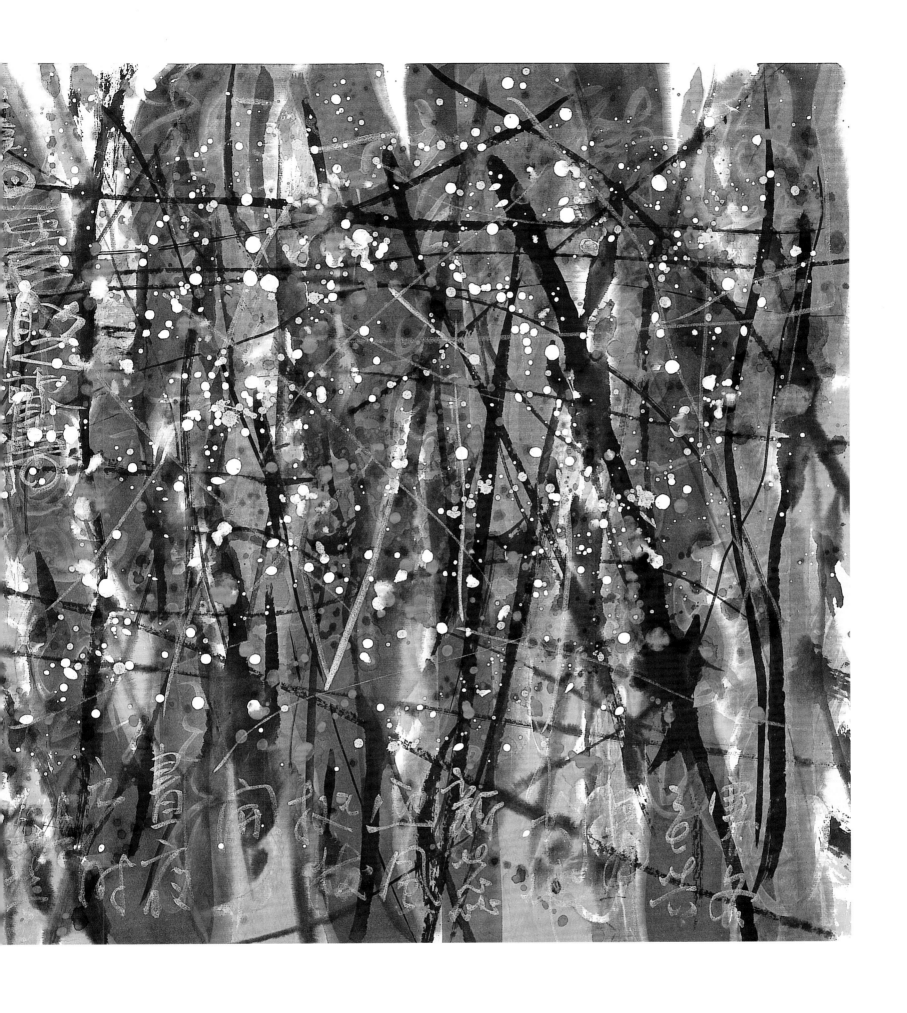

Laughter Between the Trees

《林間樂聲》 隸書行書組合 46 × 88 cm

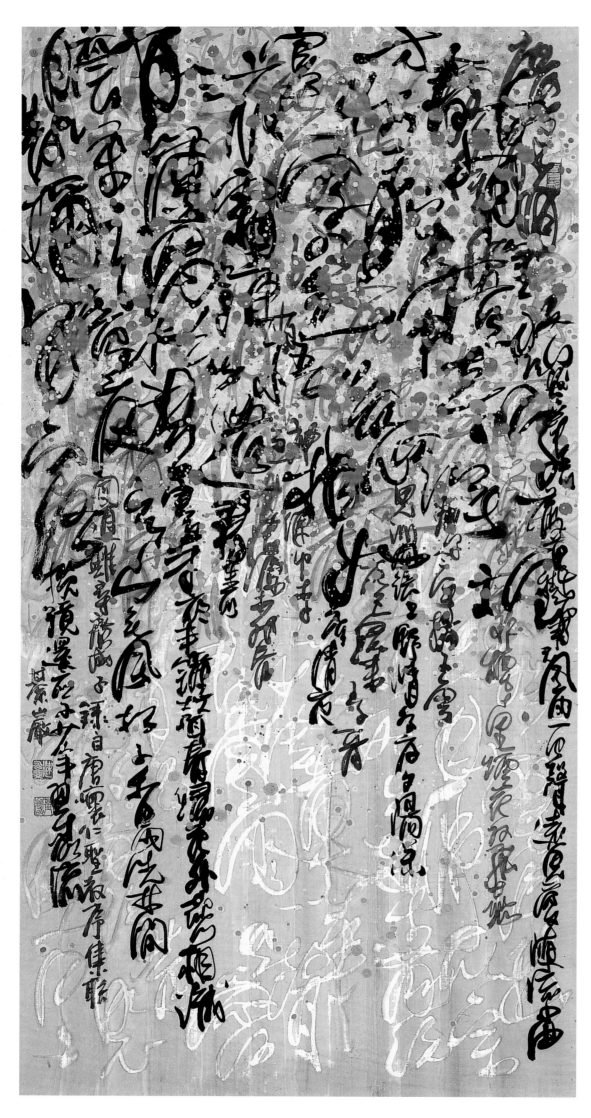

New Scene of Blooming Flowers
《繁花新境》行書 88 × 45 cm

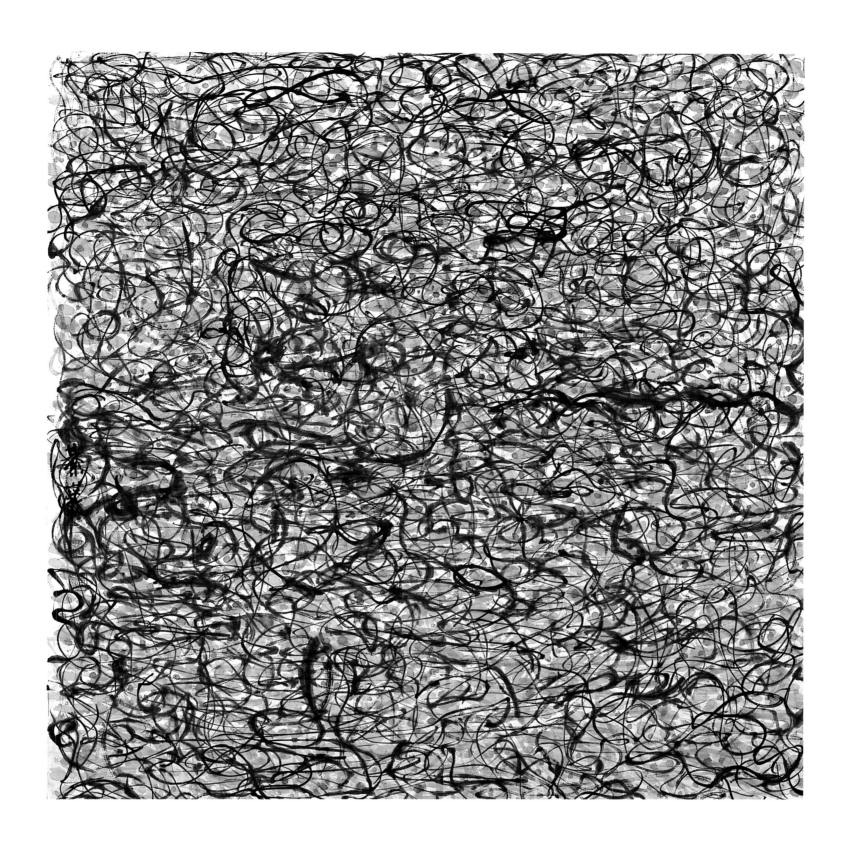

Looking at the Sky

《空眺》69 × 69 cm

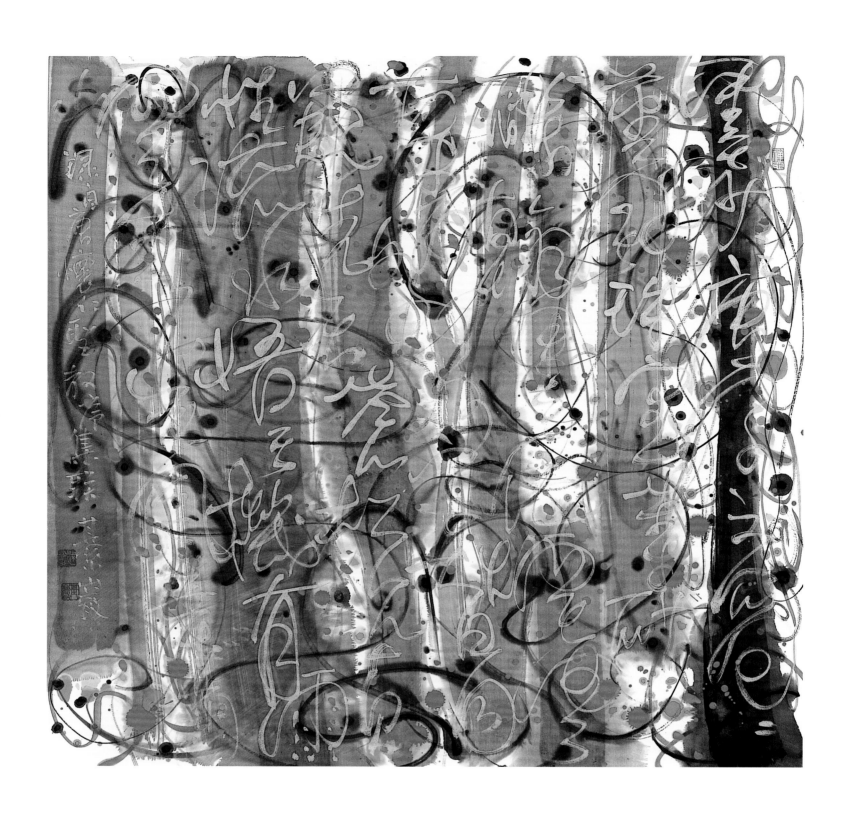

The Symphony in the Woods

《林中交響曲》行書　69 × 69 cm

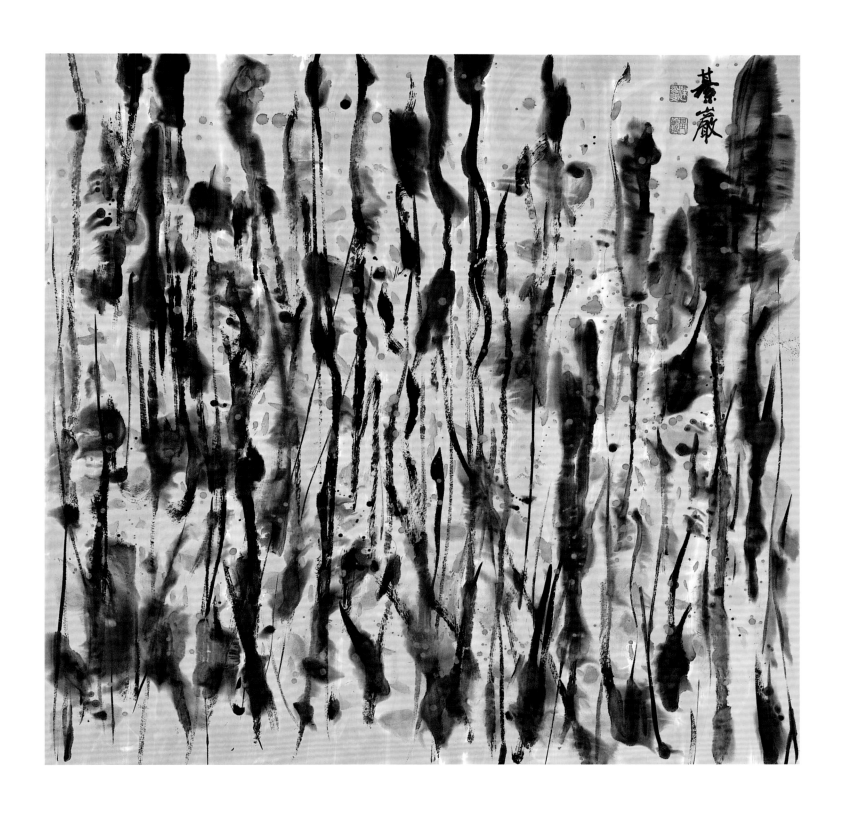

Night View of the Lotus Pond
《夜觀荷塘》69 × 69 cm

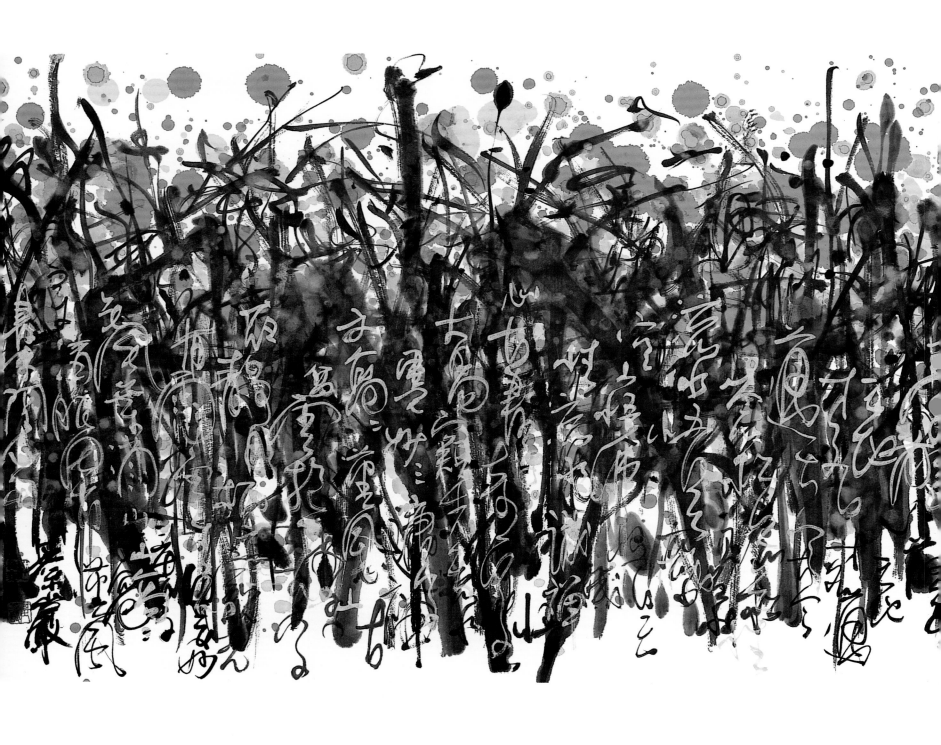

Heart of Woods

《心林》行書 46 × 470 cm

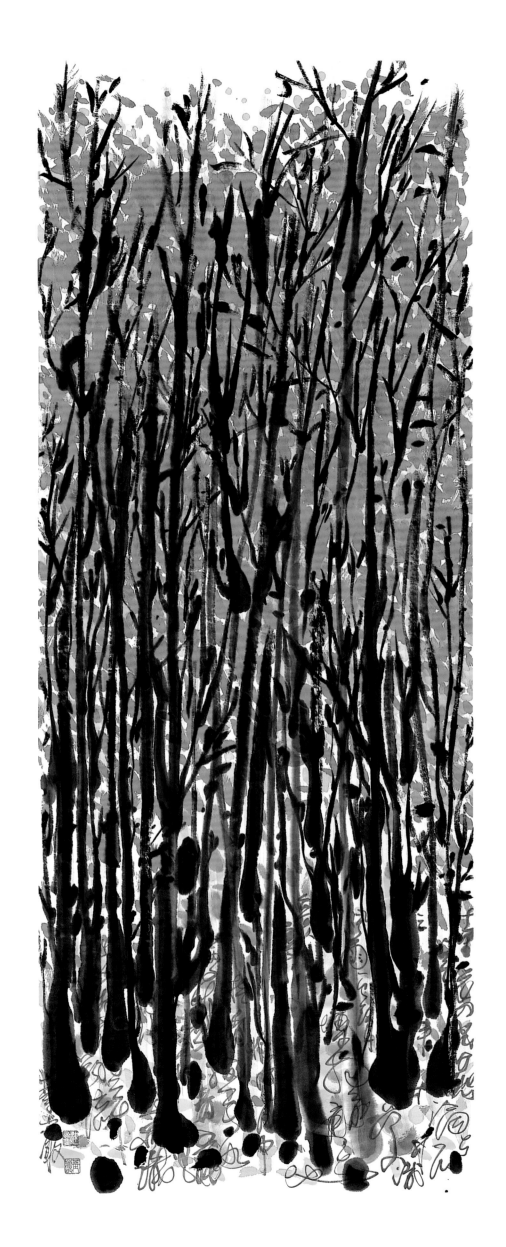

Deep Autumn
《深秋季節》行書
122 × 46 cm

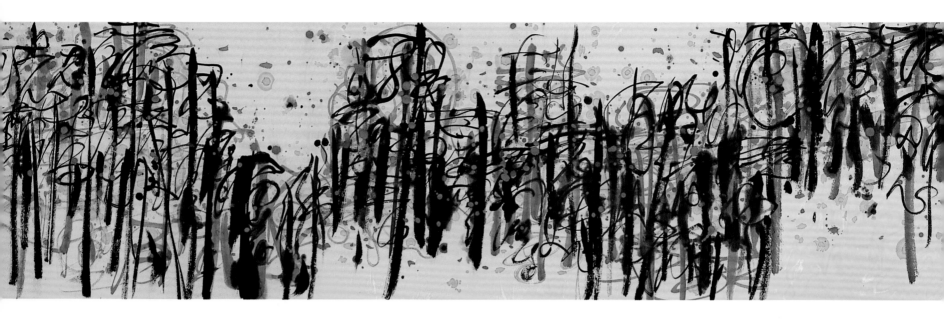

The Forest Chanting the Lotus Sutra
《群林誦妙法蓮華經》行草組合　140 × 25 cm

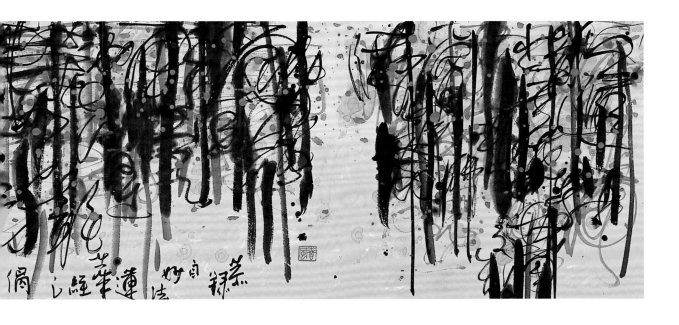

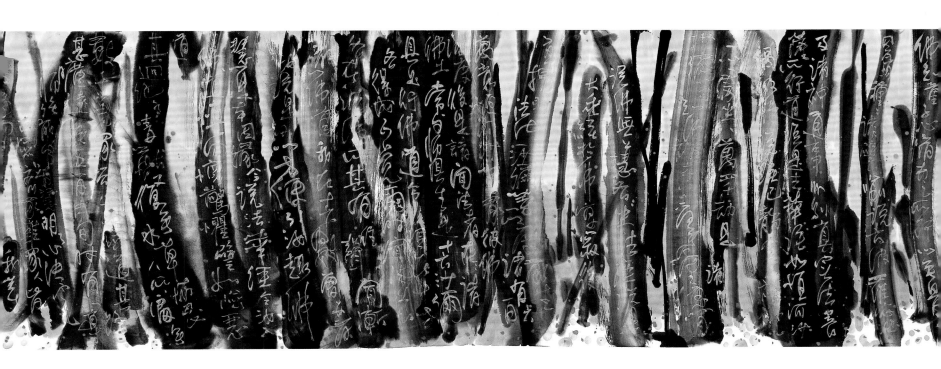

The Precious Flower Sprinkles upon the World
《寶華灑人間》 行書 136 × 46 cm

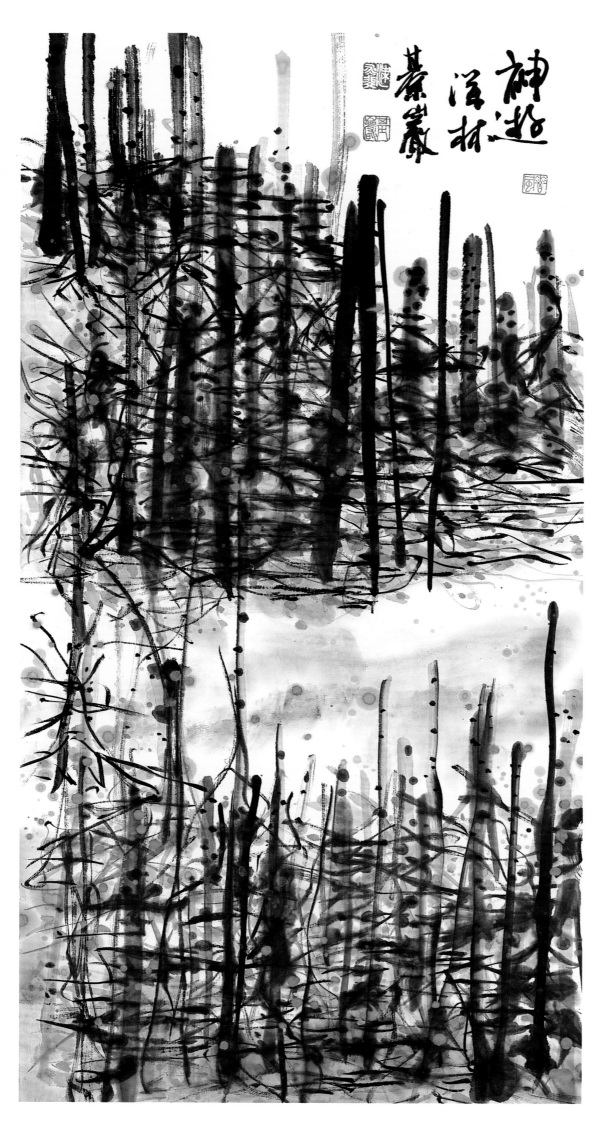

神遊深林 蔡紫峰

Wondering Deep in the Woods
《神遊深林》72 × 35 cm

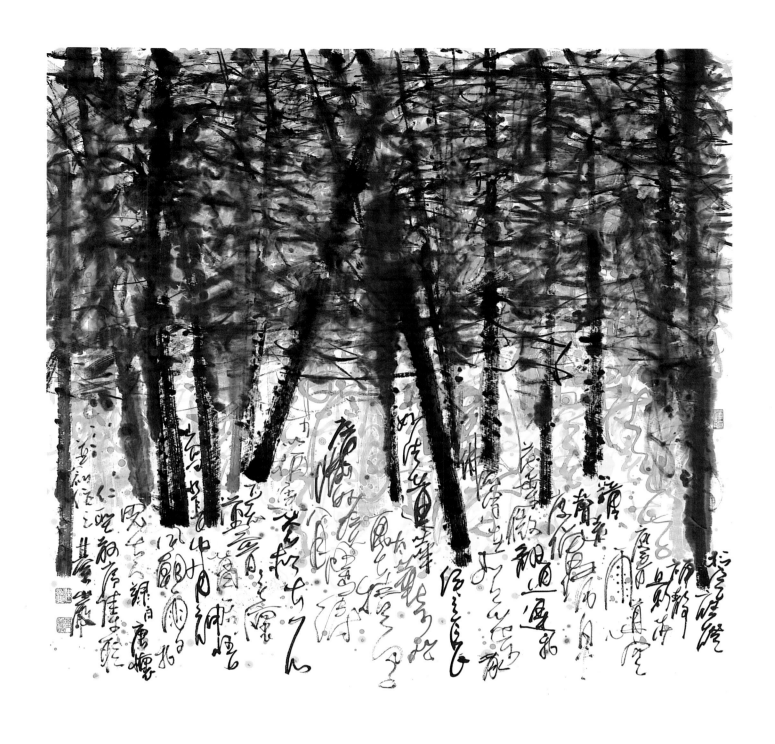

Heart Entering the Woods of Zen

《心入禪林》行書 69 × 69 cm

大 地 山 河 篇

Chapter V. Land, Mountain and Lake

用天地間的「山海」、「田園」…… 等為主題，並運用線條、字體的結構組合變化及色彩水墨技法，創作出「夜」、「大地豐收」、「煙雨城市」、「海上群峰」、「古城歲月」、「紅山映良田」…等作品，創作內容則大部分取自「經書」、「唐懷仁聖教序集聯」、「漢碑集聯」，字體則以隸書、行書為主。

Setting natural landscapes, such as "mountain and sea", "rural landscapes", etc., as the theme, with the usage of lines, combination of structures in fonts, and colors of ink-wash techniques, to create the works "Night", "Harvest of the Land", "Misty Rainy City", "The Peaks of mountain range in Shanghai", "The Years in the Ancient City", "The Red Mountain of the Great Land",…etc. The content of these works are mostly from "Sutras", "A Compilation of the Sacred Teachings Preface from Huairen in Tang dynasty", "A Compilation of Characters from the Han dynasty Ritual Vessels Stele", the fonts used are mostly Clerical Scripts and Semi-cursive Scripts.

The Misty City

《煙雨城市》行書

69 × 69 cm

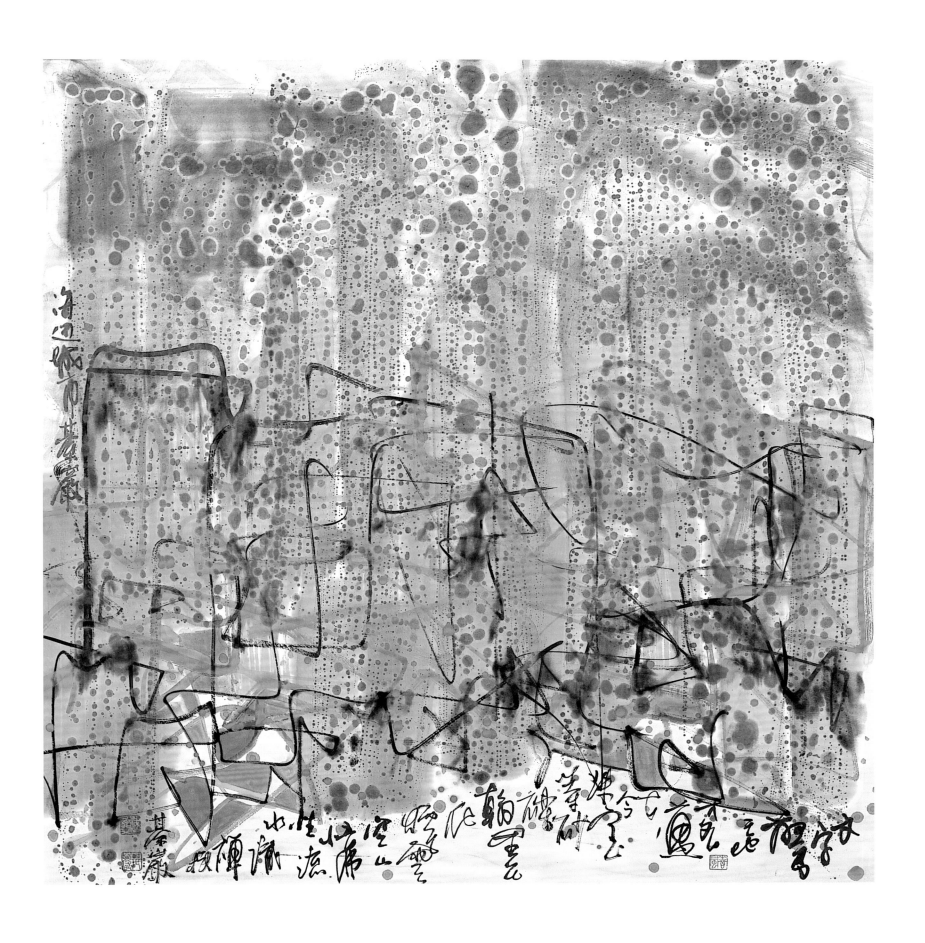

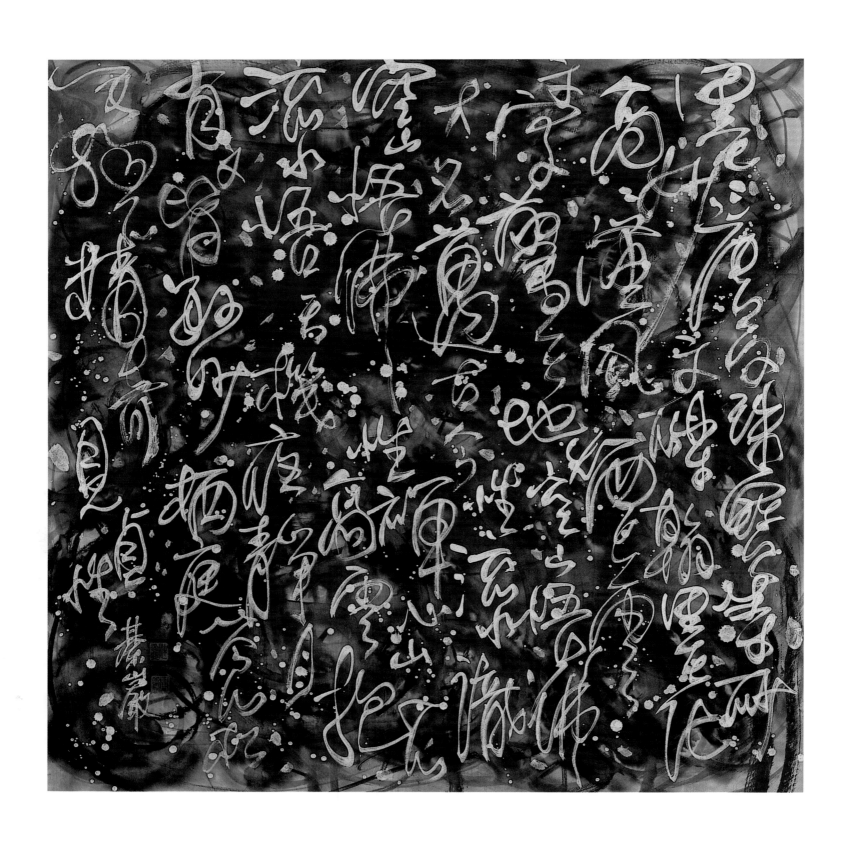

The Silence Land
《寂靜大地》行書 69 × 69 cm

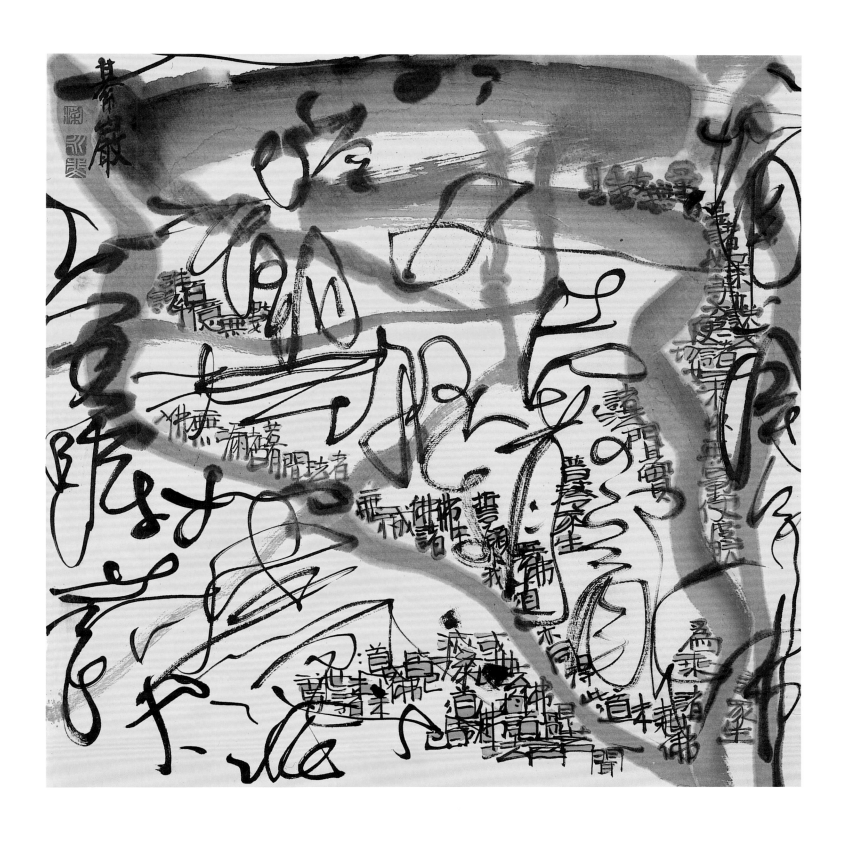

The Harvest of the Land
《大地豐收》行草隸書組合
35 × 35 cm

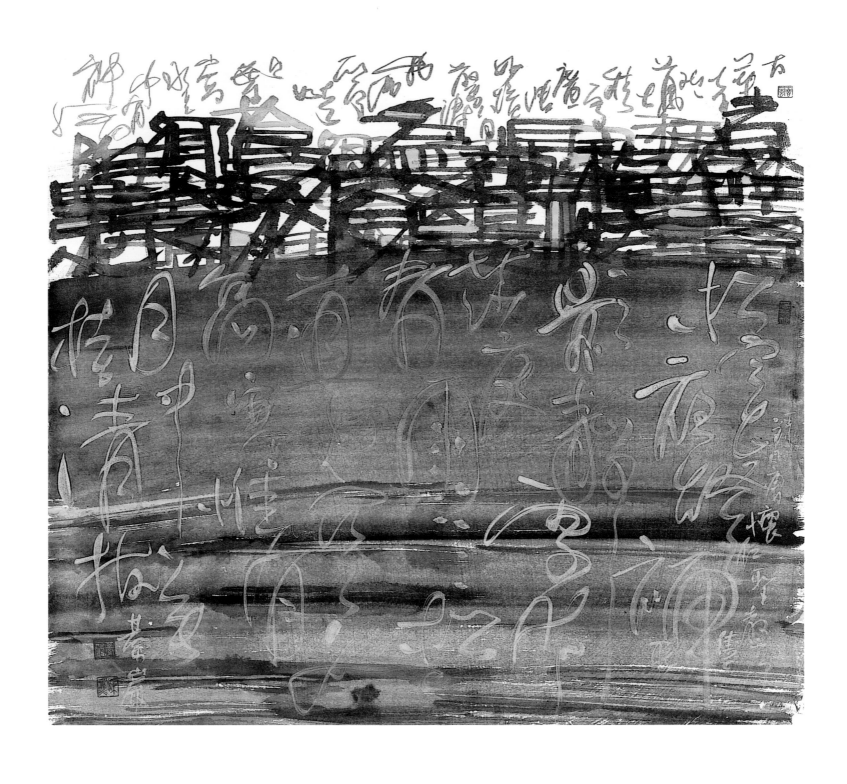

City by the River

《河邊城市》行書隸書組合

69 × 69 cm

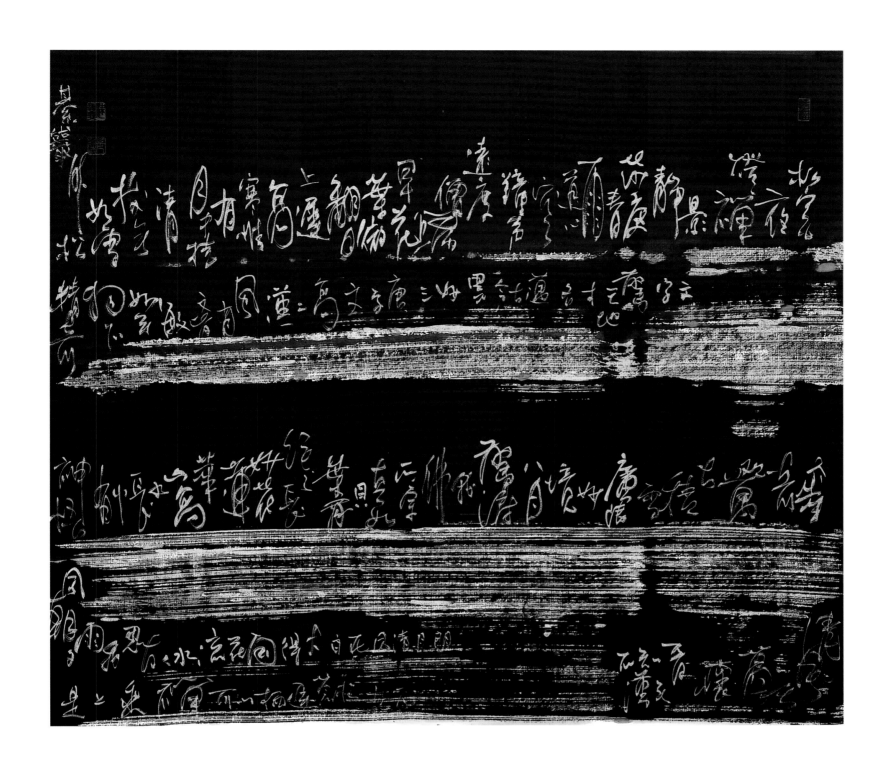

Night《夜》

行書 69 × 69 cm

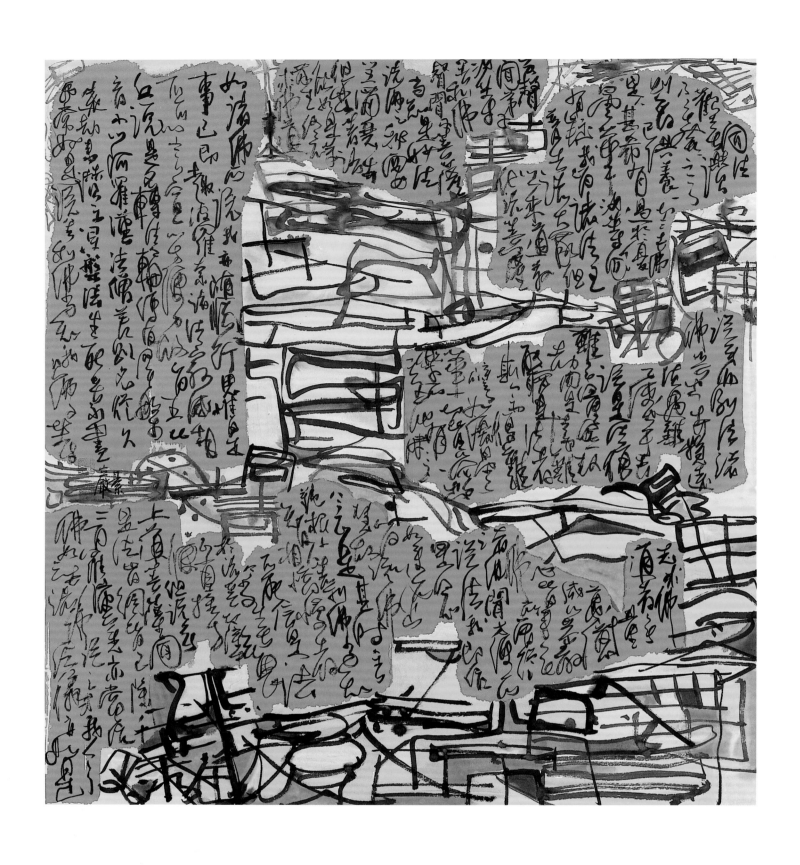

The Red Mountain and the Good Farm

《紅山映良田》行書篆書組合　69 × 69 cm

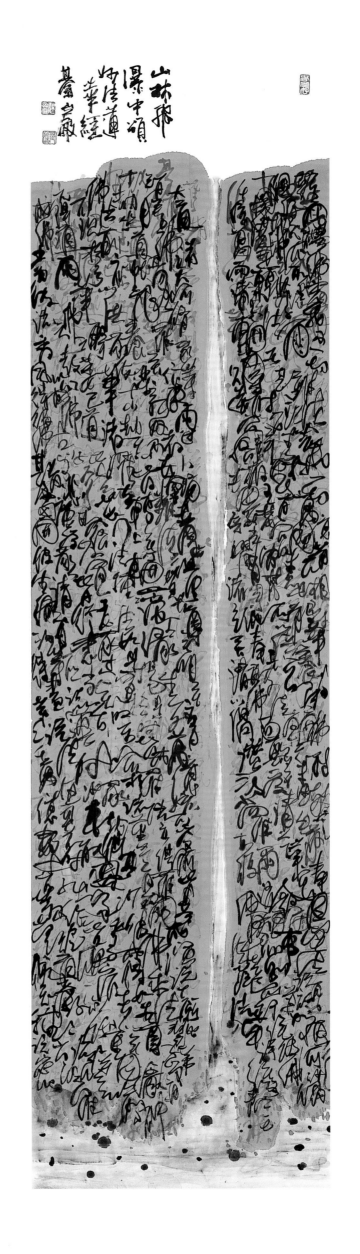

Mountain, Forest, Waterfalls
Chanting the Lotus Sutra
《山林飛瀑中頌妙法蓮華經》
行書　140 × 35 cm

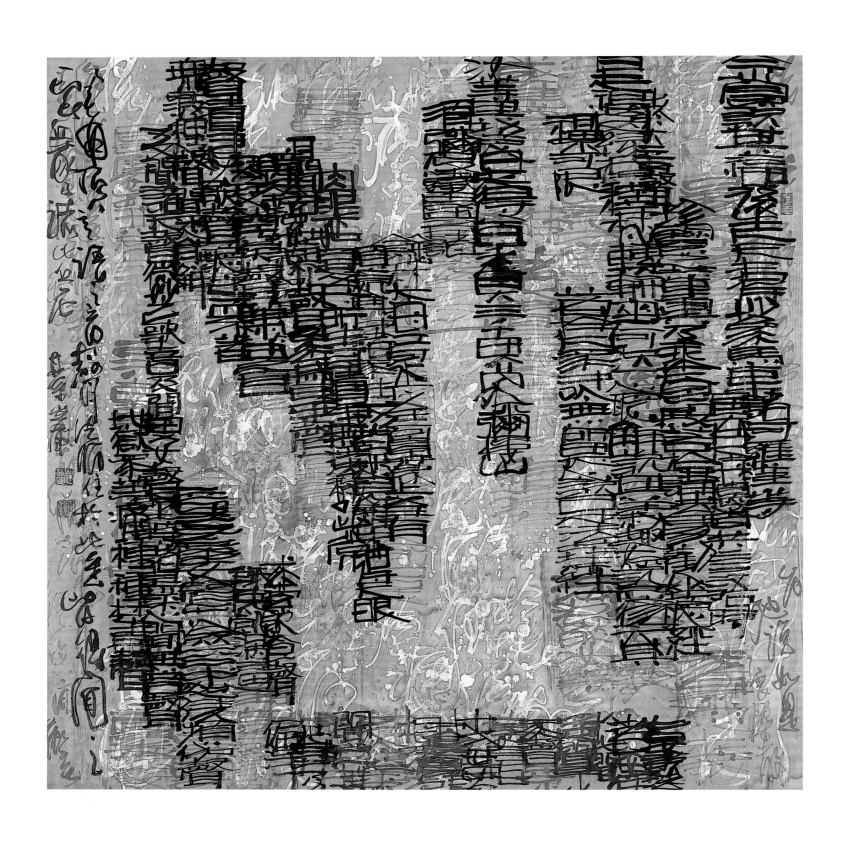

Groups of Fire above the Sea

《海上群峰》行書隸書組合 69 × 69 cm

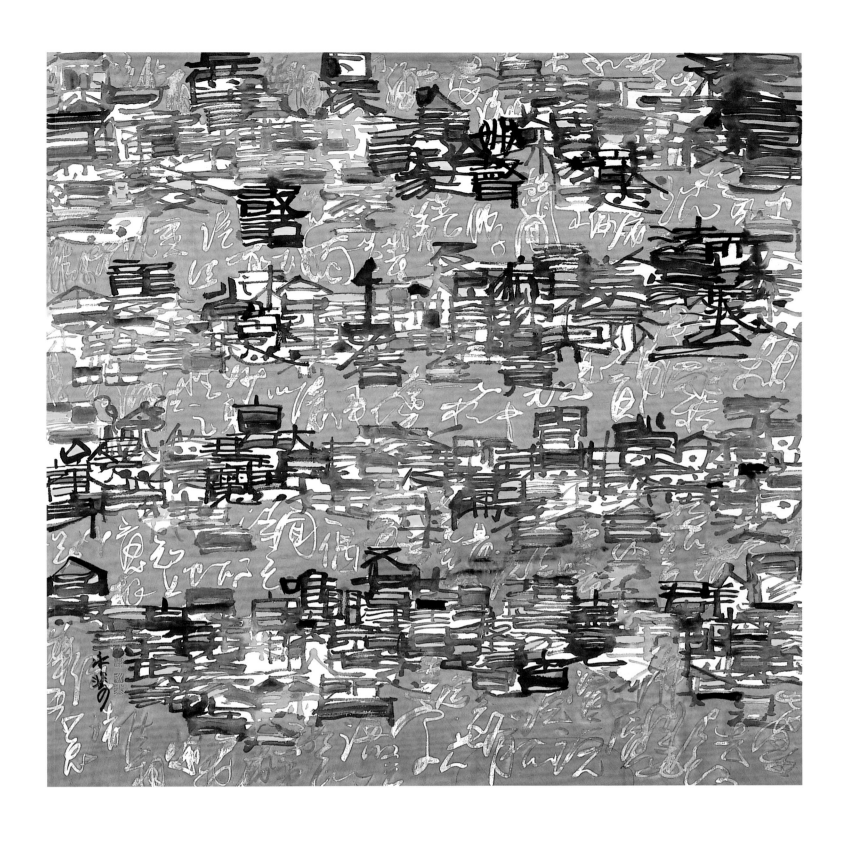

The People on the Lake

《湖上人家》行書隸書組合

69 × 69 cm

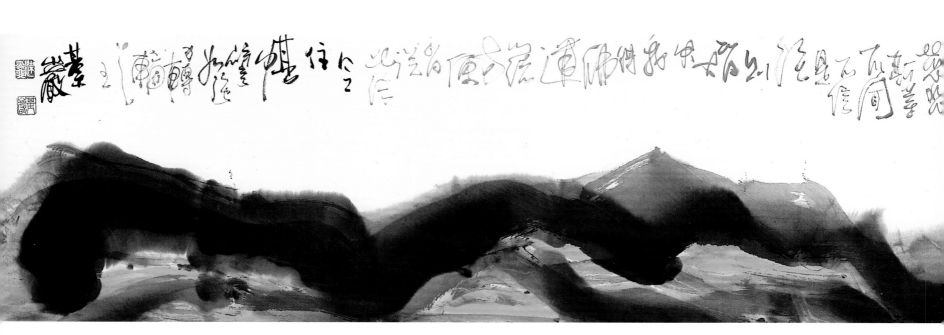

Nostalgia of My Hometown I

《思我故鄉一》佛家語 行書 140 × 25 cm

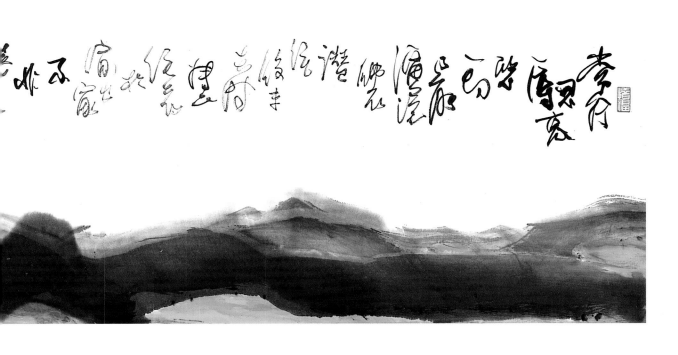

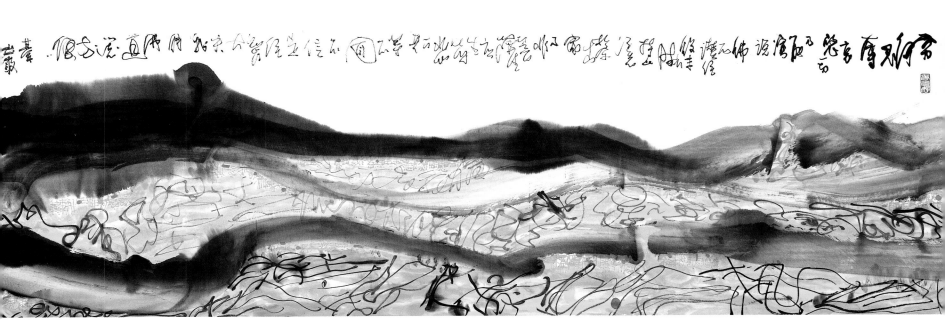

Nostalgia of My Hometown II

《思我故鄉二》佛家語 行書隸書組合 120 × 35 cm

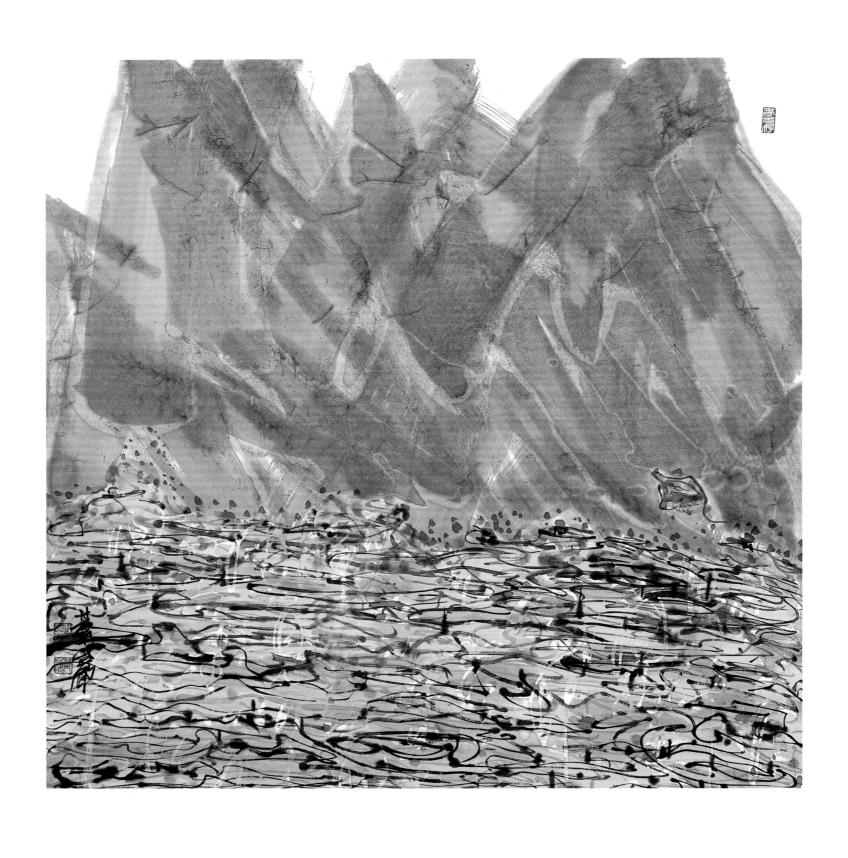

Pure Land

《人間淨土》69 × 69 cm

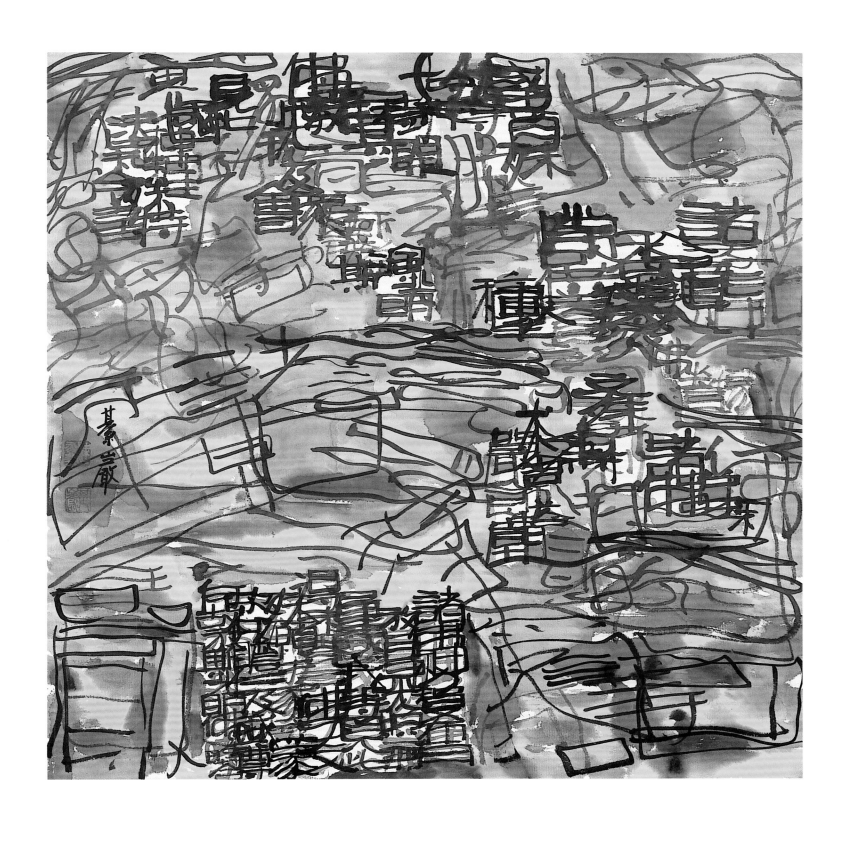

City Garden-
Combination of Clerical Script
《城市田園》隸書組合
46 × 46 cm

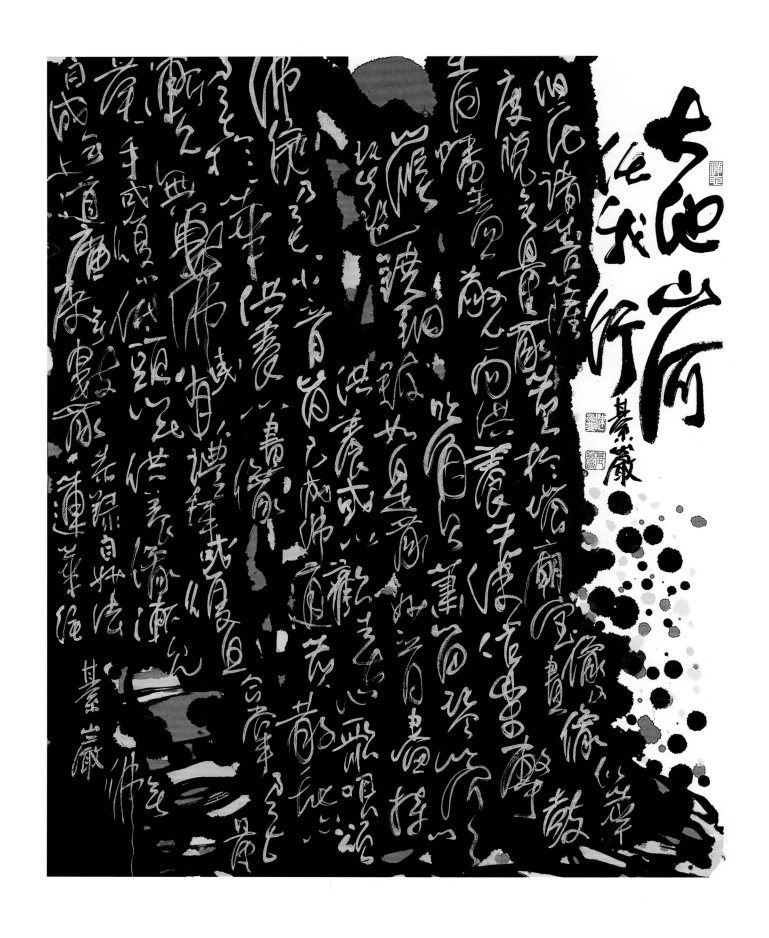

My trips on Mountain Lands and Rivers
《大地山河任我行》行書　69 × 69 cm
錄自妙法蓮華經

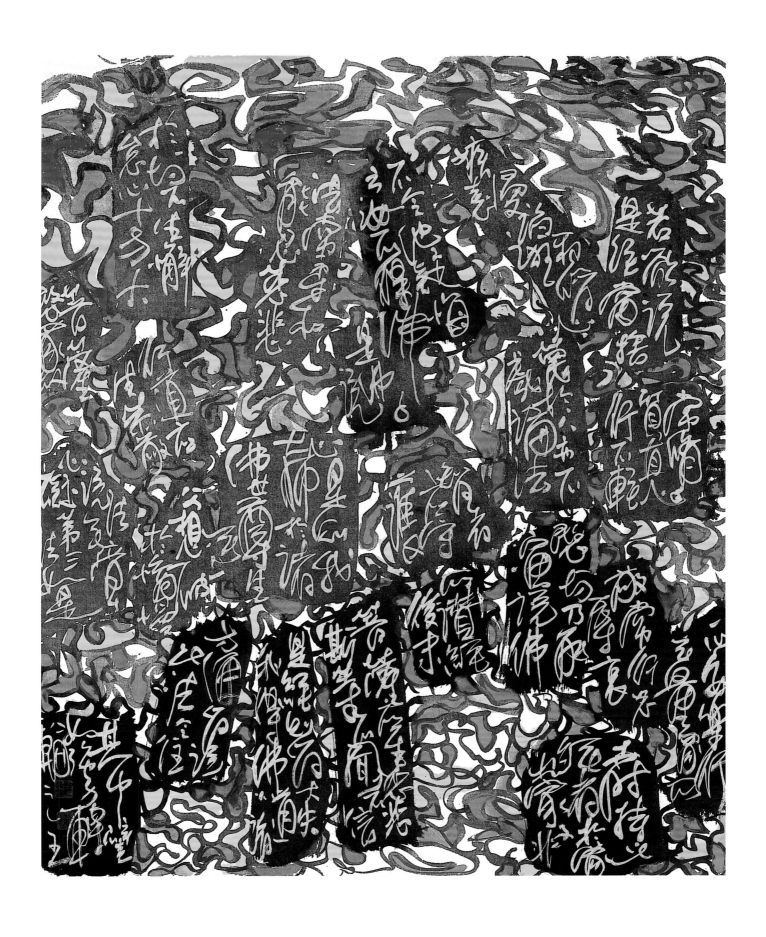

The Chanting of Mountains
《群山誦經》行書 69 × 69 cm

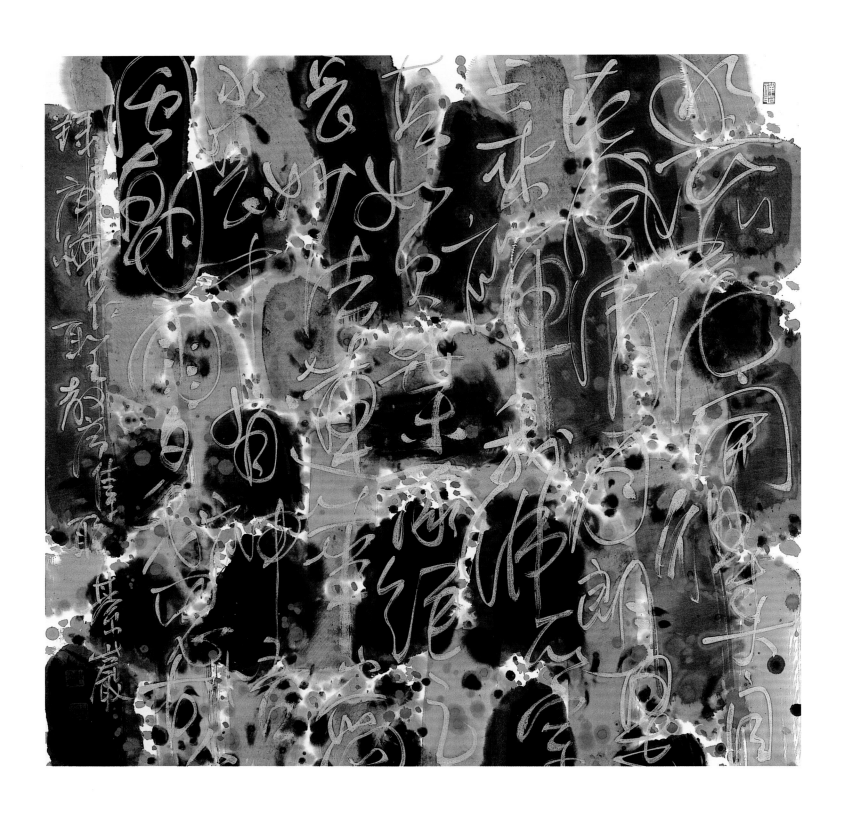

The World Filled with Blooming Flowers
《花開滿寰宇》行書　69 × 69 cm

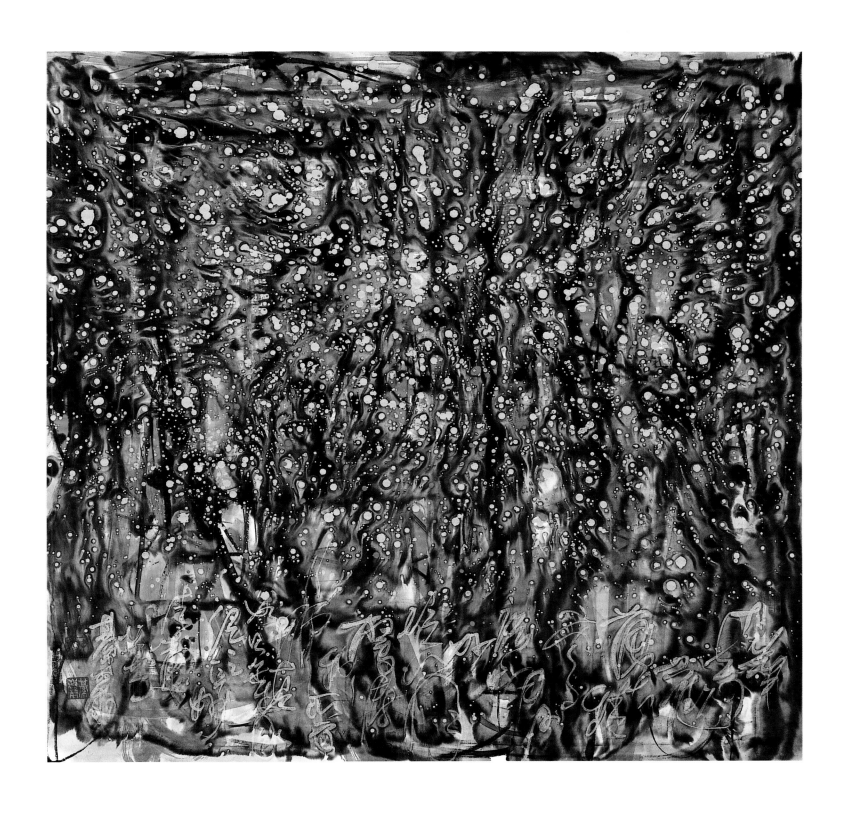

Flow
《流動》行書
69 × 69 cm

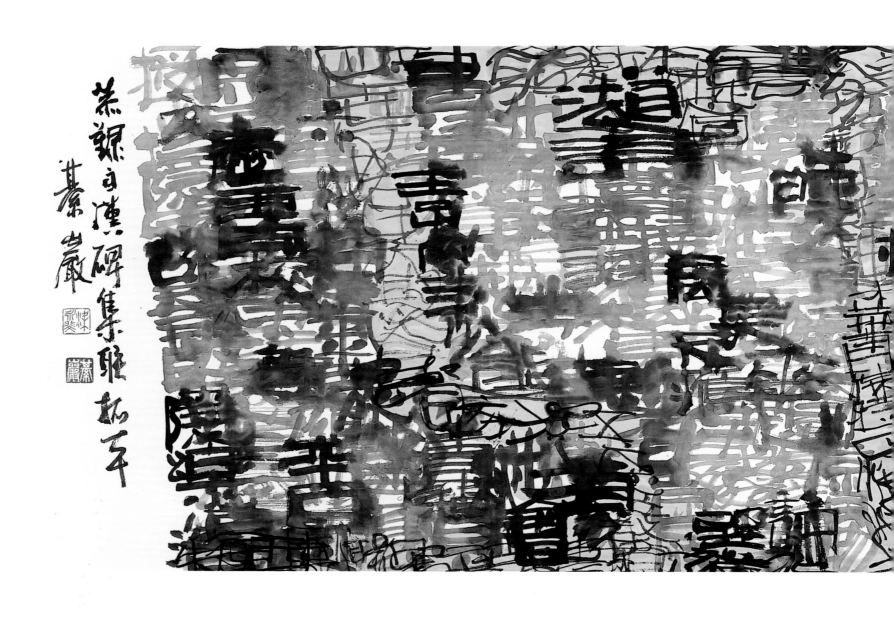

恭錄自漢碑集聯雅
紫巖基

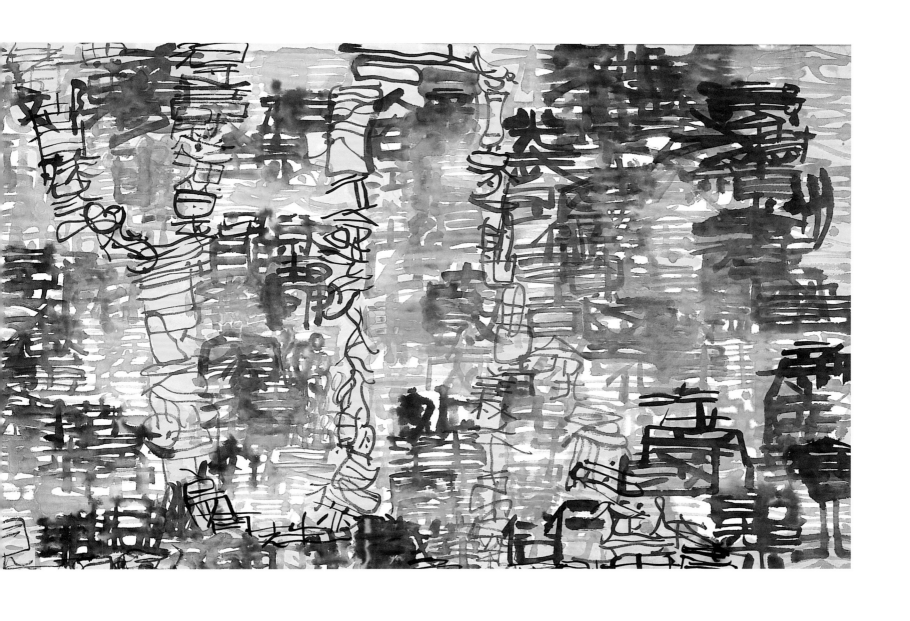

The Ages of the Old City
《古城歲月》隸篆組合 42 × 138 cm
錄自漢碑集聯拓本

圓滿人生篇

Chapter VI. A Complete Fulfilled Life

「圓」是人生最高的生活哲學，「圓融」、「圓滿」、「圓寂」…等，佛家語中曾有「理無礙、事無礙、理事無礙、事事無礙」這句話，也就是說能「圓」，則「無礙」。

本篇以「圓」為主題，透過金文、篆書、行書為創作元素，在圓中以金文、篆書呈現，並運用一些自己嘗試實驗的水墨技法，分層次處理完成，而達到一種解思鄉愁，提升心靈及利濟群生的「新境」。其中（法輪常轉）這幅作品，係金文、篆書六屏，是以佛經（八大人覺經）的內容在大小圓中書寫而成，期能護佑眾生安穩得樂。

"Circle" (yuan) is the highest living philosophy in life, "compatibility" (yuan rong), "completion" (yuan man), "pass away" (yuan ji), etc. In the Buddhist saying, "no obstructions in reasons, no obstructions in phenomena, then there's no obstructions in reasonable phenomena, and no obstructions in vitality", which indicates that the "Circle" is "no obstruction".

The theme of this chapter is "Circle" (yuan), using bronze inscriptions, seal script, semi-cursive script as elements for creation. By putting bronze inscriptions and seal scripts in circles and adding the ink-wash techniques experimented by myself, to finish the work layer by layer, in attempt to reach an interpretation for nostalgia, to promote one's spirit, and to benefit all living beings, the "new scenery". In one of the artworks, The Wheel of Transmigration Turns Unceasingly, presented with the six passages of bronze inscriptions, seal scripts, with the content of the Eight Realizations of the Great Beings written within different sizes of circles, in wishing to protect all living beings to live in peace and happiness.

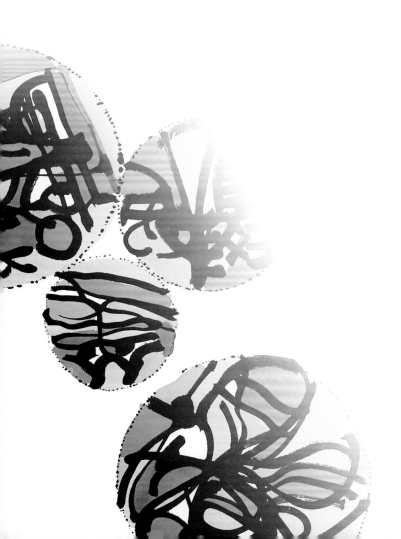

Fulfilled City

《圓滿城市》 篆書

70 × 46 cm

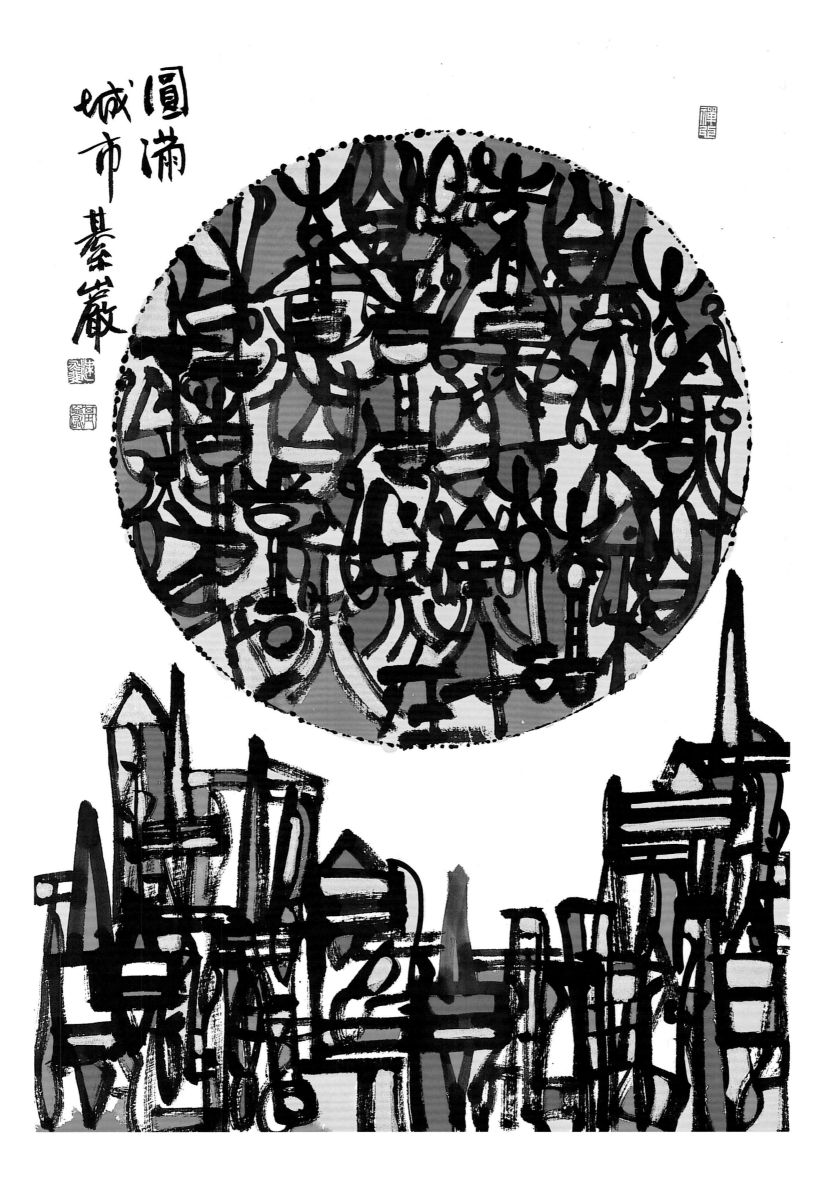

圓滿城市　墓巖

137

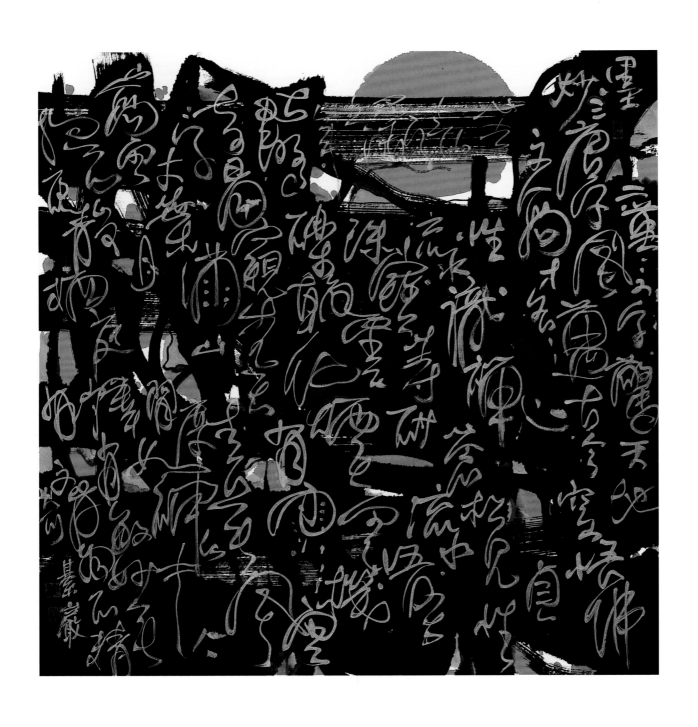

This Day
《待日》行書 69 × 69 cm

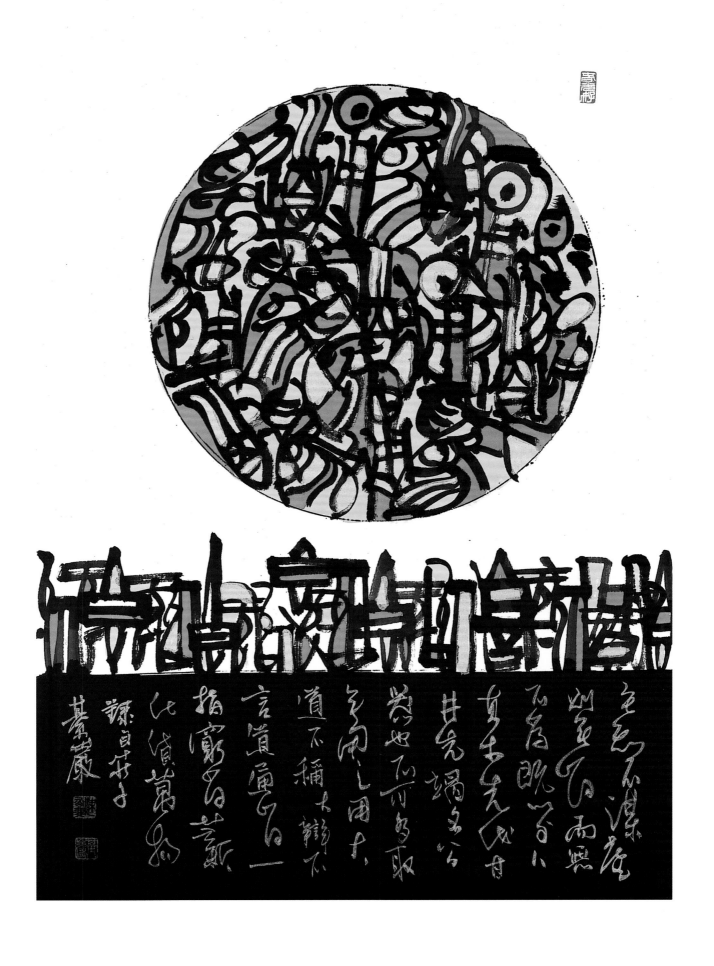

Admiring the Moon

《賞月》篆書行書組合

70 × 46 cm

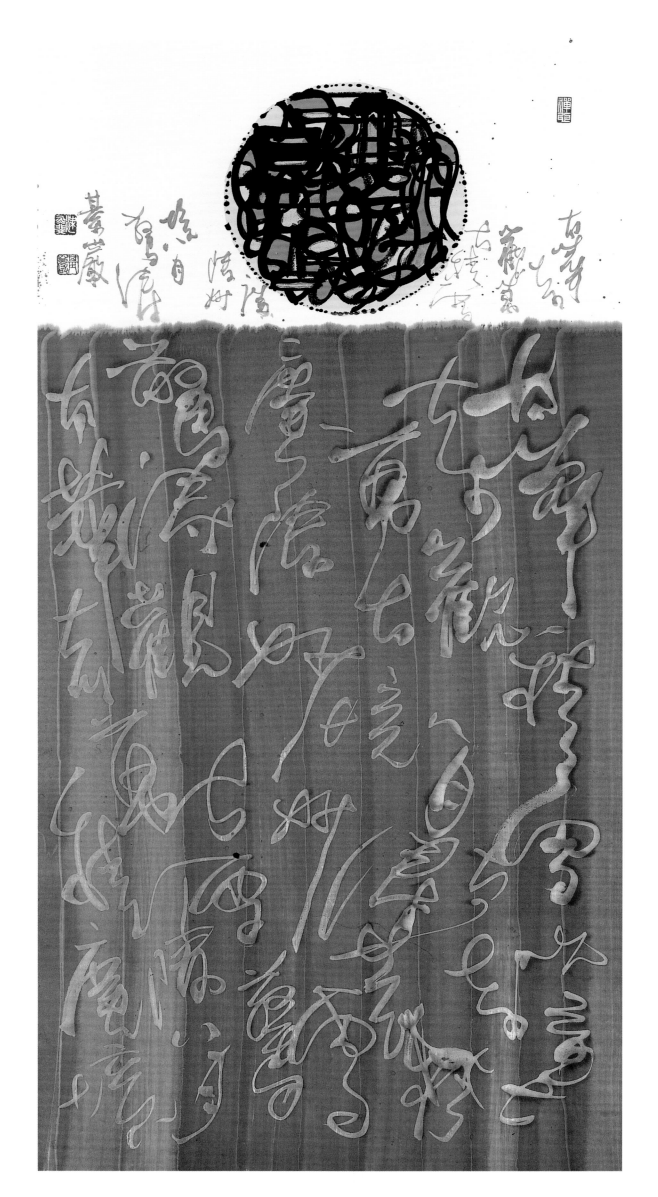

Mountains and the Moon
《群山望月》篆書行書組合
88 × 46 cm

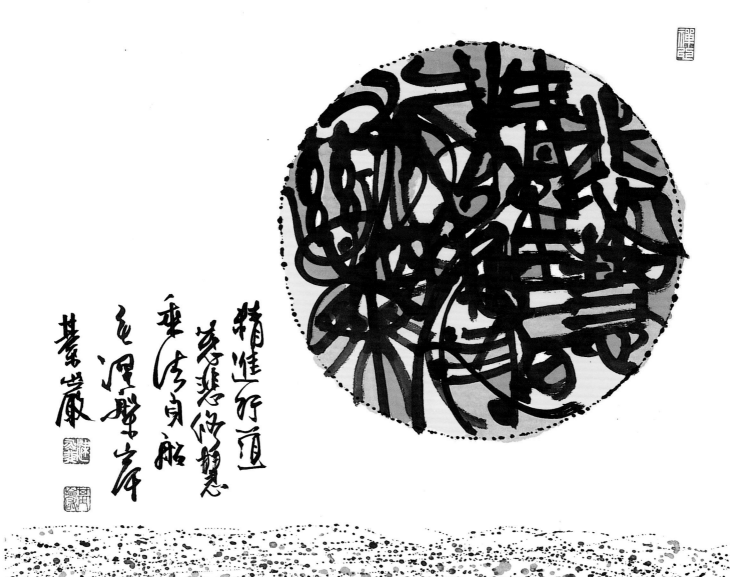

精進行道
菩薩悲修諸慧
乘法身船
至涅槃岸
慧嚴

Pearl of the Sea
《海上明珠》篆書行書組合
46 × 46 cm

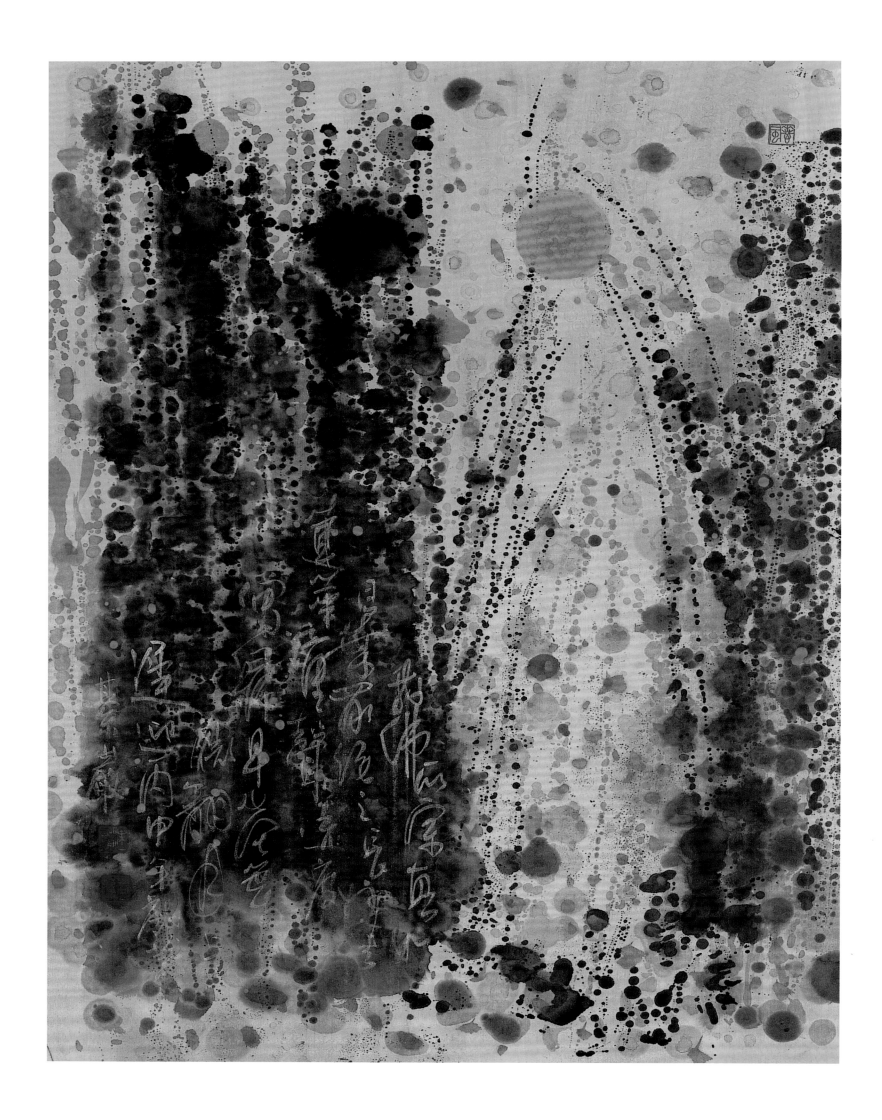

The Bamboo and Lotus in the Moonlight
《竹荷映月》行書 60 × 46 cm

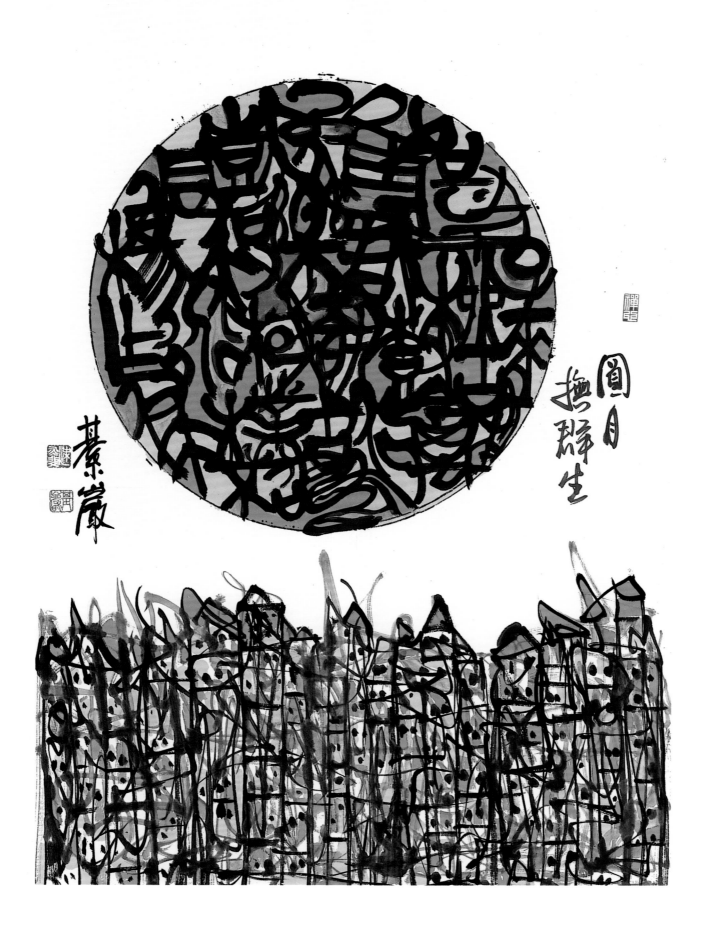

The Living Comforted by the Moon

《圓月撫群生》 篆書 70 × 46 cm

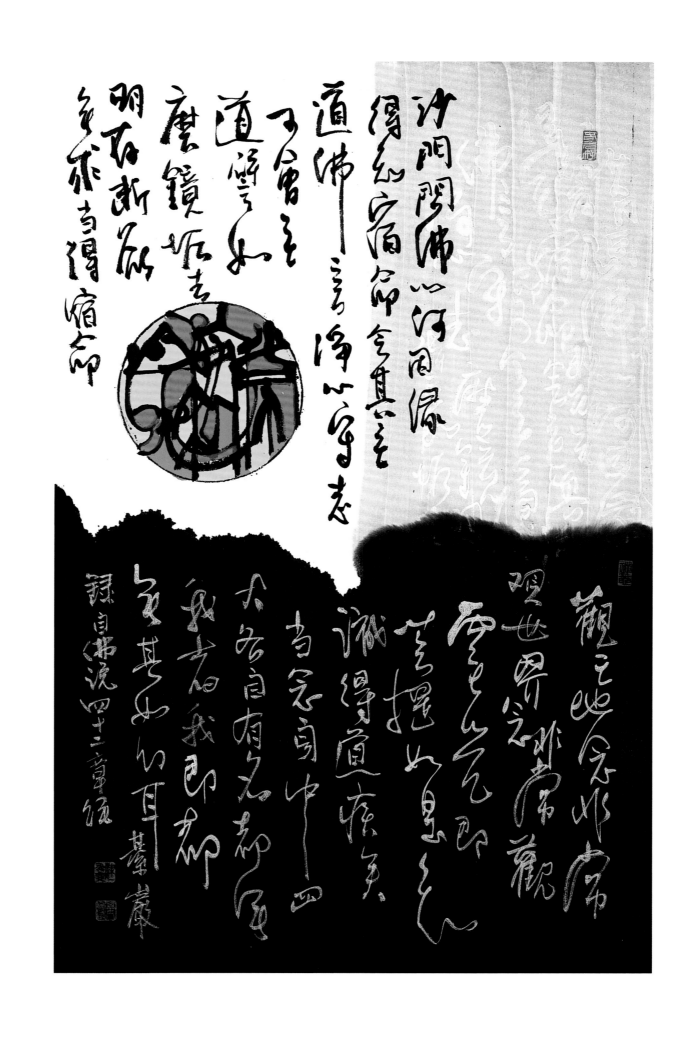

Rising Sum
《旭日東升》篆書行書組合
69 × 69 cm

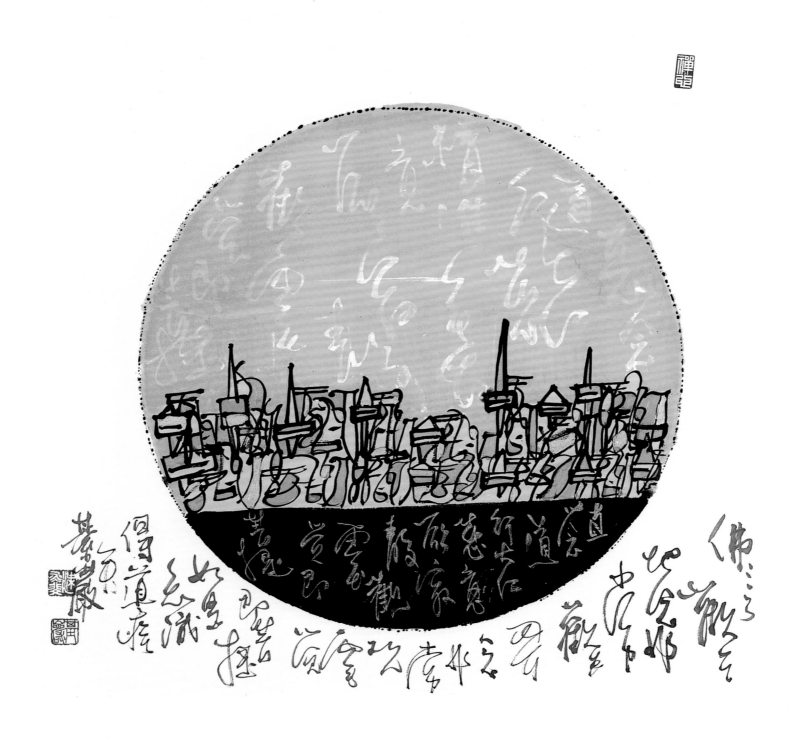

The City of the Moon

《圓月之城》 篆書行書組合

46 × 46 cm

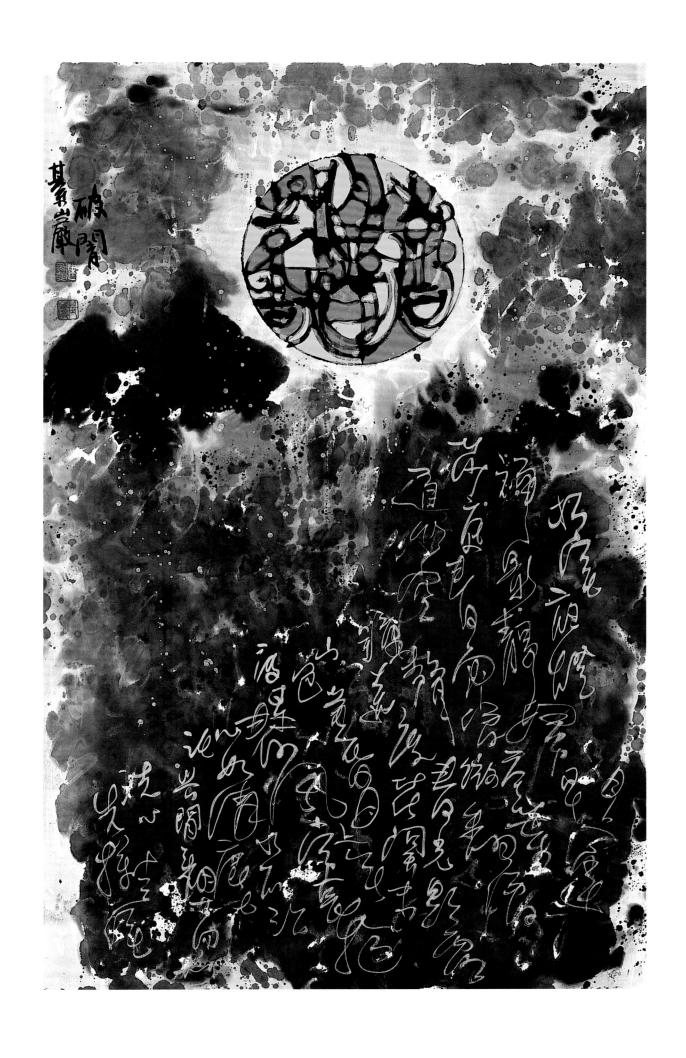

Breaking through the Dark
《破闇》 篆書行書組合
78 × 48 cm

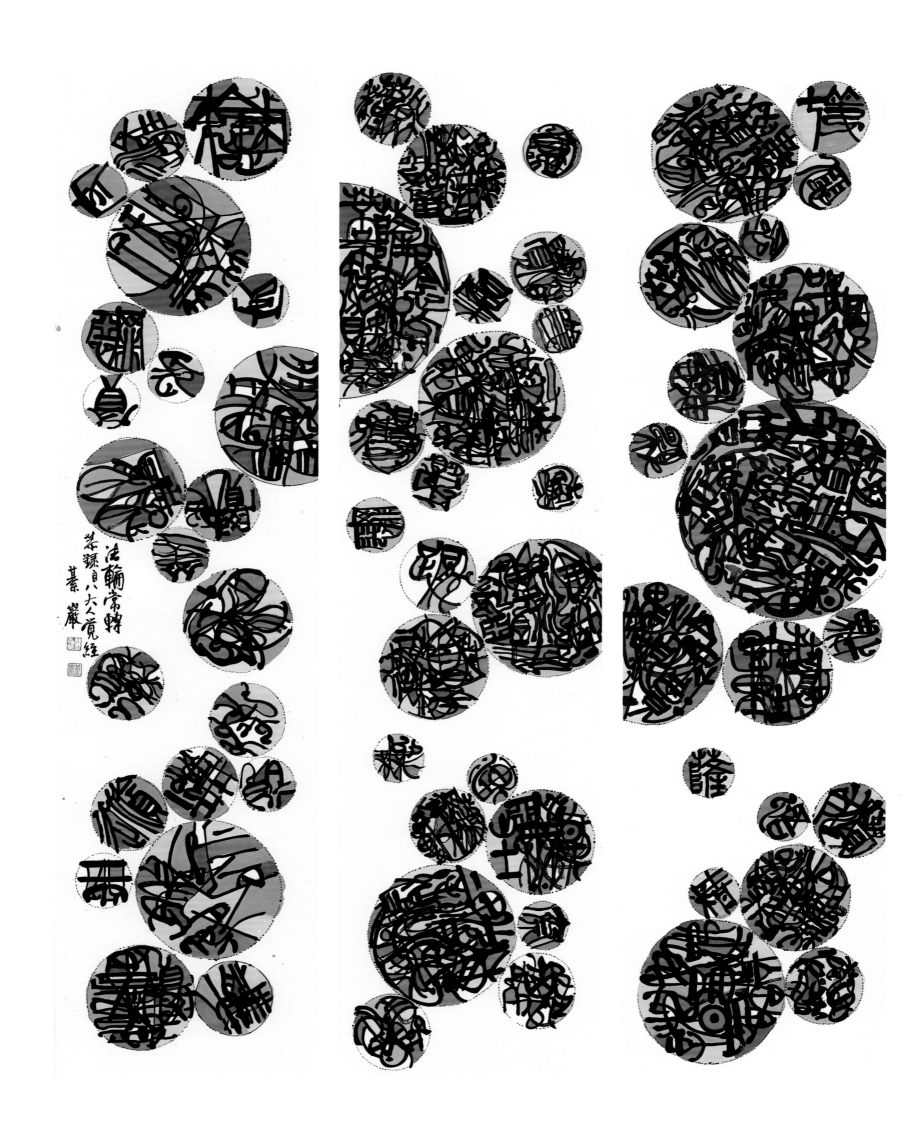

The Wheel of Transmigration turns Unceasingly
《法輪常轉》 金文篆書六屏 180 × 45 cm × 6
錄自八大人覺經

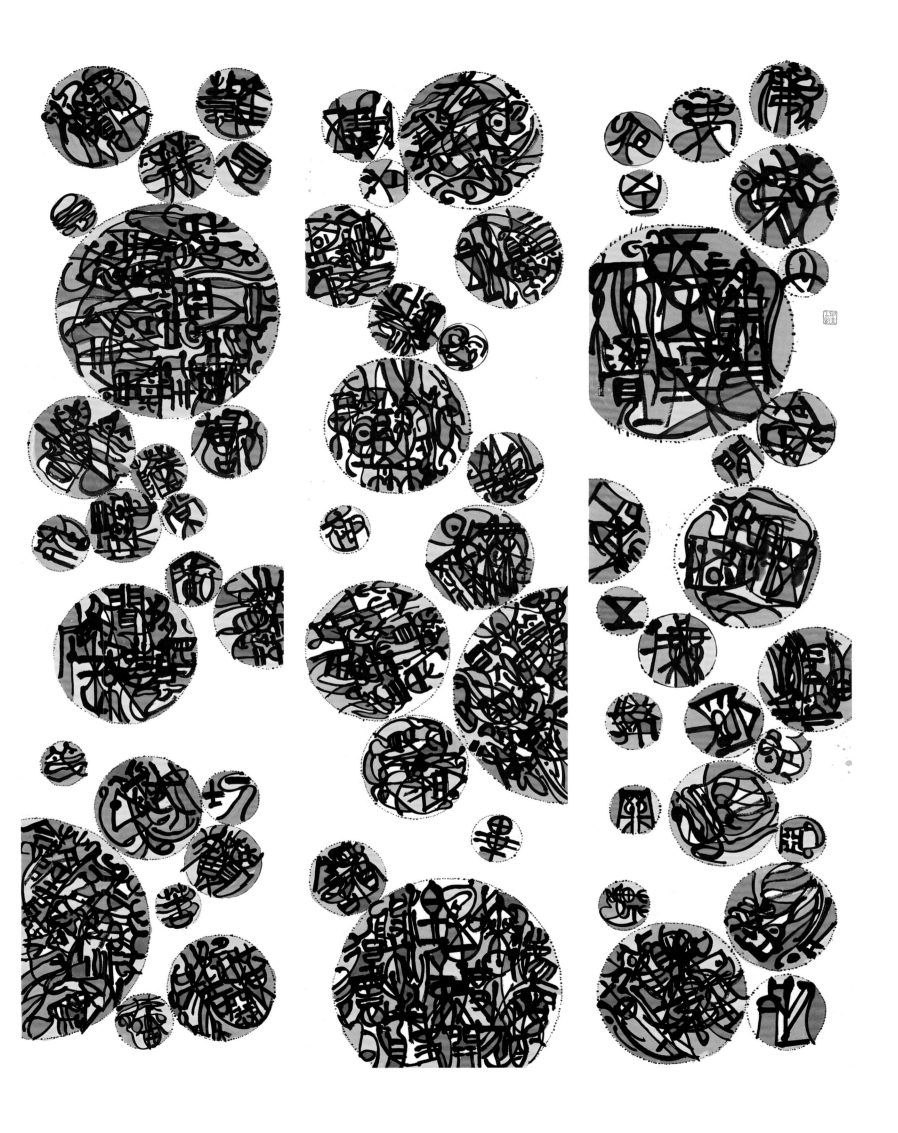

Flower of Joy
《樂之花》篆書 46 × 46 cm

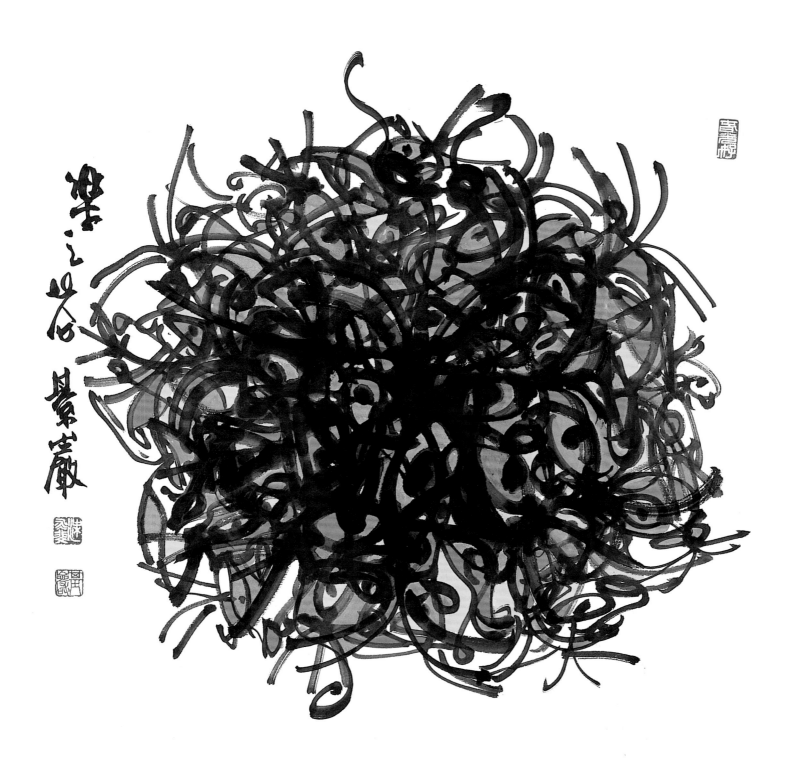

151

國家圖書館出版品預行編目資料

書藝無界：梁永斐書藝創作集　梁永斐著.―
　新北市：梁永斐，2018.01
　　　面　：　　公分

　ISBN　978-957-43-5297-5（精裝）

　1.書藝　2.作品集

943.5　　　　　　　　　107000821

書藝無界/梁永斐書藝創作集

Liang Yung-Fei ＜Calligraphy Art unbounded＞

發 行 人：梁永斐
著 作 人：梁永斐
出 版 者：梁永斐
　　　　　地址：新北市板橋區金門街163號11樓
贊 助 者：郭國華
封面題字：李奇茂
執行編輯：宋美英‧鄭明毓
攝　　影：林文正
設計印刷：林群廣告印刷事業有限公司
　　　　　地址：臺北市敦化北路145巷21號4樓
　　　　　電話：(02)27131268
定　　價：新臺幣1200元整
出版日期：2018年1月